UNREPENTANT WHORE

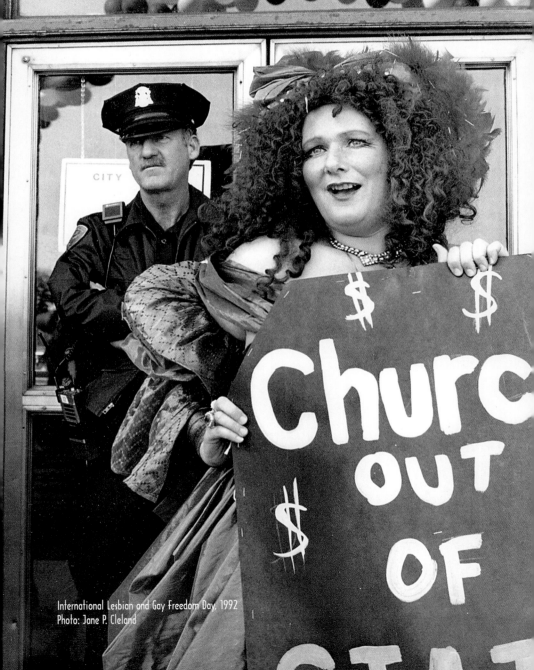

International Lesbian and Gay Freedom Day, 1992
Photo: Jane P. Cleland

UNREPENTANT WHORE
Collected Works of Scarlot Harlot

by Carol Leigh

SAN FRANCISCO

http://www.unrepentantwhore.com

Carol Leigh Productions
Box 210256
San Francisco, CA 94121

Copyright ©2004 by Carol Leigh
Published in the USA by Last Gasp
777 Florida Street
San Francisco, CA 94110

ISBN: 0-86719-584-3

10 9 8 7 6 5 4 3 2 1

Cover design: The Telegraph Company
Cover photo: Merwelene van der Merwe
Book design and prepress: Katharine Gates

Printed in Hong Kong

Acknowledgements

I thank Annie Sprinkle, the midwife to this manuscript and Katharine Gates, the doctor. I thank my closest friends and collaborators: Larry Grant, Dee Dee Russell and Gilbert Baker for their encouragement and emotional support. Thanks to Margo St. James, Priscilla Alexander, Norma Jean Almodovar, Gail Pheterson, Victoria Schneider, Duran Ruiz, Carol Stuart, Gloria Lockett, Naomi Ackers, Dolores French, Vic St. Blaise, Tallulah Bankheist, Teri Goodson, Sanday Southworth, Sparrow, Carol Draizen, Annie from the massage parlor, Kate and Lisha, Sara Angel, Tia Mercury, Rosemary Young, Deirdre Evans, Chris Trian, Simon Alexander, Noni Howard, Kat Sunlove, Madeline Lowe, Thomas R. Fox, Gaia, Tracy Quan, Maxine Doogan, Cheryl Overs, Jo Doezema, Marjan Wjers, Andrew Sorfleet, Gwendolyn, Bobby Lilly, Babe Bliss, Macha Womongold, Hinda P., Celeste Newbrough, Wang Fang Ping, Keith McHenry, Dennis Peron, John Bryan, Cynthia Chandler, Jill Nagle, Carol Queen, Daisy Anarchy, Penny Saunders, Dawn Passar, Erochica Bamboo, Lin Chew, Elna McIntosh, Cleo Dubois, Annie Oakley, Candye Kane, Alex Juhasz, Laurie Schrage, Maggie Rubenstein, Dr. Joseph Kramer, Dorrie Lane, Tamara Ching, Hima B., Bharati Narumanchi, Ms. Eisanna Eiger, Leslie Bull, Emi Koyama, Veronica Monet, Marc Perkel, Johanna Breyer, Shirletha Calhoun, Whitefeather and Sadie, the Rabbi Lady for being allies and mentors. Thanks to performance teachers, collaborators and San Francisco celebrities Joya Cory, Marcia Kimmel, Helen Dannenberg, Jane Dornacker, John Cantu, Rhodessa Jones, Margaret Burke, Smelley Kelley, Davo, Nora Dunn, Cosmic Lady and Linda Lorraine. Thanks to technology mentors Dave Bukunus, Sharkey Barsocchini and Dana Levy-Wendt, I can do something for money besides prostitution. I thank Marc Geller, Rink Photo, Jane P. Cleland and Layne Winklebleck for the years of tireless documentation and your contributions to this book. Thank you, Gilbert Baker (Chanel 2001) for my brilliant costumes. I want to thank Anne Harrison, Alex Zorn, Larry Grant, Amy Donovan, Roberto Landazuri, Tortuga Bi Liberty, Bayla Travis and Augusta (my mother) for their support and for reading the manuscript. I want to thank the Burke and Landazuri families for seeing me through the AIDS crisis and my own crises.

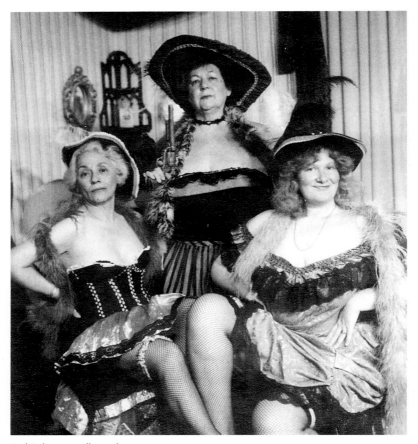

Aunt Audrey, my mother, and me.

This book is dedicated to my mother, Augusta, who gives me unconditional love, made me wise by sharing her struggles with me, cooked for me, supported me, entertained me, always believed in me and continues to inspire me.

Table of Contents

PORNOCRACY NOW! .134

WHORETOPIA .190

VIDEOGRAPHY .228

SOURCES .240

WHO IS SCARLOT HARLOT and WHY IS SHE SO FABULOUS AND IMPORTANT? by Annie Sprinkle

Scarlot Harlot is the world's best friend.
Her love is real, never pretend.
She is always there to lend a hand.
Her heart of gold is oh so grand.

Scarlot Harlot is a passionate poet.
Many people don't even know it.
Hopefully this book will help spread the news
And make her the most infamous of Jews.

Scarlot Harlot is a world class performance artist
She's one of the smartest, and one of the tartest.
She wrote and starred in her own one-woman show.
Got standing ovations from those in the know.

Scarlot Harlot is a San Francisco icon.
You'll want to shoot her with your Nikon.
From the Golden Gate Bridge down to Market Street,
For tourist attractions she's even got Alcatraz beat.

Scarlot Harlot is an activist for prostitutes' rights.
Worked hard without pay many days and many nights.
She's been on the front lines for a good thirty years.
Shed rivers of blood, sweat and tears.

Scarlot Harlot is a soldier in the fight for prison reform.
She conquers injustice in an American flag uniform.
She volunteers weekly for the needle exchange,
Always helping the underdogs and the strange.

Scarlot Harlot is an award-winning film director,
A feisty feminist and college lecturer.
She does it all with style and grace.
You can take her most any ol' place.

Scarlot Harlot organizes the S.F. Sex Worker Film Fest.
Do not miss it. It's the absolute best!
She does outreach and education,
Fighting sex worker stereotypes throughout the nation.

Scarlot Harlot is a comedian extraordinaire
Her Psychic Prostitute skit is beyond compare.
You'll laugh so hard you will turn blue,
And you'll become a devoted fan too.

Scarlot Harlot is a plus size model.
At size twenty-two she's got a bit of a waddle.
But she's a role model for us girls with big curves.
She's proud of her body! Oh pass those hors d'oeuvres.

Scarlot Harlot is a computer wiz.
She will help you with your biz.
She'll edit your video, design your flyer,
Create the packaging, and find you a buyer.

Scarlot Harlot is a fine politician,
In the Honest Abraham Lincoln tradition.
She was on the Mayor's task force.
Harlot for President, of course! Of course!

Scarlot Harlot is nothing short of a Saint
She can do things Princess Di and Mother Teresa cain't.
Scarlot Harlot is The Goddess of Compassion,
And she always wears the latest fashion.

Scarlot Harlot is the gal that we love best.
The finest whore in all o' the West.
She has made the world a more wonderful place
All this and more, plus she'll sit on your face.

PROLOGUE

Prior to the twentieth century, prostitutes were almost exclusively portrayed by male observers: historians, authors, social scientists, psychologists and preachers. Since the early 1900s there have been a number of authentic memoirs by the demimondaine, from Maimie Pinzer's letters (1910-17) in *The Maimie Papers* to Xaviera Hollander's *Happy Hooker* in the '70s. Norma Jean Almodovar's *Cop to Call Girl* and Dolores French's *Working: My Life as a Prostitute* were published in the '80s, followed by a number of anthologies of first person accounts by sex industry workers, including *Sex Work*, published in 1987. In the last decades, this self-representation has escalated, propelled by a new construct of female identity. The postmodern *puta* squirms out of the nineteenth century "slave narrative" into a broad range of archetypes from slave to warrior, from kidnapped victim to union organizer.

Because of these changes, our female shame, this "whore stigma," is lifting. Self-identified whores organize in urban societies around the world, articulating political goals and sharing personal tribulations.

At the cusp of these changes, I have seen the growing numbers of unrepentant whores, "bad girls" (and boys), who shed their shame and create new roles in society. I helped launch this movement, inventing the term "sex worker" in the '70s and creating a body of work that maps a social movement.

The material in this collection chronicles my work as a life artist. Over the course of two decades I lived and worked in the persona of Scarlot Harlot. As a prostitute I worked in massage parlors, as an independent call girl, and within a network of "working girls." Scarlot Harlot, "unrepentant whore," is one of a small number of "sex radical feminists" at the turn of the century, a mascot and mover in the sex workers' rights movement.

The remainder of the story is documented in this collection. I hope these tales inspire you, your daughters and your sons. I hope those of you who live at odds with traditional values find courage here to disclose your deviance (but you might want to hold off telling your lovers, parents and dissertation committee). My general advice: acknowledge the contradictions and maintain a sense of humor, because you'll need it.

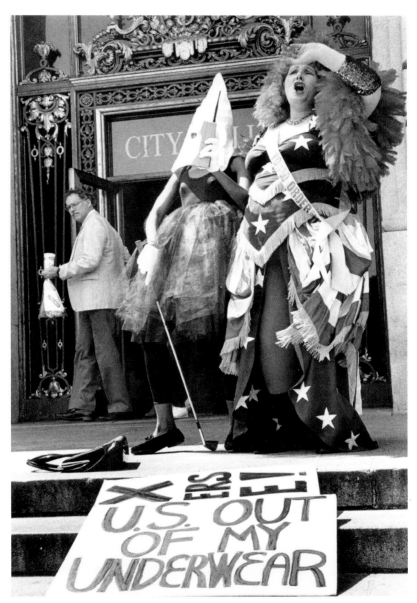

Scarlot and Dee Dee Russell exorcise their angst at City Hall in *Bad Gurlz in a Bad Mood,* 1992.
Photo: Jane P. Cleland

Disclaimer (for those who walk on the wild side)

If you get into trouble, don't blame (or sue) me. People can get hurt when they engage in illegal, stigmatized activities. Men (and women) try to fool you. Poetry ≠ Money. If you run away from home you might get into trouble. Don't be poor, homeless, sick or addicted to anything illegal or expensive—as if you have a choice. Life on the sexual frontiers can be dangerous at worst, or simply a cross to bear.

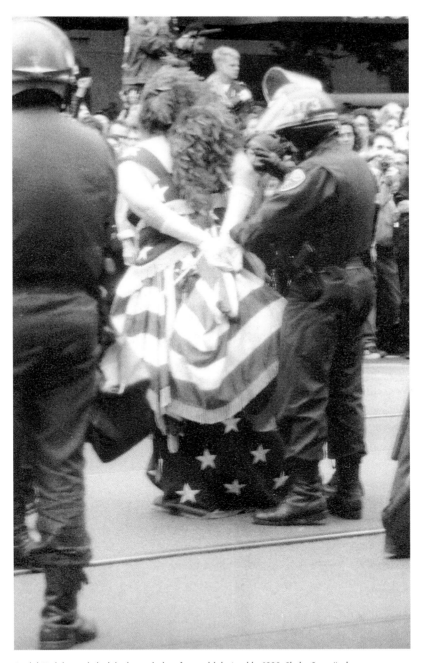

Scarlot Harlot, arrested while demonstrating for prostitutes' rights, 1990. Photo: Tracy Mostovoy

Cocks and Consciousness

From *The Adventures of Scarlot Harlot*, 1984. Photo: Charles Kennard

Red Diapers and Gender Traitors

[This collection of texts and poetry originally appeared in *Uncontrollable Bodies: Testimonies of Identity and Culture*, Bay Press, 1994.]

CHEAP

Cheap is when you fuck them just to shut them up.
Cheap is when you do it because they are worth so much.
Cheap is when you suck them till your jaws hurt
so they won't say you're uptight.
Cheap is when you do it to keep them home at night.
Cheap is when you want less than pleasure,

<div align="right">a baby, or a hundred dollars.</div>

Cheap is when you do it for security.
Cheap is what you are before you learn to say no.
Cheap is when you do it to gain

<div align="right">approval, friendship, love.</div>

Photo: Mary Eleanor Browning

Excuses, Excuses . . .

I am a self-proclaimed whore and a rebel with a fierce appetite for love and approval. Naturally, I developed a career as an artist. But how did a nice, middle class woman like me wind up a famous slut?

My grandparents emigrated from Europe before the Holocaust, surviving in New York City's garment business. My parents were both outcasts in their families. Alfred was brainy and his parents were anti-intellectual. Gussie was fat.

Their shared misery, and an admiration for Trotsky, formed the basis for their romance among the comrades. It was a time of idealism and mating, my Mom tells me. After the war, the honeymoon was over. It was Stalin's fault but the socialists were blamed. Then Stalin died and I was born. My parents abandoned YPSL[1] and turned to child rearing.

The discussions in my house were intellectual and political, mostly centering around a critique of capitalism from a socialist perspective and a critique of socialism from a capitalist point of view. My parents agreed: All systems are flawed. The masses, or lumpen proletariat, don't think for themselves. Most of all, my parents indoctrinated me with the notion that nonconformity was the loftiest state. They regarded me as a magnificent experiment and raised me in strict adherence to the progressive principles of Dr. Spock.

"Think for yourself and marry a doctor," was my mom's advice.

[1] Young People's Socialist League, pronounced "yipsel."

The Dark Romantic Forests

The dark romantic forests,
Beaches of pure white sand,
They make me feel lonely,
Needing someone to hold my hand.

I walk alone in the moonlight.
There's no one else in the world,
No one to share my feelings,
To realize that I'm a girl.

Someday when I get older,
My walks won't be alone.
A man will be there to guide me.
I'll make my world his home.

Carol Leigh, age 15

I was perfect, smart, and well behaved . . . until puberty. I fell from my pedestal at the age of fifteen, when I wanted to date (not fuck) a boy who wasn't Jewish. My parents said no, and I became an outlaw. My sudden fall from grace was unjust, exposing the tenuousness of my good reputation. It was 1966 or '67. I would find love, make love, and be free. I was a flower child and I would give it away.

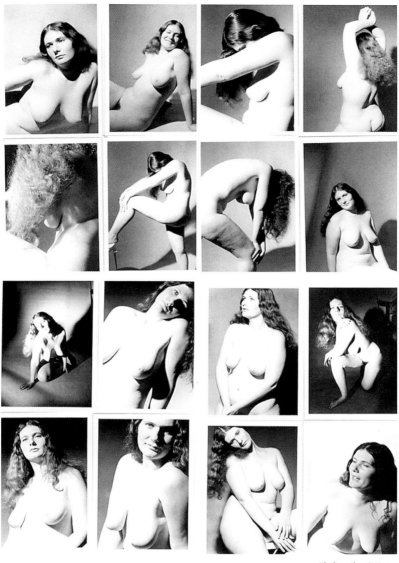

Photos: Alan F. Heinz

New England is for Masochists

I tried to find my righteous niche. I went to graduate school at Boston University to study with Anne Sexton. She committed suicide the semester I arrived. John Cheever taught fiction but he was drunk all the time. I never graduated. Anyway, what would I have done with a degree in poetry?

Feminism Circa the '70s

I decided to devote myself to less esoteric goals, like feminism (which provided a very useful map to my psyche).

In 1976 I organized a women's writers' group, dedicated to improving women's images. The "great artists" were mostly men. History was told from a man's point of view. Women were silenced and anonymous, but we would change all that. Together we would tell our secret stories! And I would find a place for my weird self.

Feminism was almost perfect for me . . . except for the fact that I was bisexual and couldn't stop fucking men. Of course, women had to attack me for that. I understood. Women had been so oppressed. Maybe I should stop fucking men? My comrade, anti-porn heroine Macha Womongold (*Pornography: A License to Kill*), introduced me to some strategies to fight the patriarchy. Macha taught me about the goddess and about how proud I could be of everything female. Macha was even arrested for some obstreperous anti-porn activism. I admired her, but my feminist angst manifested itself in different ways.

For example, occasionally I'd don a few little lacy black things and jill off to my whore image in the mirror. And once, compelled by a passionate curiosity, I dressed up in my sexiest lingerie to dance on amateur night at the Golden Banana, a tastefully monikered strip club in Peabody, Massachusetts.

My debut was before an audience of hundreds of salivating businessmen. I improvised a "strip and fall" routine. They laughed and applauded wildly at my lusty little comedy. This was certainly more acclaim than I'd received as Alma in Tennessee Williams' *Summer and Smoke* at SUNY Binghamton. I didn't even know I could get that wet.

After the show I selected *two* men—one of my fantasies. I made a deal. I gave them blowjobs at the side of the road leaning on someone's old Ford station wagon. $25 for the whole thing. They sure were lucky.

I had turned my first trick several years before, when I was seventeen. I ran away from home to the East Village and went to work at a nude modeling studio for exactly one day. I did not quite understand that this was supposed to be prostitution. A creepy white haired man offered to give me $5 if I would let him jack off and look at me. I did it, but I was very grossed out and decided not to be a prostitute. I was always ambivalent about commercial sex—curious and guilty.

"Get over it or get into it," I advised myself. I never told my friends.

They might not like it. According to my own ethics, the experiment with sex for money was not heresy because it was a private act. Cavorting publicly in lace and garters did seem bad (in the context of the patriarchy), but couldn't I explore that role and write poetry about my findings!?

Maybe not. How was I to fit my talents and interests into the scheme of society? My college career had been a bust. My political beliefs conflicted with my masturbatory practices. I was a good girl in a bad girl's psyche.

Or vice versa.

Anyway, the blizzard of '78 was the last straw. I moved to San Francisco to find my fate.

Sex! Massage! Girls!

September 1978—San Francisco was like a different country, I thought.

Everything was wonderful, except for the fact that my boyfriend broke up with me. I didn't know anyone and my friends were all back home. I had no job, and the bills were due on my credit cards. In fact, I felt desperate and low and confused and horrible about myself. I look back and honor this crossroad. It was certainly the lowest point in my quasi-torrid life. It's odd, how the most desperate circumstances can lead to one's salvation.

Besides, San Francisco had fabulous shops, and I needed furniture and a new vintage wardrobe.

I had heard that once you agreed to sell it, you crossed a line. You became a WHORE. There was no turning back. I couldn't resist. I took the dare.

A Woman's Last Resort

I took a job at the Hong Kong, a very seedy massage parlor in the heart of the Tenderloin. I figured they must be selling sex, because they certainly weren't selling ambiance. I was immediately enamored of my friendly, feisty co-workers from Vietnam, Korea and Mexico. My first trick was a regular of the parlor, a local shop owner. He was handsome, blonde, curly-haired and sweet, cuter than my boyfriends, about 35. After work, I rushed home to look in the mirror.

Now there's a prostitute, I told myself. I hadn't changed. I looked back across that line that had separated me from the old me, the good girl. The line had disappeared.

Prostitutes' issues and images became the center of my life. I'm not saying I loved the tricks or the work. It could be fun, especially if you like things like skydiving or hang gliding. But what I liked was getting this insider's view, this secret story to tell. The silence of prostitutes became overbearingly loud. Suddenly, I was surrounded by mute and righteous women, brazen, sexual women, poor women, junkies, young women who couldn't fight back against rape, women of other races, mothers, women who used to be men, women who used to be secretaries, and wild, curious women who needed money, just like me.

My new discoveries gave me excuses and revelations:

- Other women still wear high heels, bras and lipstick. They walk around in fetish gear for free, sexualizing themselves at every opportunity, and I'm supposed to play this role but not get paid. It's all whoring just the same.[2]

- All my life I'd been trading sex for approval and for relationships with boyfriends. A lot of women trade sex for some advantage, or for basic survival. This is part of life and I have a right to look square into it.

- Even Jeffrey Masson (anti-porn queen Catharine MacKinnon's paramour) was a reputed womanizer.[3] Men are studs. Women are *promiscuous*. I hate that word.

- First the patriarchy socializes me to be a sex object, then it sics its flunky cops and rapists on me . . . but that comes later. Anyway, I won't be terrorized by these envoys.

In the front lines in the battle of the sexes, prostitutes are "the only street fighters we've got," quoth Ti-Grace Atkinson in her *Amazon Odyssey*.

Prostitution occurred to me at the intersection of my needs and proclivities—my radical political bent, my feminism, my sexual curiosity, and a response to the stigma I already felt for engaging in premarital sex. Prostitution holds a potent combination of survivalism and victimization, a

[2] Depending on your definition. For definitions of whoring, look it up in the dictionary . . . Of course they are many, and contradictory.

[3] Catharine MacKinnon's romance with former Freud disciple Jeffrey Masson was displayed on the cover of *New York* magazine on March 22, 1993. Susie Bright discusses his reputation as a womanizer and that "...lovey-dovey pictorial" in *Sexwise*.

perfect recipe for my anarchist's cookbook. One press of the cookie cutter and, *voila*, one more intellectual trollop. It was my fate. I was destined to become a sexy monster thrust onto the battlefield of sexual politics, cast now as a victim, a survivor, and a traitor to my gender.

These are torrid times for a postmodern (another way of saying nostalgic) sex warrior. Feminists and moralists, communists and christians, are pitching adjacent camps itemizing munitions: genitals, guilt, sex, pleasure, rape, free speech, lust, love, christ, god, goddess, anarchy, imperialism, racism, classism, tantra, tao, dharma, AIDS, oppression, *Playboy*, MacKinnon. Competing feminists are like angels wrestling on pinheads. Ideologies writhe in contortions. Feminist arguments about free will and determinism would make a Calvinist blush.

I Know What Some of You Are Thinking . . .

Why doesn't she just get into therapy and get reprogrammed!
Great idea. Why didn't I think of that! Everyone should! Every whore on this planet needs therapy and a better job and government subsidies. This way we could end prostitution! Oh gosh. I can't believe I went to all this trouble, when it all could have been so simple. Anyway . . .

Bad Luck at Lucky's, or Caught between the Rapists and the Police

In 1978 I began to work at Lucky's massage parlor. I knew there was some danger, but I suppressed my fear so that I could survive. Measuring danger is a complicated science. As a woman, I live in constant fear of rape. If I were really careful, I'd never leave my house. You gotta take risks.

I'll fuck for money if I want, I told myself. My co-workers and the management assured me that arrest could be avoided and violence was very rare. Women taught me how to screen customers when it was my turn to open the door.

Trust your gut feeling, they told me, then went on to describe factors ranging from wardrobe and facial expression to race. As a novice, I was confused. Women claimed to get by with a sixth sense. The idea that women were advising me to weed out cops and rapists based on a subtle intuition was shocking in itself. I resented the notion. While "legal" women look to the police and courts for safety, recourse and justice, I am supposed to rely on my instincts!

I never felt safe. Some of the women were skilled in self-defense—like Kim, who could chew up and spit glass, I heard—but I wasn't good at that.

The management should have hired a security guard. There was enough money around, though not the huge sums people suppose. Women earned upwards of a hundred a day. The management kept seventeen of the twenty-dollar massage fee, which added up to nearly a thousand a day.

Security guards might eat up a sizable chunk, but perhaps the women could chip in.

I asked the boss. Connie insisted that posting a guard was just not done in this city, as it would not be in keeping with the "low profile" that prostitution businesses are forced to keep. As a prostitute, I had no recourse for challenging her. She was a gentle woman with a laissez-faire approach to business. The other workers were not at all inspired about instituting any kind of change. The whole situation was kind of paralyzing.

I had been working eight months when I opened the door for the wrong person. It was 10:30 am. I guess I was off my guard. I should have known better. It was my fault. He was clearly disqualified, according to the criteria espoused. I was adamantly and regularly told to discriminate according to race . . . but I'm not a racist! He was a street punk with a leather jacket. Nice people wear leather jackets!

He pushed his way in and another man followed. One put a knife to my throat and they raped me. For around twenty minutes I was afraid of being tortured or killed. Susie was there with me.

"Who do you think you are, bothering girls like this? You leave! Go now! Leave us alone!" she shrieked. They didn't rape her.

I don't understand why people always assume that when a prostitute talks about being raped, she's describing a situation in which she has sex and then she doesn't get paid. The threat of murder and torture was the traumatic element of this rape.

Later that week I learned from some of the other women that these men had been doing the same thing to women at other parlors in town. No one passed the information around to warn other women, I guess, from a feeling of hopelessness, from some enigmatic notion that we should all be able to protect ourselves by using our intuition.

Of course, I didn't call the police after I was raped. Connie begged me not to, as it might focus attention on our parlor, which could result in my co-work-

ers getting busted, the parlor getting closed down, and my friends being forced out on the street.

We don't protect ourselves against rape because we almost seem to believe that we should expect to be raped, robbed, or beaten because prostitution is inherently dangerous.

Good Luck, and I Hope You Make Alotta Money

This poem is dedicated to the safety and well-being of the women who work at Hong Kong, Aiko's, Yoko's, and Lilac Saigon in San Francisco's Tenderloin.
[Originally published in *Northwest Passage*, November 1984.]

If there's one thing I know, it's that I definitely don't wanna go back to
 work in the Tenderloin.
I don't care how good the money is.
I don't care that the tourist customers pay over a hundred for a half and half.
I don't care if I could be making three hundred a night.
I won't work at night. Night girls fight. I'm a day girl.
I don't wanna go back and work at 467 O' Farrell Street where I was raped
 on August 7, 1979 by two punks with a knife and couldn't bring
 myself to call the police.
I don't wanna suppress my fear.
I don't wanna be a victim.
I don't wanna be raped again.
I don't wanna live the fast life.
I don't care how much you paid at Magnin's for your creme-colored high-
 heeled boots. They make you look like you're gonna fall down.
I don't wanna spend my money on last year's shop-lifted silk blouses and
 slit skirts that the junkie booster brings around.

I don't wanna cook chicken in the sauna and rice in the electric pressure
 cooker and eat on the floor anymore, even though it was good and we
 came to know and love each other.
I don't wanna avoid discussing anything too personal.
I don't wanna lie about how much I make.
I don't wanna be ashamed of doing twenty-dollar blowjobs.
I don't wanna refer to myself as a masseuse.
I don't wanna smoke dope and watch you return from the bathroom
 stumbling on junk.
I don't wanna pretend I don't see the bruises your boyfriend gives you.

I don't wanna be the one who never gets picked.
I don't wanna know what I'm worth.
I don't like it when cockroaches crawl on my customers.
I don't wanna fuck poor men with anti-social looks on their faces.

I don't care how much money you say you make.
I like you. I mean, I like some of you.
But I don't feel safe. Don't blame me for leaving.
I have to move up. I'm going to work in the financial district.

I Want to Change the Laws That Punish Prostitutes

We don't protect ourselves because we are prohibited and inhibited. We can't share information about dangerous tricks. We are discouraged from any kind of organizing or self-protection by laws that prohibit "communicating for the purposes" or collective organizing (charged as pimping). It's hard to protect yourself from the rapists while you're busy protecting yourself from the police.

Laws Against Prostitution = Violence Against Women

I am appalled that the state assumes jurisdiction over my sexuality. To me, cops seem like rapists with badges. I read the newspapers: "Ex-Cop Linked to Hooker Slayings" and "Rapist Lures Prostitutes with Phony Police ID." The serial killers are the police—or at least there's no way to tell the difference. It isn't fair.

Prostitution busts are a form of rape. When an emissary of the government (a cop) coerces me to engage in fondling and petting through fraud (pretending to be a client), then pulls his weapon and arrests me for my sexual behavior, I call that institutionalized rape.

That's why I'm always angry. That's why I'm angry at everyone who isn't angry.

I hate the idea that a group of men who are the arms of the state are entrusted to enforce my behavior in the boudoir, whether it is for money or not.

I hate it that there are young women all over the country who are being told to ignore this violation of our rights and, instead, to spend their time suppressing sexual expression. I'm not one to deny the relationships between imagery and action, but sluts and whores and erotic entertainers are not the enemy of the matriarchy.

I am trying to understand everything. Sometimes I don't fuck for love, pleasure, or money. I just fuck in defiance.

"The stigmatization of prostitution underlies the social control of all women," says friend and activist Gail Pheterson.

Sexual control is part of social control and part of all societies, I imagine, though I'm not exactly an *anthro-apologist*.

"Don't Fuck 'Til After the Revolution"

I suppose it isn't fair to blame women for making prostitution illegal. Of course, I can't blame contemporary feminists. But historically women did play an important role in the process. To put it nicely.

The criminalization of prostitution was a cruel mistake, promoted by feminist moralists near the turn of the century. Poor women on our city streets pay for the classist follies of our predecessors. Are protectionist strategies just naturally a part of women's political contribution? I wish it weren't so, but my library is full of books about misguided campaigns to end women's sexual exploitation and to preserve women's purity. The punitive legislation that has emerged targets poor women and women of color, creating a climate which supports the cop rapists and leaves prostitutes with no recourse. My whore friends are very upset because they are the ones being sacrificed to preserve the "good" woman's illusion of safety.

I'm Trying . . .

I've been an ardent feminist for twenty years. I love feminism like I love my mom. I'm trying to be open-minded. Maybe slut-positive women can seem like the enemy. Maybe we *should* be treated like outcasts, excluded from the family of feminists, labeled liars.

> "In general, those who most adamantly promote this view, organizing various 'whores' conferences' and positioning themselves as prostitutes' spokespersons with the male-dominated media, do not choose prostitution for themselves; some have abandoned it; some never worked as prostitutes; some work as 'madams,' selling other women's bodies but not routinely marketing their own; a few actually work as prostitutes."
>
> — "Prostitution as 'Choice,'" *Ms. Magazine*, January/February 1992

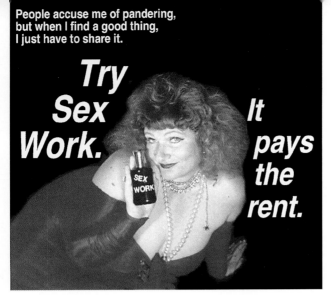

People accuse me of pandering, but when I find a good thing, I just have to share it.

Try Sex Work. It pays the rent.

Photo: May Ying

Anyway, I'm going to try and relax. I can't let this get to me. I can't expect too much of women or of humanity in general. Society has its own cycles. As politicos we play our parts, fulfill our responsibility by participating. Everyone has a right to her or his analysis. Variety is the spice . . . I can't blame women for thinking I'm an evil-sellout-dupe-of-the-patriarchy. It's the lot of a modern libertine. We all feel like we're losing. The slut radicals abhor the pornophobes.[4] I don't want to fight my sisters, and pornophobia is not quite a recognized social ill at this point, so I just better relax.

I've got to be open-minded. Just because my life offers vast evidence of the value of including whores in the family of womynkind doesn't mean it is the only truth, right? For some women, my philosophy could be dangerous. The freedom that I demand for myself is, for some women, the rope to hang herself with. I have to relax. It's just a difference in philosophy. I won't take anything personally. I'm not even mad at Phyllis Schlafly. It takes all sorts to make up the world. Some people think abortion is murder. Some people like war and nukes. I'll give everyone a break. After all, this is the patriarchy, and being a prostitute teaches me patience.

[4] From the Greek root *porne* referring to prostitutes and *phobia* meaning fear. Pornophobia means the fear of prostitutes. Pornophobia can also refer to the fear of sexual expression and sexual representation—that is, fear of pornography. Whore activists claim the term that was used as a weapon against them, pornography, as their own.

Reforming Women

I talk to everyone—even, and especially, to women who hate prostitution. Very few will talk to me, but I have a new friend. X is an ex-prostitute who embraces the abolitionist philosophy. Perhaps we could organize a unified feminist resistance to end the arrest of prostitutes. After all, even the abolitionists claim to oppose the arrest of prostitutes.

I asked X to meet me for dinner. There I would present my agenda. X is a formidable friend, or enemy, depending on which side of the patriarchy one wakes up that morning.

"All I want to do is stop the cops from arresting us. That seems reasonable," I begged.

X grimaced and said, "That must be a very safe position for you. Decriminalization will not help women, because arresting prostitutes is the only way we can get services to them."

I bit my tongue. "I suppose you do have a captive audience."

"But two or three days in jail is not long enough to get a woman off drugs. There must be a way to keep them in jail for longer," she conjectured.

Am I really hearing this? I get that familiar feeling that this situation is beyond remedy. Relax. I can't fight every battle. Just stay relaxed . . .

"Okay, Okay. We'll find another way to get them services," I offered.

Right. We'll find them better jobs. I can see it now. We'll revise the world economy, and then we can stop arresting prostitutes. "One way to unify the women might be to go after the men," I blurted out, trying to be helpful. Oops. That was a huge mistake. Going after the clients keeps the business illegal and underground and does nothing to further the rights of prostitutes. I think I just sold my sisters down the tube in an effort at conciliation. Oh, well, big mistake. Luckily, I'm not in charge anyway. At least, not yet.[5]

"If we increased services, then would you support an end to the arrest of prostitutes?!" I pleaded.

"You seem to have a one-track mind. You have to see the broader picture," X graciously informed me. "If we stop arresting prostitutes, the pimps will have a heyday. We can't let up on the prostitutes until we really go after the tricks and the pimps. Otherwise it would amount to recruitment."

[5] Ultimately X followed my advice and so the Johns' School was born. See page 124.

What am I supposed to say? Check out your history textbook. Laws against prostitution are always used to control women, mostly poor women. I could remind her that it's basically an invasion of my privacy to send the police into my bedroom. I don't want her to become defensive. I mean, either you're a protectionist or you're not.

If only I could change her mind. If only I could figure out how to influence her. I listen and listen. After all, she worked as a prostitute for well over a decade. She was probably raped and arrested more times than I can fathom. She and her friends can't stand the Happy Hookerism of my crowd. She and her friends claim that the glamorization of prostitution (one of my favorite pastimes) exacerbated her dependency and vulnerability within the life. She and her friends say that I stand in the way of women's freedom by sexualizing my identity.

Who am I to judge?! X won't let people forget for a moment that some women exist in a state of rape. The constant tremble in her voice reminds us of her hurt and anger. Her philosophy worked for her, helped her through her "recovery." In fact, she's doing very well for herself now, working with the Vice Squad and the District Attorney, after leaving her job in the jails, where she launched the local mandatory HIV testing program for prostitutes, drawing blood from those convicted of prostitution.

She said something like, "if you make it any easier for women to slip into prostitution, you'll have blood on your hands."

Blood on *my* hands? *She's* the phlebotomist.[6] I've been squirming in the straightjacket of feminist ethics long enough.

Feminists Unite! Stop the Police Control of Prostitutes (Please)

A chasm exists between women, based on our experience of, and reaction to, sexual abuse. Perhaps communication can fill the gaping wound. Maybe a dialogue could ignite a new feminist revelation, based on a union of the good girls and the sluts.

[6] A phlebotomist is a medical practitioner specifically trained in drawing blood. In California, when an individual is convicted of prostitution, their blood is drawn. If she/he tests positive for the HIV antibody, prostitution becomes a felony, even soliciting prostitution, even soliciting hand jobs with a condom. Considering the effects of HIV and the lack of medical treatment in prisons, a sentence of several years can amount to a life sentence for those who are HIV positive.

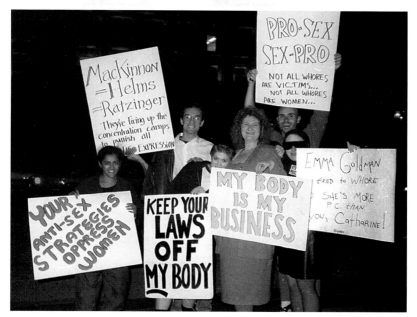

SWAM (Sex Workers Addressing Mackinnon) demonstration outside Herbst Theater when she spoke in San Francisco. Protesters, left to right: Hima B., Tom, Terry Morris, Scarlot Harlot, Vic St. Blaise and Augusta.

This could be a pivotal time for prostitutes' rights. Feminism has empowered women, so feminism has empowered prostitutes. The pendulum swings away from patriarchy. Or maybe not. Naturally, I went straight to Catharine MacKinnon who was speaking at Herbst Theater in the fall of '93.

When she finished her speech I raised my hand and said, "Catharine, you say you care about prostitutes, but you refuse to engage in a discussion with any of the feminist prostitutes or sex radicals. We all care about women's safety and well-being. Why divide the movement by vilifying us! Let's talk."

MacKinnon told me that she had nothing to discuss with women like me, that we are too far apart.

But, but . . .

Poverty forces women into survival sex and sex for money. The drug war rips apart the families and communities of those already marginalized. The AIDS crisis escalates everyone's vulnerability, particularly that of poor women, and particularly those who trade in sex. Only the harshest approach would support the arrest of prostitutes.

When most middle-class women experience harassment from their bosses, teachers, and peers, they are taught to challenge the abuses in their lives. Meanwhile, prostitutes are out there on the streets being harassed regularly by

police and no one advocates protecting their bodies, let alone their sensibilities. Feminists as a whole have been eerily silent in the face of these violations.

To stop this hypocrisy, we have to learn to work together. Whether we approach this issue from an anti-prostitution stance or as prostitutes' rights advocates, we need a moratorium on arrests now. You may not like prostitution, but I'm sure you don't want women controlled by police.

So Much To Explain . . .

There are so many issues, and so much to explain. For example:

- Laws against pimping are a big problem for whores. Pimping laws are not very effective against the bad exploiters (surprise!), but, rather, they are often used to get plea bargains from prostitutes who work together to protect each other. Pimping means "living off the earnings of prostitution." When we are arrested as prostitutes, our grown children can be charged as pimps. Our lovers are charged as pimps. Besides, I may want to fuck for money, but that doesn't mean I want to be bothered with the complicated business of finding clients, making dates, and running an establishment. Maybe I'd rather work in a house or a place with other pros, where we can afford security. Laws against living off our money may have been designed to protect us, but they are always used to control and stigmatize us. Laws should target the abuse. Living off the earnings of prostitution should not be illegal.

- Laws against pandering (encouraging prostitution) make my life into one big felony. Theoretically, if I say anything besides "I hate prostitution," I could be locked up for years. This sort of inhibits a person, but it won't shut me up. The AIDS crisis, the drug war, the sex panic and gentrification in our polarized economy inform the current discussions of prostitution law reform across the United States. I promote decriminalization of all aspects of sex work, along with enforcement of laws against abuse, rape, violence, assault, deceit, force, and coercion used against prostitutes.

- Actual working prostitutes should be empowered to control their own working conditions. Society infantilizes women, and most people think we are incapable of taking care of ourselves. The most vulnerable members of our communities are used as examples of our frailties. For instance, only 10 or 20% work on the street in San Francisco,[7] but stats for everything from drug use to child abuse are culled from this population, and used to represent the broader population of prostitutes. Then they say police should monitor our lives so that the bad men don't exploit us.

- Some recommend that prostitution be criminalized for clients, but not for prostitutes. In this scenario only selling services would be legal so that one could not organize a business, advertise, etc. This strategy is promoted where prostitution is currently legal for buyer and seller, as it is in most European countries, rather than in the countries such as U.S. where it is illegal for both parties. This system is extremely problematic for prostitutes. Criminalization of clients adds to the stigma of the work and supports governmental discrimination against prostitutes, such as the tendency of courts to deny prostitutes custody of their own children. Prostitutes need to protect their clients from arrest (as a business practice) and must operate covertly. The recent criminalization of clients (purchasing sexual services) in Sweden has resulted in very few arrests of clients, but a substantial increase in the hardships of Swedish prostitutes.[8]

As long as the sex trade operates underground by criminalizing prostitutes, third-party management and clients, sex workers are alienated from police protection, are not able to unionize and they are excluded from government benefits afforded workers in legal industries.

I repeat: peer empowerment and community building. We want alternatives and autonomy.

[7] Priscilla Alexander, "Prostitution: A Difficult Issue for Feminists," in *Sex Work*, ed. Priscilla Alexander and Frederique Delacoste (Pittsburgh, San Francisco: Cleis Press, 1987, 1997). p.196.

[8] Sambo, Rosinha. "Commentary on Swedish Prostitution Laws." According to a report by Swedish sex worker activist Rosinha Sambo, presented at Taipei's International Sex Worker Conference 2001, criminalization has forced prostitution underground, increasing exploitation within prostitution including juvenile prostitution and trafficking. http://www.bayswan.org/swed/rossam.html (18 Nov. 2001).

Fucking and Fucking Myself Up

I suppose that the rights we have for ultimate jurisdiction over our bodies are based on the rights we claim. I don't know about your rights. Maybe you are perfectly happy to give the state control over your body. Maybe you don't mind peeing in jars because you think that it's helpful to have a paternalist state. I don't give that right away. If the state assumes that right, I consider it a violation. For me, every act of prostitution doubles as an act of civil disobedience. I have the right to do anything I want with my body including sex, drugs, and suicide—the right to fuck, get fucked-up, and fuck myself up. Mmmm, this platform certainly does have a ring to it . . .

Why are feminists most divided over our sex roles as lesbian, wife, and whore? We're all in this together, surviving this gender oppression, but the tug-of-war over the righteousness of the whore stands in the way of the unified effort. Horizontal hostility . . . internalized self-oppression . . . the mood is right for oxymoron.

I hear my parents' voices at the dinner table, discussing the failure of the Socialist Party and the obstacles to social change. "Infighting destroyed us. The left always attacks itself. The oppressed becomes the oppressor."

I suppose it's natural that we fight over the crumbs of self-determination in the declining patriarchy.

The controversy among us is not only about sexual violence and representation; it is about staking our claim in the sexual terrain. Some women want to control other women's sexual expression and sexuality. Sex is dangerous, a minefield, a battleground. The fundamentalist feminist agenda is basically a call for "martial law." Or maybe *marital law.*

An agenda for reform must include us. Maybe we can embrace our whores, stop this fighting, forge a new vision, and take one more giant step in the development of a humane consciousness. And maybe not.

I'm an Innocent Person . . .

What I mean is, I'm basically optimistic. Sure, I've suffered a heavy loss of chastity, but what kind of society is this that equates my acquisition of sexual experience with a loss of purity. I know that some people look forward to the day when no one needs to buy sexual services (mostly the tricks) and no

one needs to sell it (mostly the good girls). But I'm looking forward to the day when sex work is recognized as a service. Sex work is holy work! Sex is as dirty as power and money. Whore means get more!

We complain about the way we are objectified. I long for the day that my nakedness no longer symbolizes my conquest.

The Enemy Speaks

Here I don the mask of the libertine, a burlesque artist with sad trappings. I don't care. Anything is better than being a wage slave. I am free. I am in captivity. I am the enemy of all good women. I am the catalyst of rape. I am the traitor, the whores of the death camps whose lives will never be chronicled. I am the target. My body is the bounty in the conquest of all women. I am bad. I am sin. I am shame.

Almost every day I say my mantras: LAWS THAT PUNISH PROSTITUTES ARE CRIMES AGAINST WOMEN and THE ARREST AND INSTITU-TIONALIZED HARASSMENT OF PROSTITUTES ARE ATROCITIES.

I need to repeat this to myself. I am reminded that, even though I know many powerful prostitutes, there are others who are living a nightmare.

"The prohibition of prostitution enshrines into law the view that prostitutes are bad women, and thus legitimate targets of abuse," said my mentor, Priscilla Alexander, from the National Task Force on Prostitution.

I'm proud that I'm not ashamed. All of you victims (no, no, survivors!) can identify with that. And everyone has a little pornophobia, so get in touch with it and get rid of it. I'm on the edge of my seat, waiting for a gestalt, a unifying vision. The struggle for our rights and freedom makes me feel strong. What a treat . . . just in time for our new millennium . . .

Whores Rise Up! No more Dupes of the Patriarchy

The throngs are growing. The Sluts' Liberation Movement is taking hold. Beware, the deviants can justify themselves. We have broken the code. In a few generations wives will be extinct. Only "wages for housework" will deter the armies of single-mom-tramps-on-the-dole. And we'll be goddess-worshipping pagans selling our holy favors. "Abolish monogamy!" we'll holler. "Marriage is degrading to women! Whores rise up!" They can't stop us now . . .

Fucking For Art

[The poems in this section were originally published in *Autobiography of a Whore: The Demystification of the Sex-Work Industry,* Whorepower, 1983.]

John Q., an amateur photographer, was cheerful and hairy. I saw him for three years. First we posed for pictures, then we fucked.

from **Requiem for A Good Girl, S. Harlot, 1980**

"My boyfriends are no good.
They touch me too rough, not rough enough.
They fuck me too hard, not hard enough
They come too quick, not quick enough.
And they don't pay for it."

Mr. Money vs. Mr. Love

1. *Making it with Mr. Love*

all day long in bed with love, Mr. Love
and I love him and maybe he loves me too
I'm feeling satisfied with my desire
and feeling that I won't be satisfied
really putting out
and not putting out that much for love, Mr. Love

and I'm wanting, wanting more from him
wanting him to ask me how I feel and who I am
and stop talking so much about himself
and wanting him to stop asking me so many questions
and tell me who he is
wanting a little massage and more time spent
with his tongue on my nipples in my cunt

and asking and getting it
not asking and getting it
and not asking and not getting it
and asking and not getting it
until I am dizzy with frustration,
 satisfaction and desire

I'm thinking/always thinking

thinking he will/won't give more
thinking I do/don't want more
thinking whore/thinking l-am-loved
thinking rape/thinking enough
thinking broken heart/thinking forever
thinking love is just an illusion
so what am I doing in bed all day
with my desire for love, Mr. Love

Photo: John Q.

Photo: Annie Sprinkle

while some women love/are loved by husbands
lesbians love/are loved by women
Helen Gurley Brown earns over a hundred thousand a year
my friends, the whores, earn at least a hundred a day
 while Priscilla Alexander works hard for me
 in the National Task Force on Prostitution
K. Barry and Millet remind me that I'm a victim

and I am in bed all day
entwined in what promises to become passion
doing my best blow jobs for love, Mr. Love
my body stretched towards pleasure
fucking holes in my bank account

when I could be out
out reading poems out taking classes out
making connections out fucking customers out
strengthening friendships out shopping out walking out
 teaching out eating out succeeding out
 being out reclaiming the world.

Photo: Annie Sprinkle

Photo: May Ying

2. *it's like . . . it's like . . .*

it's like a dream
 and I am Scarlot
 fallen into a cabbage patch of cocks
 organic cocks
 cocks poking up like cacti
 daring me to touch
 cocks aimed at me like like
 No! not like guns
 like diamond wands
 wet shiny multifaceted
 sparkling with lust
 it's like sleeping on a bed of cocks
 tossing turning anticipation
 an hallucination of desire poetry and financial success
 ejaculating money all over my lush white body

 soft cocks like the heads and necks of small animals
 polite cocks with rubbers like gentleman's gloves

It's Good/Bad To Be a Prostitute

Good/
What a luxurious apartment!
I have more money than anyone I know
Panoramic view pushbutton fireplace color TV stereo
All the time I need
All the inspiration I need

/Bad
Selfish girl, greedy girl
Whore!!! Taking having eating
All the time I'm getting it

Good/
What did I do yesterday to make two hundred dollars?
I think I did a handjob for twenty-five he was pleasant and polite
I did a French for fifty with clothes on he was a creep
I fucked for a hundred and twenty-five when he asked how much
I said a hundred he didn't blink so I said that was just for a straight fuck
a hundred twenty-five for half and half I coulda got more

/Bad
Oh shit everybody thinks I'm strange
Black lace garters come all over my face
Obscene phone calls dope police rape
Sellout! Sellout! Doing it cheap
For less than the promise of pleasure or love

Good/
Sophia Loren in Marriage, Italian style
Wise Xaviera who loves to fuck
Margo who wouldn't shut up
Virginia McManus, *Not For Love* (New York: G.P. Putnam's Sons, 1960)
Mata Hari
Squirrel Tooth Annie from Dodge City
And all the brilliant prostitutes I know

/Bad
Roget's *Thesaurus*
common prostitute, erring sister, fallen woman,
streetwalker, woman of the stews, brothel intimate;
hooker, hustler, casual conquest, harlot;
tart punk, chippy broad; laced mutton;
742 noun, see slave.

Good/
One man pays me fifty dollars
To give me a great Swedish massage
Till I'm perfectly ready and relaxed
He jerks me off licks and sucks my clit
And I have several deep orgasms

/Bad
Now I'm living in a men's world
Feel like I'm trapped in the wrong bathroom
Crying at five mommy daddy please help me
I won't be a bad girl Let me out

Good/
Scarlot says: It's not bad. Not that bad. Not as bad as you think.

The (Bad) Girl Next Door

These days, when people ask me if I liked doing prostitution, I tell them that, for me, prostitution is rosier in retrospect. Although I remember being frustrated with clients and angry at the laws and stigma, when I reminisce, I feel quite nostalgic. I am in awe that I played this role, that I saw so many men in such naked and absurd positions. These vignettes capture my initial thrill at the prospect of living my life as Scarlot Harlot.

[This text, originally part of "The Continuing Saga of Scarlot Harlot," was serialized in the early '80s in a San Francisco leftist-beat monthly, *Appeal To Reason*, later called *Open City*.[9] In 1987 the columns appeared as chapters in the ground-breaking anthology *Sex Work: Writings by Women in The Sex Industry,* published by Cleis Press.]

Are you one of the insatiable millions—those who are curious about most aspects of the prostitute's existence: our loves, our traumas, our sexual habits and our finances?

Perhaps you've imagined yourself a sex professional, offering the most exotic pleasures to a wealthy, mysterious and sex starved clientele. Have you envisioned dinners atop the Saint Francis, or in the dungeons of L'Etoile, dressed in a sexy elegance fit for the Academy Awards? Well, that describes my life.

(Just kidding.)

Perhaps you've envisioned yourself poised tough in the Tenderloin, amidst needles and panties, a fate you strive to avoid by paying your rent on time, and your telephone bill, and by moderate use of plastic. The abuse of plastic credit cards has been the ruin of many a poor girl. God, I know.

And you, sir?

Unloved and unlaid in weeks, months, even years? You may have imagined yourself "taking a walk and buying some," or procuring the services of an elegant courtesan, fresh off the pages of *Hustler*.

"But how will I get her phone number?" you ask. Will she lay like a lump, give me a disease? Will she steal my money? Will she fake it?

[9] Writers for *Appeal To Reason* included Jack Michelene, Lawrence Ferlinghetti, Deirdre Evans, Chris Trian, Julia Vinograd, Peter Pussydog (AKA P.W. Stevens), Paul Krassner and Margo St. James among others. Publisher John Bryan published the first underground newspaper, *Open City Press* in San Francisco (1964-65), which was a model for *The Berkeley Barb*. Bryan, my first editor and mentor, documented Scarlot Harlot's art and activism in his own writing.

Wonder and worry no more! Here it is! All the information you probably want about the *fille de joie*, snuggling up to your eyeballs in the persona of Scarlot Harlot. That's me. Of course, I am a prostitute.

If you've been following my saga, you know that, though I strive to divorce myself from the stereotype of the Sorry Slut, that image insinuates itself into my life like a commercial for my oppression.

When last we left Scarlot, she was recuperating from a short affair with a poet/actor who stole her savings, then began threatening her on the telephone, demanding more money and sex.

"He wanted to be my pimp," she explained. "My girlfriends said they'd beat me up and never talk to me again if I went along with him. Of course, I told him where to shove it and in what position. And I know plenty of them because of my experience."

"Prostitution is a crash course in assertiveness training," says A. I'm learning, and A, the toughest of the prostitutes, is a fine teacher.

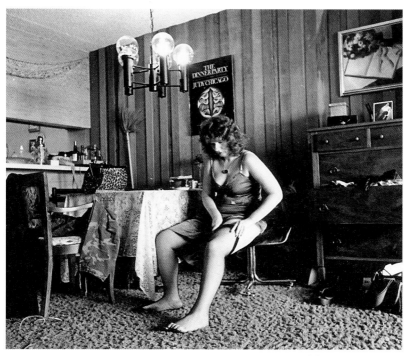

Photo: Ann Marie Rousseau

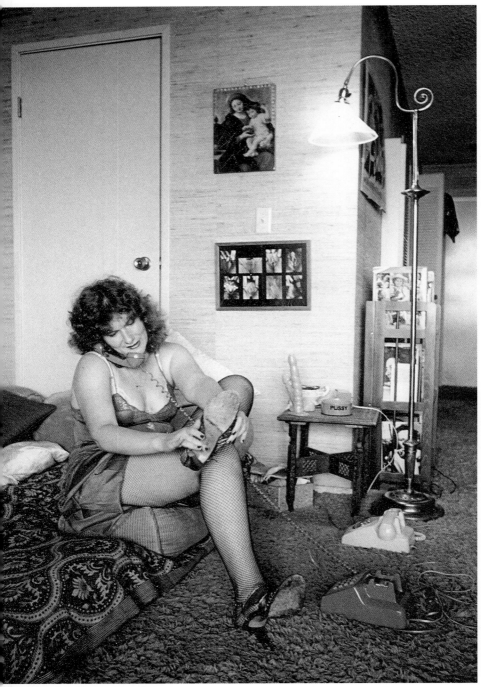

Photo: Ann Marie Rousseau

Memories of rape. Fear of rape. Frightened and haunted, Scarlot raved, "How can we protect ourselves from the pimps and rapists when we're so busy protecting ourselves from the police? I give up. I hate this fate."

Scarlot withdrew. Agoraphobia, fear of the marketplace, possessed her.

She vowed to remain in her luxurious cell, depending only on her telephone for business and companionship. No more personal lovers. Clients must present solid references. Scarlot became one of the vast number of ivory tower prostitutes; these serious women who pass their time painting, writing, watching television, reading best-sellers and pop psychology and waiting, waiting, waiting for the phone to ring . . .

Brrrring . . . Brrrring . . . Brrrring . . .

This better be money.

"Hi, Scarlot. Listen, I need your help." It was N, a friend and member of Scarlot's sex workers' support group. Her voice was plaintive.

N was only twenty-four. She'd worked as a prostitute for several years. Recently, she decided to go straight. Now she's a secretary. She plans to get married and pregnant. "I'm entering the Big Beautiful Women Beauty Contest. They want me to send in a list of my accomplishments. What can I say? I'm an expert in fellatio? I worked the streets and now I . . . ?"

"You worked the streets? I didn't know you worked the streets." I was impressed. And, yes, this did sound like a job for Scarlot Harlot.

"Yeah, well, I only did it a couple times. Last time was when me and T went down to the 'Loin. It was T's first time. 'Ya gotta get in the car with the guy,' I told her. 'How else are ya gonna do it?' But T was too stupid. This dude pointed her out, but she ran away. So I climbed in his van. I don't think he was into it. I had to force him. He got off okay. After that, I had it with the streets. It was too rugged. I moved my ass back into a massage parlor."

"That was an accomplishment," I said, trying to be helpful.

"Yeah, but not for a beauty contest," she moaned.

"I guess not, but you were a great whore."

"Thanks, Scarlot."

"Well, it isn't fair! We should be proud! No one understands or respects us. I hate this secrecy and isolation!"

"That's the way it blows, honey. Hey, I'll just say I'm a social worker."

"Or an actress. We need status as actresses!"

"Thanks, Scarlot."

thanks ma. thanks a lot

thank you for teaching me how to be sexy.
without you it would seem so complicated.
and thanks for your enthusiasm over the padded, push-up bra.
what a difference!
even though, we both agree, I'm big enough.
together we've thanked Clairol for my red hair, since age fourteen.
redheads do seem more exciting.

and thanks, especially, for taking me shopping
once a year to the Charlotte Shop,
where the rich girls shopped.
(still, you had me in ethnic primaries,
daytime shades, while my thin, blonde competitors displayed the dawn).

Photo: Ann Marie Rousseau

thanks, anyway.
overweight, you said I looked good in that red velveteen bikini
I never bought.
no, it was too much.

these confessions make me aware of my calcium-
my mother's towels were thin and torn.
her sisters owned fur stoles and gold bracelets.
she married Love, then Love abandoned her.

dad barely worked and mom supported him.
dad was always chasing her to fuck.
she did it lotsa times to shut him up.
she felt like a whore and didn't get paid.

my towels are as thick as steak.
I own antiques and a glamorous wardrobe.
I won't marry Love.
my daddies chase to fuck.
they pay. I fuck. I shut up.

(thanks ma, thanks a lot).
I'm ready for that red velveteen now, ma.
they like me better when I dress up.
you were right, ma.
rich princes are waiting on line to rescue me.
well, maybe not.
but middle class men are making appointments and keeping them.
thanks ma. thanks a lot.

As the Trick Turns

Clients have been demonized, with male lust as a source of danger more than plea-sure for women. My relationships with clients over the years have paralleled my rela-tionships with my father, brother and teachers, but not those of my lovers. Mostly I have been resentful of the presumptuous, rude and cheap clients, amused by the devot-ed and sweet, and grateful for those who are respectful and generous. Statistically speaking, my clients have fallen equally into those categories, though some straddle and cross the lines.

Who is he?

[Reprinted from *Sex Work*, Cleis Press, 1987; originally published in *Appeal To Reason*, 1982.]

Hank just stopped by. I've seen him for several years and he's one of my favorites. We've never actually had a conversation, but I think he has a sense of humor because he smiles when I make jokes. Today I greeted him in my apron (saves time dressing) and I told him that I was just cleaning the house and forgot to put on my clothes. He seemed amused. We embraced at the door. I turned around and said, "Look, no panties. And I've been exercising."

We discussed my muscles and flab as he fell to his knees and kissed me all over.

"Take off your clothes," I said, and hopped like a bunny into bed.

He stroked and kissed and massaged me everywhere. I said it was good, and it was, because Hank has a warm, loving touch and no ejaculatory con-trol. Within minutes he was up, dressed and darting out my front door. Easy come, easy go, as we used to say in the Tenderloin.

"See you soon, darling," I called after him. I do have a fondness for this man. But he makes me a little nervous. I mean, who is he?

I love the ones who pay . . .

[Originally published in *Autobiography of a Whore*, Whorepower, 1983.]

Photo: Ann Marie Rousseau

I love the ones who pay,
the ones who need me so much,
more than autos or watches or socks,
more than money or pride or love.

I love the ones who pay this much,
the ones whose wives are discontent
with their husbands' fumbling touch,
wives who know they don't have to fuck for a buck.

I love the ones who pay to fuck,
who hesitate before they touch,
reach into their pockets, ask is it enough?
look to my face to know it's okay.

I love the ones who pay:
Ernest, Pete, Henry, Roger, Jim,
Fred, Frank, Douglas, Ronald, David, Bob
who come in the day and sit and chat
and wait for me to rise from my opposite chair
and rub their necks and pat their hands and say,

"I'm so happy to see you thank you. I'm touched."
and I hope they believe me
because I need this money to buy clothes and food and furniture,
for I have been poor for much too long
and a Good Girl for just long enough.

Do you like my cock?

[Reprinted from *Sex Work*, Cleis Press, 1987; originally published in *Appeal To Reason*, 1982.]

Brrrring . . . Brrrring . . .

Wow! Maybe it's an activist prostitute, calling to help me plan the revolution.

"Hi, honey. What ya up to?"

Oh, shit. It's Frank. Should I or shouldn't I? I am so immersed. I don't feel like working. I just get in this really sensitive space. I'm an artist! I shouldn't have to. And he's really an effort. But I need the money. "Oh, I'm great darling. I was just hanging around. Why don't you come over? I'd love it."

"Be right there." He's happy.

"Just give me a half hour to get dressed and clean my apartment."

"Don't bother for me."

"No, I have to. See ya."

I straighten up my desk, make my bed, shower and set my hair with electric rollers. Whore Magic. That would be a great brand name, I think as I smear my lips and cheeks with Wild Cherry. I should start a business and sell cosmetics, oils and sex toys by Whore Magic. I'd make a fortune, I lament as I choose matching bra and garters and a low-cut dress, sadly, because I know that tail is more profitable than retail. I choose music and light the incense. The doorbell rings. Frank appears in tennis drag (the alibi to his wife) but this is not a matter of love.

We kiss and hug. I drag him into the bath and wash him with ritualistic tenderness, sponging and sucking and cooing. I drag him back to bed and proceeded with the oral sex. Maybe he'll just come like this and leave real fast so I can get back to my art and politics. But I tease to extend his pleasure so that he'll come back again.

Hurry up, hurry up, I think as my mouth and fingers linger.

"What about sixty-nine?" he asks, as if I might refuse him.

"Mmmmm. Oh yes, yes," I whisper. Shit. I don't want to get all involved. I don't feel like getting off. I never feel like it, but I'd rather come than fake it and the clients in my call girl network expect us to act like we like it. I wish I worked turnover like in a brothel or massage parlor. Regulars are so much pressure, but I work this way to avoid police.

"It's great you love to fuck and suck so much. You really like it, don't you?" he moans to my crotch.

"Oh, yeah, I do etcetera . . ."

"Do you like my cock?"

"Oh, yeah, I do etcetera . . ." Oh, c'mon, I think. Now, if sex workers had status as actresses, I wouldn't suffer from the tension of these lies. "I like it. Please fuck me."

"I can tell you really do. I think the woman should enjoy it. I know you really do. That's what turns me on."

"Oh, yeah. I love it. I love it." I say. What I hate the most is that these guys think we're sex-crazed. They think we're aching for a hot time in the sack. I don't know why he keeps asking. I certainly respond passionately enough.

Frank comes. He rolls off and hugs me. "How many times did you come?" he asks.

"Oh, yeah, I don't know. I lost count."

Frank's a nice guy and a good lover, but my mind is somewhere else. My call girl friends agree: sex work is a lot easier when you see a lot of men. When one sees three or four men a day for several days, one can enter a sexually-open state. But I don't have time for that, so I find the work irritating.

I know! I should write a book for tricks about how we really feel about these encounters. I could interview all my friends. Ah, when whores start telling the truth and lifting the burden of these lies we will become so powerful and the future of prostitution will be so rosy . . .

John Palmer vs. Love

I met "John Palmer" (not his real name) at a poetry reading. I liked him, and we started dating . . . well, fucking for free. Early on he told me that he sometimes paid for the services of prostitutes. He was candid about his feelings about paying for sex, more candid than my own clients would have been with me.

[Originally published in *Autobiography of a Whore*, Whorepower, 1983.]

John Palmer's in the world!
And he's all alone John Palmer
waking up at 6 am in Berkeley
with his B.A. in English
and his four dollar an hour job
putting disabled men to sleep and waking them.

John Palmer feels lonely knows he's too shy to meet nice girls he sees (jacks off instead). No nice girls want to know his name. Whores talk too much. All laugh at him.

John Palmer cruises Berkeley in his gray Chevrolet, stops in at a cafe to observe how women balance their lips across teeth, always on the brink of teasing him. He scribbles poems that say:

> All the women, beautiful and aloof . . .
> And no one wants to know my name.

Later that day John Palmer is at the dirty cinema!
In the dark he imagines himself fucking.
His eyes are wet and stiff as pussy.
He comes in his pants without touching.

Whores talk too much.
No nice girls want to know his name.
That evening—

John Palmer home in his room, in his study,
his bookshelves climbing the walls,
swollen as capillaries,
and on the small, square patch of rug on cold linoleum,
he tosses a bag and blanket
and wraps himself alone.

He closes his eyes.
John Palmer conjures nice girls,
their faces translucent as movie screens,
invents slender thighs, sighs, tries,
can't come,
can't sleep.

John Palmer alone,
gets dressed,
goes out in the world, John Palmer,
into his car, drivin' down the side street,
goin' to the parlor,
and all the nice girls are laughing at him.
He picks the one who looks like all of them.

Whores talk too much.
Not enough fuck.
Pays forty for The World[10]

Which is everything.

[10] "The World" means "half-and-half," or "fuck and suck."

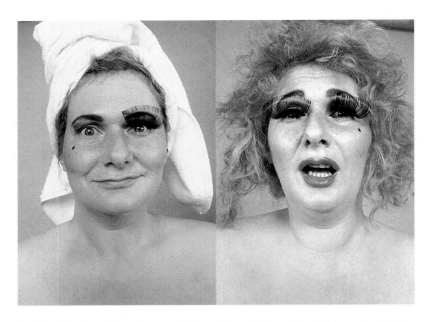

Scarlot Harlot gets ready for a glamorous date, from *Sluts and Goddesses Video Workshop or How To Be A Sex Goddess in 101 Easy Steps* by Annie Sprinkle and Maria Beatty. Photo: Tracy Mostovoy

Eating The Upper Crust: Fucking for Money at the Bohemian Club

[Reprinted from *Sex Work*, Cleis Press, 1987; originally published in *Appeal To Reason*, 1983.]

Everyone wonders about the mysterious prostitutes who entertain the Bohemians who "travel across the river." Well, I am one of those prostitutes. I call myself Big Red, like the logo on the Wrigley's gum wrapper, which I paste on card stock and use for business cards. I try to amuse myself. "I'm Big Red! See, here's my card. Only there is no gum. You'll have to come back to my room if you wanna chew . . ."

We enter the bar at eight or nine at night. The festivities at The Grove are over at nine-thirty or ten, but if we're lucky, we can catch an early bird. Plus, we're bored. There's nothing else to do. We enter the bar, fresh from about an hour in front of the mirror. We look our best. We sit with our girl-friends who immediately begin raving about our appearances. We discuss each woman's good qualities and assure her that she will make a lot of money that night. To be sure, we are very beautiful, though ridiculously out-of-place at the informal golf club bar. We know it and flaunt it, yet we are disturbed

that there are so many townies at the bar. They stare at us and snicker; when the town boys get drunk they insult us. We look around and wonder, who are the cops and who are the reporters? We discuss it . . .

We recall the old days at Hex, a casually elegant hotel bar. During the period of the "encampment" we had the bar to ourselves. The gay clientele went elsewhere and the call girls and Bohemians could proposition each other with delightful abandon. I had a reputation for being particularly "sex positive." I used any excuse to show the prospective clients a split-wet picture of my cunt. Another woman came dressed like a bird in a bikini top made of feathers . . .

Wealthy men pay only a little more than middle class men. We make less up here per hour than we might make at a massage parlor.

Sometimes we feel cheated. We say they're cheap. Bohemians tell me that a man is less of a man if he pays more than his friends for a whore. For some of them, swindling us is a sport. Others are gentle and kind. They leave the bar with us as soon as we ask, or they ask us—they ask how much we charge and pay what we want—in bed they are gentle and fast. They flatter us. Many promise to return to us and don't. Others come back and give us more money than we expected . . .

I moaned, "I haven't been out once tonight. I'm getting depressed." During a good evening a woman might see three or four men.

"Oh, don't worry about it, Red. No one's caught tonight. The guys are all window shopping." Jamie's always supportive. She's also very beautiful. If she didn't catch, no one did. "Keep your spirits up, sweetheart," she says with a sympathetic pout.

"Oh, I'm never gonna make any money!" I like to complain.

"You think you got problems?" Martha's a mountain woman and very colorful, but she's new in the business so she doesn't make very much money. "Last jerk I did only paid me half a' what he said."

"You gotta get the money up front, darling," Jamie reminded her. "You can't trust anyone 'cause there are some creeps around here who'll want to rip you off. I hate men," Jamie giggles.

"What about more money? I wanna get more money from these guys. I mean, somebody should pay for all the time we've been sitting here. How do you do it, Jamie?" I'm always asking.

"Just tell 'em you're worth it, Red," Martha offered, proud to be of help.

"Tell them that your specialty is oral sex and that you're the best," Jamie confided. "That's what I always say."

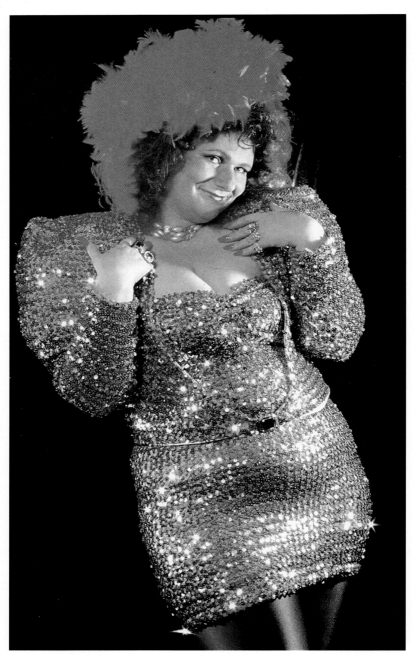

This gold sequined suit was made (and worn) by my friend, Gilbert Baker AKA Sister Chanel 2001 of the Sisters of Perpetual Indulgence. Baker is most well-known as "the Betsy Ross of the gay community." He designed and sewed the Rainbow Flag as a symbol of gay pride and diversity. Photo: Annie Sprinkle

"Great idea, Jamie. But if you're supposed to be the best, I'll hafta be the second best. I'll tell 'em I try harder. . ." I grinned, trying to amuse myself.

"Peg, what do you do to get more?"

"I ask for it. If that doesn't work, I beg." Sweet, shy Peg is an accountant and an embezzler as well as a part-time prostitute. Later that evening, I tell a man that I give the second best head. I introduce him to Jamie and tell him she's the best. He sees me that night and sees Jamie the next. We try to help each other out . . .

One year we organized a union. We had one meeting in which we heatedly discussed whether or not we should make a pact to turn anything under two hundred down. We talked about "appropriate" versus "slut" behavior at the bar. Some of the women claimed to be embarrassed by the behavior of others. We talked about approaching men only when they were unaccompanied by a woman. We didn't agree on anything. I was proud that we met like that . . .

One of us is a lawyer. One is an administrative assistant. Many of us are mothers. I am an actress/writer/producer. One of us was an elementary school teacher (now a full-time pro). One of us has a daughter who is deaf and may be going blind. One of us was a Sunday school teacher who had herself hypnotized to believe she was beautiful and horny so she could have the confidence and inspiration she needed. She wanted to break down her inhibitions, but her plan backfired. In the end, she wound up giving it away. We laughed and teased her the next day . . .

When there's not much money around, we feel tense. Some girls fight, and some of us cry. One cries because her boyfriend stole money from her again! And after he promised to stop. One cries because she hasn't made any money all night, and the last trick she brought to her room told her he doesn't pay for it. One woman cries because a trick she likes favors another woman. I cry because I wound up doing too much for not enough cash, because I'm just not assertive enough and I don't know how to bargain and those two guys I did together were so demanding. When we are making enough money we feel elated and no one cries . . .

At the end of the evening we have parties "women only" in the larger rooms. We usually are giddy, some of us drunk, most of us anxious to tell our stories. We hug and tease and flatter each other. At one party we hugged and kissed in twos and threes on the beds. Last year only a few of us did coke; most of us smoke pot and drink. I perform at these parties, with my tape recorder and telephone, and my poetry. I try to amuse myself . . .

Prophylactics and Twenty Dollar Bills

dedicated to all the prostitutes working before and during AIDS crisis

[Originally published in *Autobiography of a Whore*, Whorepower, 1983.]

1. In the morning I count my prophylactics:

 One bluejay blue lubricated TROJAN,
 One gold see-thru superdelux extra-sensitivity TROJAN,
 One black and white hospital tested GUARDIAN.

 Enough. I like the gold ones best,
 but variety excites me.

 I don't have to stop at the drugstore today.
 Good. The druggists know what I use them for.

 I should be buying them in twelves like eggs,
 But I can't seem to make that commitment.
 Instead I buy them in small quantities,
 With guilt and satisfaction like cigarettes.

 In the morning I count my prophylactics.
 In the evening I'll count twenty dollar bills.

2. I work from 12 to 6 in the afternoon.

I wanna get laid.	How much will you pay me?
How much is it?	I like to get eighty.
I don't have eighty.	How much do you have?
How's forty?	That's not enough. But I can handle sixty.
Okay.	Good.

 Customer #1 hands me three twenties. I choose the TROJAN blue.

I want everything.	Perfect. I'm glad. How much?
How much is it?	Tell me what you wanna spend and I'll tell you what I'll do.
I only have forty.	That's enough for French.
You clean?	I don't know. Are you?

You got a rubber?	A rubber for French. Great. I used to try to do every French with a rubber but I got too many complaints.
I like to be careful.	
My wife.	Good for you.

Customer #2 hands me two twenties.
I pull out my hospital tested GUARDIAN.

I wanna have sex.	Good. Me too. I like to get eighty.
What's that?	A prophylactic. What do you think?
I can't get off with that.	Too bad I have to use it.
Oh, please. C'mon, please.	
please, please.	You'll catch a disease.
Oh, yeah?	No, not really, but I could catch one.
Oh, c'mon, I'm clean.	Look, I'm not a loose woman.
Hey, I tell you I'm clean.	Shit, okay. One more twenty.
Okay.	Okay.

Customer #3 hands me five twenties.
Gold superdelux extra-sensitivity goes back in my purse.

3. Wow. What a day!

Two prophylactics used. Recalling how they popped from my purse,
Like perfect toast.

My gold superdelux extra-sensitivity remains tucked in my purse,
like a lid of grass,
like a dietetic candy bar,
like a free pass to the movies,
like five yellow valium that I wish I had but I avoid.

In the morning I count my prophylactics.
In the evening, twenty dollar bills.

One two three four five six seven eight nine ten.

Recalling how they slipped in my purse,
Movie stars into satin sheets.
Ten twenties. No police.

The Birth of Scarlot Harlotism

[Reprinted from *Sex Work*, Cleis Press, 1987; originally published in *Appeal To Reason*, 1982.]

I provide sexual service to a handful of clients, most of whom I've known for at least a year. I trust these married businessmen. I know their real names and I have their phone numbers at work. They tell me they love me or like me so much. They pay what I ask and they leave when their time is up. I trust them. I need to trust them.

"You're crazy, girl! Don't let your guard down. Men have a bad attitude towards women. Especially working girls. Fucking us over is a game for them. Why do you think they call 'em tricks?"

"No, no, no! I can't be that suspicious!"

But it's worth it. I only have to work a couple hours a week. The rest of my time I spend at the typewriter, complaining and bragging about my life. I stay home a lot. I entertain myself. At night I pick up my guitar and sing:

"My life was so boring, 'til I started whoring."

Pretty funny, huh? Oh, forget it! I'm being facetious, sarcastic, sardonic, I'm miserable. I hate this fate. I made those changes in my life, but I can't go on living in fear and isolation. I can't. If only . . . If only the streets were safe . . . If only women were not haunted by submissive images. I remain home and depend on my telephone.

And what of telephones? Oh, those twisted umbilical cords! I have three obscene phone callers—two of whom don't seem to know that I'm a prostitute because they don't mention it. Many women are plagued by this phenomenon. We restrict ourselves to listing first initials in the phone book rather than our full names, because there is an army of men out there who use the telephone book as a map. They choose their targets, call and attack.

If only we weren't haunted by these invasions. If only we could protect ourselves. If only we could choose to be sexual whenever and with whomever we want . . . if only . . .

I give up. Wait a minute . . . what a great idea! Yes, I will stay home. So far I have rearranged my life to protect myself from the evils of this world. What I should do is formulate a plan to rearrange the world and make it safe and fair. Perfect! I can't wait. This useful endeavor will certainly keep me occupied as I pass the time in my luxurious cell.

I will begin by reorganizing our nation's economic structure.

1. Prostitution is too rampant. Most of us are forced by economic need to share this deep intimacy. About half the prostitutes I know are mothers who support their families. My solution: The President and Congress will arrange to pay mothers decent salaries for child raising. This will eliminate about half the prostitution. The remaining prostitutes will make more money. Everyone will be happy.

2. In general, all the boring, dangerous and unpopular jobs will pay more than the interesting, popular jobs. That will improve most people's lives.

I have a lot of ideas. I'll write them down and organize a comprehensive plan. And when I've completed this manifesto, then I will . . .

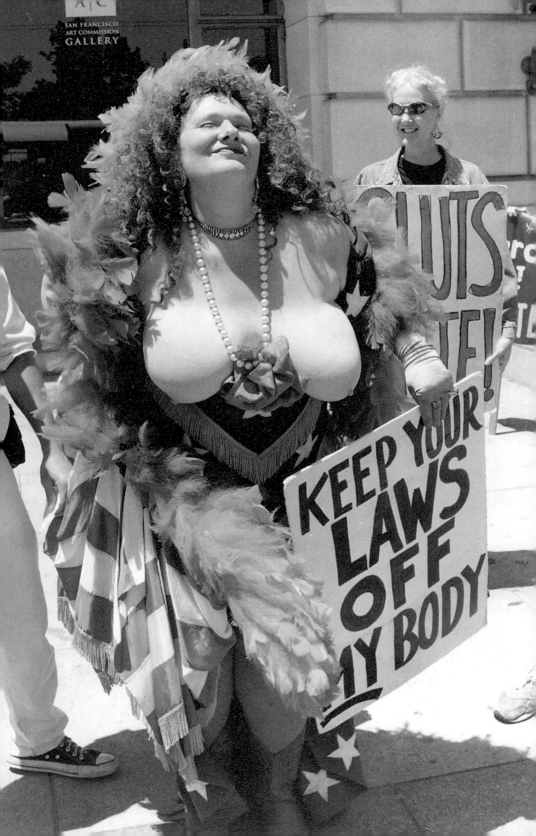

Multimedia Whore

Organized by *Whorezine's* Vic St. Blaise—Father River Sims, Jeff Bullard, Teri Goodson, Tortuga Bi Liberty and several others celebrated Sexual Freedom Day on 6-9-96. We marched from City Hall and through the new library chanting, "Grab your make-up, fix your hair, prostitutes are everywhere!" Photo: Kerri Lemoie

This Paper Bag 1979–1987

The material in this section documents Scarlot Harlot's earliest political endeavors and performances. I was one of the first in the country to "come out" as a working prostitute. The persona, Scarlot Harlot, afforded me some anonymity.

From Inventing Sex Work
[Originally published in *Whores and Other Feminists*, Routledge, 1997.]

I invented sex work. Not the activity, of course. The term. This invention was motivated by my desire to reconcile my feminist goals with the reality of my life and the lives of the women I knew. I wanted to create an atmosphere of tolerance within and outside the women's movement for women working in the sex industry.

In the early '70s, I read feminist authors starting with Betty Friedan, Germaine Greer, Kate Millet, Phyllis Chesler and Ti-Grace Atkinson, who helped me understand how my power was thwarted by "internalized oppression." Through my anti-war activism and "peace and love" world view I had developed what I considered a "feminine" politic based on compassion. If women had more power, we would realize justice in the world.

What would my role be in this movement? I aimed for basics, beginning with the betrayal of my gender by the language. The editorial 'he' rendered women anonymous. In *Language and Women's Place*, Robin Lakoff explained how linguistic revisions could be used as an activist tool by feminists. As a poet and a wordsmith, I was intrigued by the potential of linguistic activism to bring women out of anonymity and proudly write our new herstory.

I had a strong sense of being both witness and participant at the inception of the reinvention of womanhood. From the beginning, however, I confronted the contradictions. Although I began disdaining "femininity," didn't this rejection of "femme" often translate to condemnation of women?

In the mid-'70s I took Women Against Pornography's tour of the Boston porn stores. I remember an inspired young woman picking up the magazines with pictures of naked women in bookstores and ranting against the images. Her approach reminded me of ways I'd been called a "slut," and of the shame

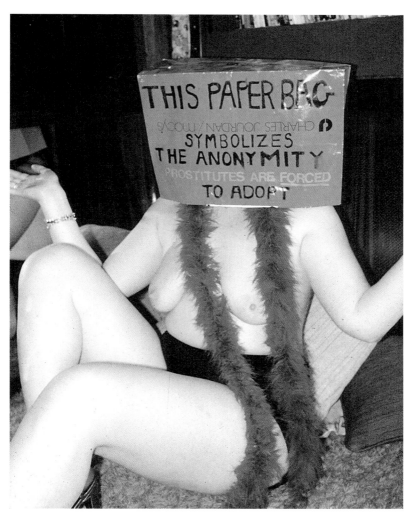

Posing in the paper bag I wore on many occasions, starting with my first National Organization for Women meeting where I met Priscilla Alexander in 1977. Of course I wasn't topless at that meeting. Photo: John Q.

I felt about being feminine. I felt protective of my naked sisters—now we call it "whore-identified."

I came to realize that feminist perspectives of the anti-porn activists did not match my own beliefs. Being chastised as a slut was part of the way I was oppressed by the patriarchy, my sexual proclivities condemned. Anti-porn ideology echoed that condemnation. I did not want to take sides, however.

The women in the porn magazines made me feel exposed and envious. I longed for an analysis that would incorporate my contradictory needs: to be free of sexual shame, and also to criticize and change the sexual imagery in our culture. I would have to look further. I discussed my questions about feminism and sex industry with my friends. Finally, Celeste Newbrough, an older feminist, poet and lesbian activist whom I admired, confided in me that she turned tricks a couple of times when she needed money. Celeste defied my stereotypes. I was intrigued.

Why was there so little information in feminist circles about prostitution and porn from the point of view of the women in the movies, in those magazines, and from people like my friend Celeste? Many lesbians were "out" as lesbians, but where was the prostitute in this new woman we had been inventing? She was degraded and objectified anew by the feminist rhetoric, and she didn't exist in feminist communities as a real person.

Several years later, as feminism had been a revelation to me, so was prostitution politics. The reality of my daily life as a prostitute was a startling contrast to my prior assumptions about prostitution.

My priorities became aligned with the goal of ending the divisions between women. These divisions were based on the contracts we made with men for the purposes of our survival. This quest for commonality was only the start, a direction, and not a comprehensive analysis of sexual relations.

But how could women who worked as prostitutes and porn models tell the truth about their lives within the hostile environment of the women's movement? The words used to define us contain the history of centuries of slurs. Some feminists used slurs against us such as the word "whore," and the censure of pornography [11] as a weapon against the contemporary sex trade.

What words could we use to describe ourselves? The word "prostitute" was tarnished, to say the least. In fact, "prostitute" is yet another euphemism, like lady of the night, hooker, *fille de joie*, etc. "Prostitute" does not refer to the business of selling sexual services—it simply means "to offer publicly." The euphemism veils our "shameful" activity. Some prostitutes don't use the term to describe themselves, as they want to separate it from the negative connotations (e.g., to compromise one's self).

[11] For example, in Dworkin-MacKinnon's anti-porn legislation, images were termed "degrading" if they portrayed a woman as a "whore by nature." The term "pornography," then, was being used as a weapon against women, marginalizing us and casting us outside of the approved feminist circle.

Taking Back the Night

In 1978 I attended a conference in San Francisco organized by Women Against Violence in Pornography and Media. This conference was part of a weekend of activism featuring Andrea Dworkin and an anti-porn march through North Beach, San Francisco's "adult entertainment district," during which the marchers embarrassed and harassed the strippers and other sex industry workers in the neighborhood.

I had intended to be a sort of ambassador to this group, educating feminists about prostitution. I planned to identify myself as a prostitute, which was almost unheard of at that time in a public and political context.

I found the room for the conference workshop on prostitution. As I entered I saw a newsprint pad with the title of the workshop. It included the phrase "Sex Use Industry." The words stuck out and embarrassed me. How could I sit amid other women as a political equal when I was being objectified like that, described only as something *used*, obscuring my role as an actor and agent in this transaction?

At the beginning of the workshop I suggested that the title of the workshop should be changed to the "Sex Work Industry," because that described what women did. Generally, the men used the services, and the women provided them. As I recall, no one raised objections. I went on to explain how crucial it was to create a discourse about the sex trades that could be inclusive of women working in the trades. I explained that prostitutes are often unable to reveal themselves in feminist contexts because they feel judged by other feminists. The workshop participants were silent and curious. One woman, another writer and performer, came up to me after the workshop to tell me that she had been a prostitute as a teenager but was unable to discuss it for fear of being condemned.

The term "sex worker" resonated for me. Today, "sex work" and "sex worker" is used widely and internationally, throughout the media, by academics, health service providers, activists and more. I first used the term in my one-woman play, *The Adventures of Scarlot Harlot,* also titled *The Demystification of The Sex Work Industry*. "Sex workers unite!" shouts Scarlot as the play begins.

The Adventures of Scarlot Harlot

I began reading and performing my "harlot poetry" in San Francisco coffee houses and clubs in 1978. In 1981 I wrote and produced a multimedia performance piece based on these poems called The Adventures of Scarlot Harlot, *directed by Joya Cory.*

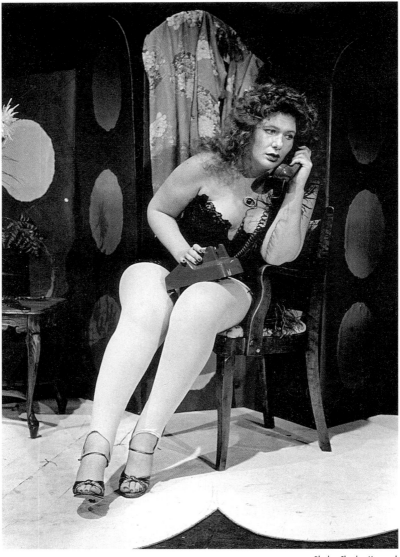

Photo: Charles Kennard

For Immediate Release

Date: May 21, 1983

Location: National Festival of Women's Theater, U.C. Santa Cruz, California

Event: *The Adventures of Scarlot Harlot*, a one-woman performance piece by Carol Leigh

Subtitled "The Demystification of the Sex-Work Industry," this one-woman performance piece was written by a prostitute.

"It is an outrage that there are laws in this country which deny a woman's right to receive payment for sexual services."

Through the use of satire, drama, tapes, costumes, props and interaction with the audience, Ms. Leigh presents Scarlot's quest to expose the hypocrisies, which are responsible for the illegality and stigma of prostitution.

At the start of the piece Scarlot ascends the stage with a paper bag on her head, which reads: "THIS PAPER BAG SYMBOLIZES THE ANONYMITY PROSTITUTES ARE FORCED TO ADOPT!" She begins to read her DEMYSTIFICATION MANIFESTOS when the telephone rings. It is one of her clients, Art. Scarlot apologizes but she must take the call because she needs the money.

"Art really pays," says Scarlot. "I mean . . . a poet's gotta eat."

In the course of demonstrating her work, Scarlot is compelled to use risqué language and to descend into the audience and sit on their laps.

"I thought I'd be more like Emily Dickinson," she laments, trying to appear as modest as possible considering the nature of her subject.

Compulsively honest, Scarlot confesses: "That's not how I really do it. That was just symbolic."

With the assistance of her telephone and her friends, including Priscilla Alexander of The National Task Force on Prostitution, Scarlot manages to get herself out of one theoretical scrape and into another demystifying situation, maintaining her courage in ". . . this maze of patriarchal capitalism."

Porsche-titution

In The Adventures of Scarlot Harlot, *Scarlot sits at her typewriter and tries to figure out how to make the world safe for prostitution.*

SCARLOT

Puh . . . puh . . . prostitution. That doesn't sound so good. I don't even like the word prostitution. [She looks through her dictionary.] Prostitution. Prosthetic. Prosthedontic. Prostitution.

Photo: Charles Kennard

1. Trading sexual services for money or goods.

2. Selling one's talents for an unworthy cause.

That second definition tarnishes our reputation. There's plenty of causes less worthy than survival or feeding your family. What about Porsche-titution? That's selling one's talents for a Porsche.

That's right! Why should I be ashamed? I shouldn't be ashamed. I won't be. I'm not. I'm proud. I'm proud that . . . I'm proud that . . . Well, I'm proud that I'm not ashamed! And I'm going to tell the whole world. Let me see . . . Who should I tell first? My mother!

MOM

You're a sex worker? What are you saying? You're working in a dildo factory?

All right, so I believe a woman's body is hers to do with as she wishes. So everyone has to work. So some people use their hands. They're magicians. Some people use their mouths. They're politicians. Some people use their feet. They tap-dance. You? You use your . . .

All right, so without sex most men don't function properly. So you're providing a service. Some service. That's right, there's a stigma. But, what's a stigma? A stigma is a mark society places on you. Society, I don't trust!

But it's illegal. My daughter, the outlaw. You're a victim. I'm sorry. It's true.

My daughter's very sensitive. She has a need for acceptance of family and friends. Of course, I'm gonna worry about her. I hope she can handle it.

Photo: Charles Kennard

So I'm not overjoyed, but I'm glad she told me.

You know, at least she's getting paid for a change.

I always say, a daughter is the continuation of her mother.

If I were thirty years younger, who knows? I might go into prostitution.

You think I'm strange? No one can believe a woman of fifty-eight thinks like this. All right, so I'm fifty-eight. I know, everyone always says. 'Oh, you don't look it. You look so much younger.' You know what I say? I say, 'This is how a woman of fifty-eight looks.'

Women have to start telling it like it is. When people start hearing the truth about our lives, then and only then can they become sympathetic. All right, so she's a victim. So we're all victims. We're victims of hype. And you can quote me on that.

Photo: Charles Kennard

Whore Moans

[Reprinted from *Sex Work*, Cleis Press, 1987; originally published in *Appeal To Reason*, 1983.]

No wonder I'm all stressed out. This work is weird. This stigma is weird. I'm weird. Everyone I know is a weirdo. It usually takes about an hour to wind down after an encounter. What should I do now, while I'm waiting, waiting for the next phone call?

I can always read *The Mamie Papers*, a collection of letters written by a brave and guilty whore at the turn of the century. The book depresses me. I cringe as she calls herself unclean and immoral. There is no repose.

I'd rather be contemporary, anyway. I think I'll watch television. I check out the *TV Guide*. Oh, no! I can't believe it. Margo St. James on a talk show, and just in time, I tune her in.

Ah, there she is, chronically courageous, impenetrably brave, grinning after the commercial in her stylish pink sweater dress and thick, neat farm-girl hair. I admire her ease, yet I worry through the patter of the talk show host, posed carefully seductive in his loveless sports suit. I relax as I observe his good-natured interrogation.

"So, you're retired now?" He seems disappointed.

"Not tired. Just retired," Margo replies in her alto drawl as she stretches comfortably on her couch. The audience chuckles. The host mugs a pout.

"Would you be inclined to kiss and tell?" he asks, squirming in his seat.

"Oh, we don't kiss. Too many germs!" she replies and sits erect. "By the way, why are you rubbing your thigh?"

A whore speaks! Not quite the revolution I had hoped for, but she certainly is afforded respect. The audience gasps, titters and applauds this heroine. They seem to care.

Margo and the host continue to serve and swat their double entendre until flutes signal a commercial interruption.

"Thank you very much, Margo St. James . . ."

But Margo interrupts. The cameras are stuck. The music stops.

"Wait a minute. I have an announcement to make. COYOTE is having a Hookers' Convention during the Democratic Convention. '84 is the year of the whore! We're inviting the delegates to stay in our homes, the female delegates, of course. That's informal. I'll put up a few gals in my lobby," she belts as the music ascends, her voice fading behind the horns.

"Thanks," he says, quite rushed, "And now a word from . . ."

Just my luck. And just as I was beginning to relax in my nest of cash and condoms, I witness a call to duty on my television set. Well, I suppose I was asking for it.

I knew, when I decided not to join the Cats and Candlelight Womanpower Commune, that I had opted to confront my oppression on a daily basis. Rather than excusing myself from the men's world, I chose to challenge the enemy, Ernie, my boyfriend at the time. He never quite agreed with me, and finally I grew to smother my bitterness, complaining to my sisters in angry whispers.

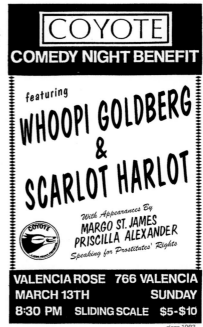

"I despise men's tacit acceptance of our oppression. It's a conspiracy!"

As the years rolled by, I grew inwardly understanding and outwardly calm. A flick of fate made me a prostitute. I was poor and alone when I first moved to this open city. It seemed like the logical thing to do. In these last years I have developed a caring for the men in my bed. Individually and close-up they seem innocent and vulnerable. Besides, they are my clients, my lovers, my wards, my employers, my intimates. Eventually, the word "patriarchy" began to slip from my vocabulary.

I learned that women led the movement to make prostitution illegal. The Suffragists. My foremothers.

And now, I consider the challenge and call for a new tally. We are the whores. Who are our friends?

I must descend from my icy abode and attend those bagel brunches, contriving platforms amidst feminist hunches. Together we will make prostitution an issue along with the other issues such as abortion rights, equal pay, lesbian rights and rape. We will organize and speak, and they will be staring at us.

That's right, I'm afraid. Our potential astounds me. The fact that prostitution is illegal shocks me, almost paralyzes me. Am I allowed to help organize a Hookers' Convention?

I don't think I'm allowed to talk to another prostitute. That's a conspiracy. Suppose I was describing a new sexy dress I had purchased in order to make my fortune? It's illegal to talk about business.

I don't think I'm allowed a personal lover. He would be suspected of being my pimp and may be arrested for associating with me.

Theoretically, I'm not allowed to talk to anyone. I have very few rights, except the right to a trial and certainly not one by my peers.

Priscilla Alexander, friend and activist, once said:

"The right to be a prostitute is as important as the right not to be one. It is the right to set the terms of one's own sexuality, plus the right to earn a good living."

So, descend I must. And luckily during my retreat, I wrote a song about our struggle. Perhaps I'll play it over coffee and croissants to an audience of whores, friends and activists.

We're doing prostitution
Although it's no solution
It's just a substitution
We make a contribution
We've found a resolution
To our destitution
We don't want persecution

We're doing prostitution
It's an age-old institution
Ya know, it's not pollution
We need some absolution
Perhaps a revolution
A brand-new constitution
To end this persecution

Yeah, yeah, c'mon yeah!

Prostitutes take on issues that make them 'criminals'

By Harriet Swift
The Tribune

Prostitutes from across the country spent four days in the Bay Area this week discussing taxation, city zoning laws, client screening — and sexual techniques.

The women who ranged from street walkers to high-priced call girls, met for the seventh Hookers' Convention with the aim of bringing into the public eye the issues that they say endanger their lives and their right to make a living.

"The whole issue is being who we are; to be accepted legally and morally," said Vicki, an attractive young mother from Marin County.

For four days Vicki (who asked that her last name not be used) and 50 other delegates discussed ways they could break through the barriers they say make them unwilling criminals. Their convention was carefully planned to coincide with the Democratic National Convention to give their issues national attention.

Their program for decriminalizing prostitution and establishing a set of ethics and political goals will be announced this afternoon at 3 at a press conference in San Francisco.

The group's platform, hammered out Monday through yesterday in five-hour sessions, calls for the repeal of all laws

See PROSTITUTES, Page D-3

By Sean Reynolds/Special to The Tribune

Carol Leigh, left, and Margo St. James, head of COYOTE, at a session of the Hookers' Convention.

Oakland Tribune, July 13th, 1984

COYOTE (Call Off Your Old Tired Ethics) and the Hookers' Convention

In July of 1984 Margo, Gail Pheterson and Priscilla Alexander organized a convention for prostitutes in the U.S. During day long sessions about a hundred of us from around the country came up with an agenda and a list of law reform priorities based on the following:

- The main function of the laws prohibiting prostitution is the social control of all women and people of color, and the laws are discriminatorily enforced against these populations.

- Prostitutes' rights is an issue of self-determination: we have the right to control our own bodies.

- Sexual stigmatization oppresses prostitutes, and, by extension, serves to keep all people from exercising choice about their personal lives.

Sluts Unite!

[Reprinted from *Sex Work*, Cleis Press, 1987; originally published in *Appeal To Reason*, 1983.]

. . . The pressure is on. When we last left Scarlot, she was emerging from her nest of cash and condoms to heed the call of duty and help organize a Hookers' Convention just before the Democratic Convention.

"I'm afraid," she confessed. "Our potential astounds me, but the fact that prostitution is illegal almost paralyzes me. Am I allowed to organize with other prostitutes? I don't think I'm allowed to talk to another prostitute. That might be conspiracy."

But here I am, in the midst of it. Two or three times a week I descend from my brothel-pad to meet with a variety of outlaws and deviants. (Deviants? No, we are the norm.) We band together to share our secrets of survival, celebrate our triumphs and exorcise abuse. We are the whores. We are the dykes. We are the working class women. We are the black women. We are big fat women. We are the incest survivors. We are the academics. We are the experts. We are the activists. We toss our tales into the circles. I squirm in my seat at the potential.

Will we affect the world? Is this the birth of a movement? Scarlot pleads for vows of faith and solidarity. "This is the revolution!" she cries, lurching to the edge of her metal folding chair. Fat women smile. Black women smile. Some women nod their heads. Other women stare into the center absorbed in private dramas. I wonder what will come of this puddle. I extract metaphors of frogs from tadpoles. I'm impatient.

Do you want to join an organization? You can buy t-shirts and carry a membership card. We'll call it FLOP—Friends and Lovers of Prostitutes. Good idea, huh? I bet all my pals would be proud to wear that on their chests.

Bad Girls Go Everywhere

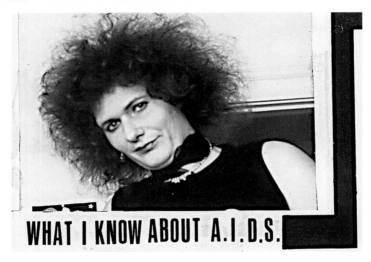

From *The Harlot Herald*, February 1985. Photo: Helen Burke

The Scarlot Vector: The AIDS Crisis

Little did I imagine that my adventurous bent would cast me into a modern day leper's role.

In 1983 Priscilla and Margo from COYOTE began warning me about a mysterious disease that was affecting gay men. They insisted that I use condoms to protect my health. I did not respond immediately. I was trying to earn money to finance my play, *The Adventures of Scarlot Harlot*.

Scarlot Harlot was casually working towards what seemed like a far-off goal: the repeal of laws against prostitutes. Suddenly, more than a casual approach was needed.

In 1984 the AIDS crisis was more than a rumor. I stopped performing *The Adventures of Scarlot Harlot*. The whore stigma was no longer my most pressing issue. In fact, this experimentation had landed me at death's door. Maybe I should have embraced the stigma, I thought, as that red "A" burned into my breast.

I was seeing only five or six regular clients at the time, and most of them were not using condoms. I'd been working in a network of call girls that

shared a relatively elite clientele in San Francisco. In these circles, many men objected to the use of condoms, and in such a highly competitive milieu I found it too stressful to insist. Friends who worked outside of our network— in the street or in massage parlors—were extremely critical of the practices of the call girls. We charged less and gave more time for the privilege of working in a system that provided a steady base of affluent, referred clients, thus eliminating the risks of encountering strangers, who could be police or rapists. As time went on, COYOTE's warning became more urgent, and I began the difficult task of practicing safe sex.

The local media was suddenly filled with horror stories about heterosexual transmission: "Prostitute Spreads AIDS" was typical of the shrieking headlines. I became terrified that I might have AIDS. Every cold seemed to portend a shameful death. Confronted with my mortality, I was overwhelmed with feelings of shock and fear.

News of AIDS created an undercurrent of panic in our midst. We spoke for hours on the phone, as call girls do, discussing our fears and risks, vowing to abandon condom-phobic customers. Some of us began relying more on individual wealthy clients. Others shifted their focus to family and schoolwork. Most of us were tested for exposure to HIV; at first, none of the women I knew tested positive. Clients I'd been seeing for years left, vowing celibacy and monogamy. Business dropped off by 25 to 50 percent.

It took me about a year to accept my mortality, to resolve the fact that it is no shame to die. It took less time to rearrange my priorities. I gave up my play, my apartment and the clients that still balked at using condoms. I moved away from the city to escape the media barrage and began publishing a lowbrow and sporadic journal so that my friends would know I hadn't fallen off the edge of the earth. *The Harlot Herald* was for and about my friends, and filled with gossip, silly questionnaires, news about my diet and my obsessions with past lovers, especially Smelley Kelley.

```
ARE YOU A MASOCHIST,
OR DO YOU JUST ENJOY SUFFERING?
(Find out by taking this quiz)
1. I live
a) East of the Rockies        5
b) West of the Rockies        0
2. I have
a) blonde hair               2½
b) black/brown hair           5
c) red hair                  '0
d) green hair                 5
3. I destroy myself by
a) smoking cigarettes         3
b) the use of cannibas       '1
c) drinking alcoholic drinks  4
d) eating Franco-American
         Spaghettios          5
e) jaywalking                 1
4. I think prostitution is
a) a good name for a board game 5
b) a good way to make a million
            dollars in a week    4
c) stupid and disgusting      3
d) never funny                5
e) only good for women over 80 0
5. I_____ THE HARLOT HERALD
a) like                       5
b) detest                     5
c) am vaguely amused by       5
d) worship                    5
e) read like a bible          5
f) eat                        5
g) use in gross ways          5

1-10 Oregonians and Vegetarian
quiche eaters.
20-60 General Range ("People who
get off by ripping their toe nails
off," says Jimmy Jive.)
60-75 Self-destructive masochist
("People who enjoy getting flogged
by Mr. T," says Jimmy Dread.)
```

The Harlot Herald, Nov.ember 1984.

THE HARLOT HERALD

GOOD GIRLS GO TO HEAVEN BAD GIRLS GO EVERYWHERE

September 1984

Eugene, Oregon

HARLOT VANISHES DURING DIET

Welcome to the first edition of The Harlot Herald, the only newsjournal which describes the life of Scarlot Harlot. As you are all aware of the journey embarked upon by 'The Harlot,' you are probably asking yourself, "Where the hell is she and why hasn't she written?"

Answers to these questions and many more will be included in this month's edition. Reports indicate that Ms. Harlot has been spotted at several unlikely locations along the scenic Rte. 5 through California and Oregon. Locals describe a large redheaded visitor, most likely from this planet, who purchases large quantities of fruit and always travels with a blender.

"That must be her," reports Herbal Life Corporation. "Scarlot Harlot is on a diet." Herbal Life went on to say that their diet prescribes a liquid protein powder, which, when mixed with fruit and $75.00 worth of vitamins a month, garantees huge losses of weight.

"I'm on a diet," were, indeed, Harlots last words as she embarked from her Wyman Street residence where she occupied a household along with such notable and bizarre friends as Davo, Helen "Wallpaper" Burke-Landazuri and Shashi (also known as 'The Sha____ of Wyman Street.')

Apparently _____

$6.95) and Trave____
Bill and Kathy's ____
Grandma's. Folks ____
these well-known ____
Later that ____
calls to local ____
snow. I can sin____
have to pay me. ____
A short v____
demonstration ____
The Two Year O____

A SMELLY DISAPPEARANCE

Why do they call him Smelley? Doesn't he take baths?
____ have a boyfriend named Smelley? ____

THE HARLOT HERALD

GOOD GIRLS GO TO HEAVEN BAD GIRLS GO EVERYWHERE

West Coast Edition

November 1984

SMELLEY AGREES TO WEDDING REUNION

HARLOT DOES THINGS

Welcome to the select pages of the nation's only "Harlot Herald" where you can snatch the latest snitches about the one and only traveling/ folksinging/ poet/ prostitute/activist Scarlot Harlot.

The word is out. Indeed Ms. Harlot did preempt Bob Newhart in her half hour special (prime time) on which she sat and talked about sex. Eugene residents spotted the Harlot at organic food stores where she was purchasing food for her

any, my job would be less stressful. Well, the whole situation became quite embarrassing when the press began asking me what I was doing here. Luckily, the prostitution movement is based on a loose system of statistical improvisation so I bluffed my way through. I don't think I really ____ anyone in the process. I mean,

"So you know I told him that he'd have to beg me if he wanted me to visit. I just didn't feel like I really wanted me. I waited for two months. Still, no phone calls. No letters. So I called him. I asked him, didn't he still love me and if he did I'd hop right in my Scarlotmobile and transverse the country just to see him."

"Well, baby, I sure would like to see you," replied the Smell,"but I got me a job cookin' six days a week at this new chow ____

THE HARLOT HERALD

GOOD GIRLS GO TO HEAVEN BAD GIRLS GO EVERYWHERE

Western Edition

February 1985

The Arizona Daily Star Tucson, Friday, February 8, 1985

Carol Leigh, "The Scarlot Harlot," strikes a pose

'Scarlot Harlot' stars as 'adult comedian'

FATE THRUSTS LOVERS TOGETHER

(OR AN OFFER WE CAN'T REFUSE)

"Remember when we were together... wasn't it BLISSFUL?" purred Scarlot.

"It's fate, Fate, I tell all those ____

"You didn't 'come off like that when we wuz together, Huhhhhh," retorted The Smell.

TWIT and TWAT

[Originally published in *Felix: A Journal of Media Arts and Communication*, Spring, 1992.]

Where was room for my weird self?

I was not one of the skinny, pretty or ordinary people on TV. Mass media stole diversity and individuality from the cultural vision and left me out of the picture.

I headed for Texas. I'd sing about safe sex and educate people who weren't thinking enough about AIDS. I would speak out against mandatory HIV testing. I would form an organization—T.W.A.T. (Texas Whores And Tricks). I would cast my fate to the wind, deconstruct my life, and perhaps eventually realize one of my long-range goals, to take my political art to the mainstream, to truly influence American culture, like my one of my idols, Norman Lear.

My car began making horrible noises in Tucson. I pulled off the highway at the Speedway exit onto Oracle, which turns into Miracle Mile, the adult entertainment strip. "Live Girls," the signs said. This town could use a visit from Scarlot Harlot.

I picked up the Tucson Weekly to look at the personals, hoping to meet someone with whom I could have a passionate affair, since I was stuck there anyway. I answered an ad by local artist, Dennis Williams who billed himself as a poet, life artist and performance artist. We arranged to meet that same afternoon and I handed him my thick packet of Scarlot Harlot publicity. He immediately took me down to the romantic stucco hideaway in the barrio to meet the TWITS (from Tucson Western International Television).

Top to bottom: Performance artist Dennis Williams and Leigh (as mom) with chicken; Leigh (as Elaine) and Leigh; Pizza Dance from War and Pizza in the Global Village; Marabell Lee from TWIT's Brain Damage episode written by Larry Beizer

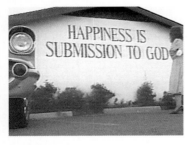

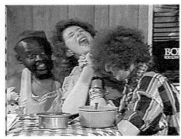

Video stills from "Elaine's", produced by TWIT. Top to bottom: Leigh at the dog pound; Leigh and Bukunus; a Tucson church; Darwin, Leigh and Kelly Gonzales.

Synchronicity and a virus thrust me into this futurist TV performance ensemble in the middle of the desert. Tucson Community Cable Corporation is among the three or four best-funded public access television resources in the country. TCCC offered free training, free use of equipment and funding for artist's work. There isn't much else to do in Tucson. The summer heat fries your brain. The mundane becomes spiritual and profound. Dave Bukunus, head TWIT, producer/writer/ comedian/editor became my mentor. Dave was gay, so he understood what I was running away from. I fell in love with Dave and we shacked up, which was a little complicated, but it made my life very interesting.

On The TWIT Show, Dave's two-hour weekly, live comedy show, I created and developed several characters–prostitutes and funny old ladies. I worked with an ensemble, most of whom were also performer-technicians. I wrote and learned to improvise on the character generator. With Dave's guidance I produced, wrote, starred in and edited, "War and Pizza (In The Global Village)." Through a $3,000 grant from Tucson Community Cable Corporation, we created "Elaine's," a six-episode situation comedy based on different political issues. "Elaine's" was produced and directed by Dave Bukunus; written, edited by and starring Carol Leigh and Randy Harris.

Television had been a big part of my life. My father was a television repairman. I recalled being suckled by my mother in a room full of television carcasses. Occasionally, I accompanied my father on TV emergency house calls. Instantly, the visual, electronic media became the center of my life.

I published a journal called T.W.A.T. (Tucson Whores And Tricks), organized a few meetings and engaged the media on some local issues for prostitutes. I launched a campaign against mapping. Tucson was one of the first cities to prohibit prostitutes from visiting certain neighborhoods as a condition of their probation. Usually these are the same neighborhood where social services are provided or where their friends and family reside, so mapping is quite a hardship.[12]

I worked through my ad in the Tucson Weekly as Vanessa, looking for a discreet rendezvous with a generous gentleman. When they called, I politely and euphemistically explained that I was actually a call girl. If he didn't mind that arrangement, I'd meet him at a cafe. If he liked, he could schedule a future session. This approach was a bit labor intensive, but fairly safe.

I stayed in Tucson for two years, and then headed back to San Francisco.

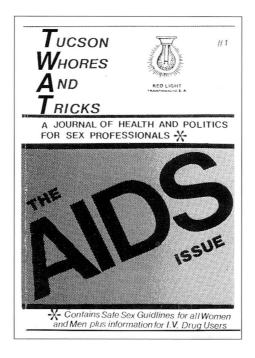

[12] Chief Magistrate Ann Bowen supported our objections to travel restrictions for convicted prostitutes, according to the *Arizona Citizen*, May 29, 1985. See page 121 for our demonstration against San Francisco's 1992 attempt to "map" prostitutes.

Talk Show Tart

The Late Show with Arsenio Hall—February 13, 1987

Scarlot: I'm proud. I had sex with over a thousand men. And that was just last night. (The audience laughs.)

Arsenio: Disease must be knocking at your door.

Scarlot: (Pulling a condom from my bra) Oh, no, I use condoms all the time. Would you like one?

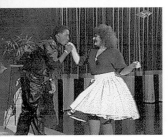

Nightline—June 5, 1987

I was seated near on a panel Morgan Fairchild, and we didn't smile at or acknowledge each other. She looked like a call girl and I was dressed like a college student.

"Many Americans use IV drugs and may not be using condoms with their regular partners," I said to Dr Paul Volberding, also on the panel, "Would you recommend using nonoxynol-9 based lubricants until we are able to use condoms?"

I mentioned using nonoxynol-9 because some experts suggested it. The doctor wasn't sure. Now they say that nonoxynol-9 actually increases your risk of infection.

Scarlot with Arsenio Hall, 1987; Arsenio kisses Scarlot's hand.

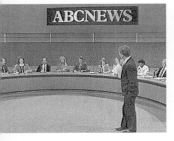

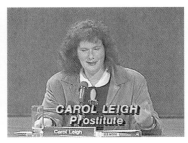

Video stills, Carol Leigh on *Nightline* with Ted Koppel: "Town Hall: The AIDS Crisis", 1987.

Video stills, Scarlot as a "Corporate Call Girl" on *The Geraldo Show*, 1988

Geraldo—July 11, 1988

We taped the show on Flag Day [June 14], so I wore one of my flag outfits. We were billed as *Corporate Call Girls*. The other women wore big wigs and dark glasses. Geraldo was friendly and treated us respectfully. When I told him I was a performance artist he asked me to sing. I complied with a folk tune I wrote: "A better job, a better job, everybody's waitin' cause they're gonna get a better job. I ain't complaining cause I'm gonna get a better job..."

Access America with Fred Willard—August 14, 1992

I produced various shows in public access television for over ten years. An episode of "Sex and Sports" produced by Scarlot Harlot and the TWITS was featured on this Comedy Channel public access series.

Video still, Scarlot with Fred Willard on *Access America*, 1992

The Donahue Show—March 1994

Guests included District Attorney Terence Hallinan, Diane Feinstein's daughter, Katherine and Mike Fluke from Save Our Streets. We discussed the mission of the San Francisco Task Force on Prostitution.

Donahue: Carol Leigh, You're proud of what you do.

Carol Leigh: As a matter of fact I am.

Donahue: You want to push decriminalization, but you're against this idea of barracks.

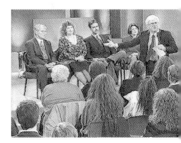

Video still, San Francisco Task Force on Prostitution on *Donahue*, 1994

Carol Leigh:	Well, women in San Francisco are sort of embarrassed about this talk of locking prostitutes up in barracks.
Donahue:	Not locking.
Carol Leigh:	Well, not locking, but, in Nevada, where it is legal, prostitutes are not allowed to leave the premises. They are not allowed to vote in the town where they work and we're concerned with some of the kinds of legislation that goes along with legalization. So we would like the laws against contractual consensual adult sex repealed. We think they are unconstitutional, anyway.
Donahue:	Are you going to have any hookers on this commission?
Terence Hallinan:	There are going to be . . . well, I can only say ex-hookers on this commission.
Carol Leigh:	It's not fair to say that there won't be any sex workers on the commission. People aren't going to go into our bedrooms to see what they are doing.
Donahue:	Let's understand your position here: Decriminalization would make it easier to work out of your house, work without a pimp; it would also take women off the street. There's better money and better working conditions if you can do this without fear of being arrested in your own home. Let's see what someone in our home audience thinks.
Caller:	Every prostitute is a disgrace to women. I think you're sick!
Donahue:	The issue is not about who you think is sick. It's about an activity that all of us have to admit is not going to ever go away. How much money do you want to spend? How wasteful is it? It's about what a progressive city like San Francisco, that may wind up leading the way, is going to do about hookers.

Video stills, left and center, Carol and Phil on *The Donahue Show;* right, backstage with Phil, 1994

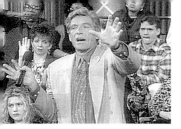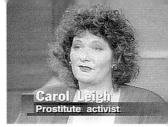

Video stills, Carol Leigh with madams Rebecca Rand and Cherie Woods on *Maury Povich,* 1994

Maury Povich—April 21, 1994

The theme is a bizarre juxtaposition of bad cops, prostitution and family values. The guests were lured on the show to address their serious allegations of police misconduct. Rebecca Rand and Cherie Woods are both mothers. Cherie bills herself as "The Real Hollywood Madam" and promoted her book which details police abuse and Hollywood scandal.

Cherie: There's so much hypocrisy. The police were also breaking the law. They came in and had sex with the girls and arrested them after the fact.

Povich: How did the business treat you? Was it good to you?

Cherie: It was great! I was very successful, more than Heidi Fleiss.

Woman in Audience: It sounds like you have a case of green envy. Her notoriety is not respectable and we are not going to respect you for coming out with this. (The audience screams with glee.)

Cherie: It wasn't my lifestyle that hurt my family. It was the police. She was a premature infant, and the cops took her from me when they arrested me. She died when they left her alone in the back of the police station.

Rebecca: I have two kids. My daughter is an attorney. Any pain that has happened to my family has been through the criminal justice system.

Povich: But what about the families? Would you want your daughter to do this?

Rebecca: When a person is an adult I think they should have the right to make their own decision about consensual adult sex. I don't think the rest of us get a vote.

Carol Leigh: Millions of women work all over the world as prostitutes. Millions of women are supporting whole families, extended families. We are looking at it in a narrow way on this show. If some people have a judgmental attitude there's nothing I can say, but opening our hearts to the situation for these women might be a good place to start.

Video still, Scarlot Harlot on *Montel Williams*, 1995

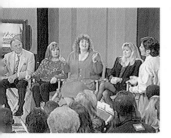

Video still from *Geraldo*, 1997. Daryl Gates is on left.

Video stills from *20/20*, 1999.
Guests included Carol Leigh,
Teri Goodson, Norma Jean Almodovar,
Vic St. Blaise, Victoria Schneider
and other incognito sex workers.

Montel Williams—March 18, 1995

The producers told us to dress wildly and be as outrageous as possible. They promised that this show would be a positive environment where we could express our pride. Then they surprised us by bringing on a sobbing older woman who just found out that her husband of 50 years visits prostitutes. He spent all their money and abandoned her. No thanks, Montel.

Geraldo—June 18, 1997

This show was decidedly anti-prostitution featuring former L.A. Police Chief Daryl Gates. I was sandwiched between Lois Lee from Children of The Night and Cherie Woods. There were 20 guests, including a 17 year-old prostitute told us that she felt safe because she carried a gun. In the heat of the moment, I defended her. I advocated decriminalization of adult prostitution within this shouting match. Daryl Gates provided the feminist rhetoric.

ABC 20/20—June 1999

John Stossel produced a pro-sex worker segment from a libertarian point of view. Every sex worker activist in San Francisco agreed to do the segment. We were generally pleased with the results. However, Victoria Schneider[13] complained that Stossel's producer shared her "off-the-record" story with the police. Also featured were Cosi Fabian, Veronica Monet, Daisy Anarchy, Vic St. Blaise, Norma Jean Almodovar and several others in disguise.

Scarlot: I don't believe that police have the right to come into my bedroom and police what I do between the sheets.

The Roseanne Show—February 2000

My friend, Dee Dee Russell also appeared. Dee Dee told the producer about her comedy act: She pays men to strip on stage. The producer wrote it up for Roseanne.

Roseanne: Scarlot, what did it feel like the first time a man paid you to have sex? Was that good or bad?

Scarlot: What was good was that it was over really quick. (The audience screams.)

Roseanne: You think they'll ever legalize in Las Vegas?

Scarlot: Right, now it's only legal in nearby counties. I am mostly worried that they will shut the brothels down. There are problematic aspects to conditions and laws in Nevada, but I think it's important that we have some legal venues.

Xaviera Hollander, the Happy Hooker, is on the phone.

Roseanne: Do you have fun even though you are Jewish and a prostitute?

Xaviera: I am only half Jewish, darling. I only have half the hang ups and I'm not a prostitute for twenty years, anymore.

Roseanne: Do you have sex?

Xaviera: I'm tri-sexual. I'll try anything at least once. (The audience laughs.)

Roseanne: So how old are you now? About 70?

Xaviera: 56. How old are you?

Roseanne: What?

Xaviera: How old are you? Can we talk about weight or talk about age?

Roseanne: You gained a lot of weight.

Xaviera: Yeah, but you too at one time, didn't you?

Roseanne: I saw a picture of you. You were really, really large.

A few weeks later Xaviera wrote, "She is supposedly one of the more sympathetic interviewers. I can just imagine what the OTHER talk show hosts in the USA are like? It is the banality of the TV shows and the people in the audience, that seem handpicked for their stupidity, that irritate the living daylight out of me. Give me a sophisticated brainy in-depth interview with BBC, for instance, or Channel 4."[13]

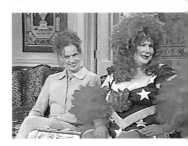

Video stills, *Roseanne*, 2000. Guests included Dee Dee Russell, Xaviera Hollander (on the phone) and sex worker/journalist Jen Lynn Sweet (who went Nevada to write a story about the brothels and wound up working there).

[13] Hollander, Xaviera. "include me out of roseanne barr shows." October 6, 1999. Online posting. Email list Whorenet.net

Strumpet Solo

I never made it to Austin, but I wrote lots of satiric songs and produced music videos. I was endlessly amused by the idea that I was supposed to be a "fallen woman"—and it was true! The abuse of plastic (credit cards) really did lead to my downfall.

Scarlot's Rising Sun
[Sung to the tune of "House of the Rising Sun"]

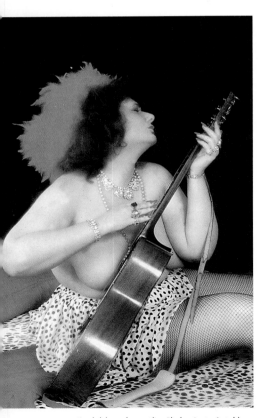

Scarlot loves her guitar. Photo: Annie Sprinkle

There is a bank in Illinois,
who'll give credit to anyone,
and it's been the ruin of many a poor
 girl,
and God, I know, I'm one.

They sent me Visa and Mastercard,
American Express and Diner's Club.
I sent them all my money cause
their statement matched my stub.

I never entered a lottery,
and so I never won.
Instead, I spent 10 years pleasuring
 the men,
for five minutes or until he would
 come, whichever was first.

I still send checks to Illinois,
and don't tell anyone.
They raised my credit limit. Oh boy!
I'm glad I'm not a nun.

Celebrity Hooker

[Lyrics & Music by Carol Leigh AKA Scarlot Harlot]

Everybody's gotta make a living.
You gotta pay your bills and drive a car.
Everybody's gotta get by somehow,
but my girl has gone too far

She's a celebrity hooker, celebrity hooker,
appearing on TV in every bar.
She's a celebrity hooker, celebrity hooker.
That's one way for a girl to be a star.

Not every woman's born to be a mother.
And we ain't had one yet for president.
I only wish my girl would find another
way to find herself and pay the rent.

I asked her once to marry me and move away from town.
The next day on the news I see, my proposal's been turned down

By a celebrity hooker, celebrity hooker,
appearing on TV in every bar.
She's a celebrity hooker, celebrity hooker.
That's one way for a girl to be a star.

[Musical break]

I never tell her what to do cause I'm a modern man.
I just can't get excited that they love her in Japan.

She's a celebrity hooker, celebrity hooker,
appearing on TV in every bar.
She's a celebrity hooker, celebrity hooker.
No autographs. No, I won't smoke your cigar.

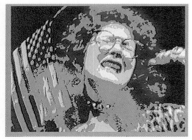

Video stills, *Safe Sex Slut* music video, 1987

Safe Sex Slut

{Lyrics & Music by Carol Leigh AKA Scarlot Harlot}

I won't become disease infected.
Me, I'll be so well protected.
I always pay my income tax.
I eat granola for my snacks.
I don't make fun of lumberjacks.
Or fuck with sheep that have anthrax.

Safe sex [4 times]
Any time of night or day.
Even with a Green Beret.
Safe sex.

I split the city, bought a Hyundai,
Drive across the bridge each Monday,
Fasten belts to stay alive,
I never drive past 55.
I watch TV. I don't hang glide.
I never drink insecticide.

Safe sex [4 times]
At the movies, in a car.
In a bathroom at a bar.
Safe sex.

I protest bombs and nuclear war.
Won't buy a house near Livermore.
I live just like a Mouseketeer.
I don't mess up the atmosphere.
The bedroom is the last frontier.
Condoms leave a souvenir.

Safe sex
Only nuns are safe, you see.
But no nuns will have sex with me.

Safe sex.

Diet Song

[Lyrics & Music by Carol Leigh AKA Scarlot Harlot]

I've taken drugs. I jogged. I tried the Cambridge Plan.
The Scarsdale was too hard and so I shot the man.
They say you're what you ate.
I know I am what I am.

I'm overweight.
Don't mean to start a riot.
Whoa, baby, I'm on a diet.

I'll cut the junk food, beer,
I'll live on sprouts and sex.
I'll soon be wearing
horizontal stripes and checks.
I'll fit in all my clothes
and I'll be less convex.

It's not too late.
Don't tell me.
Please be quiet.
Whoa baby, I'm on a diet.

I'll be thin enough
to fit in a Honda.
Of course I wanna
look like Jane Fonda.
I'll eat less so I'll be
more like the next chick.
Watch out, I'm going anorexic.

Photo: Michele Clement

Acting Up 1987-1991

My Speech Before the Senate Judiciary Committee

[Reprinted from *City Lights Review* #2, 1988.]

Gentlemen, there must be, I hope, one or two among you who is still sitting on the fence about the mandatory HIV testing of prostitutes. It's rare that prostitutes can speak for themselves on these matters. As a result, you couldn't exactly say we have much representation.

I am a prostitute. I provide safe sexual services to men exactly like yourselves. I know that most of you have brothers, cousins or golf partners who have partaken of the services of prostitutes. And then, there are those of you who have used our services. It's common practice to use us and discard us and our rights afterwards, so I can only appeal to your sense of justice and chivalry in hopes that you still have some conscience left after devoting yours lives to a career that is certainly more hypocritical and corrupt than my career.

As a working prostitute of ten years, I know that prostitutes use condoms. Without condoms sex is incredibly messy and was so even before AIDS.

Now, I have encountered disgusting clients who try to bully and insult me into having sex without a condom. Now I hear that you want to punish us for spreading a disease. Coercing or bribing a person into not using a condom could be a crime.

Many of you understand these hypocrisies, yet you believe that the punishment of prostitutes is an appropriate symbol and tactic.

Photo: Rick Gerharter

Some of you have confided to me that it's very important to ensure a clean pool of prostitutes because, after all, boys will be boys. This legislation is designed to ensure that there are clean women to use at the expense of those who will be quarantined.

It's common knowledge that police have sex with prostitutes, before they arrest us, and sometimes in exchange for lenience and protection. If you want to know if the prostitutes have AIDS, why not test the Vice Cops! This system sounds like an institutional form of rape to me.

Cheaper than arrests, cheaper than higher salaries for the rapists with badges, would be education, job training, dis-

Scarlot lobbies then Assembly Speaker Willie Brown at a demo organized by AIDS Action Pledge in the halls at the Capitol in Sacramento in 1988. "I would never scapegoat sex workers," Willie claimed. Photo: Rick Gerharter

ability payment, more IV drug recovery programs and a needle exchange.

Do you realize that black women, who represent a minority of prostitutes, are the ones who will be affected by this legislation? Although most prostitutes are white, 85% of those sentenced to jail are women of color. Poverty and drug addiction can force poor women into prostitution. The most vulnerable women, those who would be most affected, are those who have been raped as children, are now at the mercy of exploitative pimps, and are further victimized by the law and the police.

Your vote today will influence the tide of the nation about the registry and quarantine of victims of the AIDS crisis. I must implore you gentlemen, hesitate before allowing such legislation to sweep the country. I implore you to do what you can to stop a dangerous situation and act courageously.

The most basic compassion and recognition of our rights should prevent your passing this bill, which in my mind, would be a far greater crime than any blow job I've ever given.

Bad Laws

[Sung to the tune of "Bad Girls," a 1978 disco hit performed by Donna Summer.]

See them doing it in broad daylight,
hoping they don't catch the latest blight.
They don't get laid 'cause their butts are too tight,
and so they make it a crime.

You ask yourself,
"Just who do they think they are?"
They come from California, Quebec or Dakar
and they make bad laws, bad laws,
after they had a good time.

Monday morning, it's time to vote.
He owes a favor for the bill he wrote.
And so he offers up the old scapegoat.
He say's you're gonna do time.

You ask yourself,
"Just who do they think they are?"
And while you're wondering they've passed legislation
that imprisons prostitutes for the rest of their lives
statistically speaking, if we are HIV positive.

Bad laws, bad laws,
all they do is add laws.
Bad laws, bad laws,
they-just-make-us-mad laws!

You and me, we're both the same,
except you're a guy and I'm a dame.
I hate to say it but I think you're lame.
You hypocritical slime!

I circulated this flyer when I performed "Bad Laws" to explain a complicated situation. Willie Brown was being challenged from within the Democratic party by five Democrats. He badly needed to pass some sort of law, so he chose this issue. (Anti-prostitution laws are easy to pass, winning the support of both parties.) The local newspapers reported the saga of the passage of this legislation focusing on the power struggles involved with the "Gang of Five," rather than on the legislation.

You ask yourself,

"Just who do they think they are?"

They wanna all be big shots and make payments on their cars,

so they make bad laws,

bad, bad, bad, bad laws.

Now I tell you what I'm gonna do.

I'm gonna get myself a new tattoo,

says "Let your government die for you."

Cause they make bad laws!

Lock your date in quarantine?

Look who's talking, Mr. Clean.

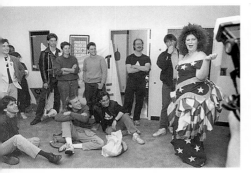
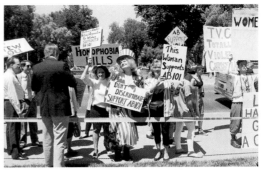

Entertaining the troops— ACT UP lobbies Senator Cranston, 1990. Photo: Rick Gerharter

Scarlot, Mickey Demerest and Bobby Lilly support antidiscrimination bill, AB 101, 1990. Photo: Kat Sunlove

Stop the Quarantine

In 1986 I joined Citizens for Medical Justice, precursor to the AIDS Action Pledge, precursor to ACT UP in San Francisco. I was welcomed into this community where I learned how to organize non-violent civil disobedience. I organized protests and rallies with the broader community of AIDS activists. I educated fellow activists about prostitutes' issues and I began advocating for prisoners. Prostitutes and prisoners were similarly threatened by proposals for testing and quarantine.

In the early '80s, COYOTE helped launch CAL-PEP (California Prostitutes' Prevention Education Project), which was one of the first models for peer advocacy and outreach. In Australia and Canada, sex workers organized HIV prevention services for their communities. I began working with sex workers in these health service projects, developing a political agenda that could address the onslaught of punitive legislation that *all* of these communities were facing.

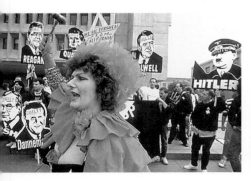
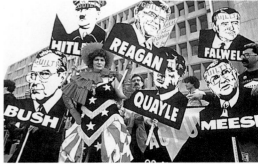

In 1988 ACT UP converged on Washington in the first large-scale national AIDS action at the FDA headquarters, protesting the indifferent federal response to the AIDS crisis. Photos: Marc Geller

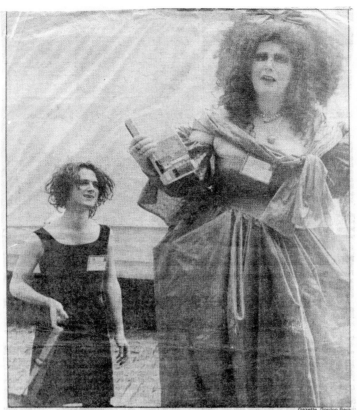

Singing prostitute Carol Leigh of San Francisco performs a number at conference.

Friday, June 9, 1989

Unhappy hookers slam meeting

Montreal

Photo: Gordon Beck, *Montreal Gazette*

Unhappy Hookers Slam Meeting

Montreal Gazette, June 9, 1989

"Singing Prostitute Carol Leigh of San Francisco performs a number at conference . . . Calling out prices and encouraging delegates to 'get it while it's hot' four prostitutes briefly joined the drug and condom companies plying their wares at the 5th International Conference on AIDS yesterday. 'Vaginal Intercourse with a condom, $100,' yelled San Francisco prostitute, Carol Leigh . . . The demonstrators said they are being made scapegoats by scientists and politicians who claim prostitutes are likely to spread AIDS.

'If it were true half the government would be dead already,' said Toronto prostitute Valerie Scott."

—Paul Wells

Arrested

For Immediate Release

Outlaw Poverty, Not Prostitutes—June 22, 1990

Contact:	Carol Leigh
11:30 am:	gather at 4th and Market St.
Noon:	March toward Moscone center, rally with speakers on women and AIDS
12:30:	Street Theater Civil Disobedience is anticipated during the protest.

Although prostitutes are targeted and scapegoated in the AIDS crisis, US immigration laws prohibit participation at the AIDS conference by prostitutes as they are not permitted to enter this country.

"The United States has laws which bar anyone who has ever been a prostitute from entering this country, remaining in this country as a resident or becoming a citizen . . ."

Priscilla Alexander
The National Task Force on Prostitution

Prostitutes are systematically denied citizenship status in almost every country as we are prohibited from traveling, from residing with friends or relatives (as our associates may be charged with pimping) and denied police protection from rape and other crimes against us as a result of our legal status. At the same time governments have instituted mandatory HIV testing and quarantine of HIV+ prostitutes in a majority of countries, controlling women through systems of compulsory health checks which do nothing to stop the spread of the disease. Studies in the west corroborate the lack of evidence of transmission of HIV from prostitutes to clients, yet prostitutes are scapegoated, and our civil liberties are violated for the ostensible purpose of public health.

HEALTH AND BEHAVIOR

Hope mixes with AIDS discord

By Kim Painter
USA TODAY

SAN FRANCISCO — Scientists and activists leave the Sixth International Conference on AIDS in an uneasy truce.

At least 300 activists were arrested during well-choreographed street demonstrations through the week. But the violence some anticipated never happened.

Sunday, activists shouted down a speech by Louis Sullivan, secretary of health and human services. Yet many scientists and activists left the meeting insisting a new era of cooperation for better AIDS care and research had begun.

That was the theme Saturday, as hundreds of delegates — physicians, nurses, scientists, educators — joined thousands of activists and supporters in a "unity march."

By Eric Risberg, AP

ALL FOR ONE: Thousands of AIDS activists march in San Francisco Saturday with hundreds of delegates from the Sixth International Conference on AIDS in a call for improved research and care.

"We're making progress on all fronts, but let me tell you, this is the breakthrough. We're working together," conference chairman John Ziegler told the throng at at a post-march rally.

"As long as we're listened to and as long as we get participation in the process, we don't want to make trouble. As soon as that stops, we'll be back out on the streets," says Robin Haueter of AIDS Coalition to Unleash Power. Some ACT UP members left Saturday's march to demonstrate at a pharmaceutical company's display at Moscone Convention Center. And on Sunday, they turned their anger at the Bush administration on Sullivan.

This came after a week of street theater. Activists drew neon chalk bodies on sidewalks to dramatize AIDS deaths, plastered the city with trademark Silence = Death stickers and stormed government buildings to protest AIDS policies.

But they also were much in evidence inside the conference, sometimes sharing podiums with their adversaries. The most dramatic encounter came when San Francisco activist Martin Delaney announced promising results from an unorthodox trial of the drug Compound Q.

Arnold Relman, editor of the *New England Journal of Medicine,* called Delaney irresponsible for possibly giving AIDS patients false hope with unscientific, unverified data.

But more typical was a community meeting the same night, where activists and scientists reviewed progress and problems in getting promising drugs to more patients.

The head of government AIDS research, Anthony Fauci of the National Institute of Allergy and Infectious Diseases, was at that meeting.

Sunday, he acknowledged the activists in his address to delegates: "They do have something important to say ... When it comes to clinical (drug) trials, some of them are better informed than many scientists can imagine. Yet, they are sometimes incorrect."

And activists still believe scientists and government officials are sometimes incorrect — in the drugs they choose to study, in the money they spend and in the pace of progress.

Delaney says, "There's been progress, but I'm still burying my friends."

▶ **More on session: 1A, 1D**

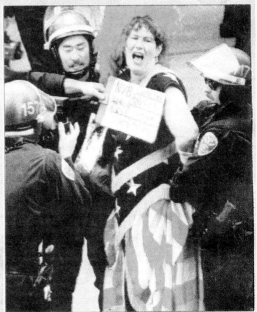

By Dan Groshong, UPI

ARREST: Carol Leigh of San Francisco was taken into custody Friday while protesting exclusion of women from AIDS programs.

Pope, Don't Preach, I'm Terminating My Pregnancy

[Lyrics by Carol Leigh AKA Scarlot Harlot, based on the song, *Papa Don't Preach (I'm keeping my baby)*, by Brian Elliot and Madonna]

First performed at a fundraiser for the Pope's visit held by Mayor Diane Feinstein on July 23, 1987, where, according to the San Francisco Sentinel (July 31, 1987), Scarlot Harlot and The Whores of Babylon, Sadie, Sadie the Rabbi Lady, the Sisters of Perpetual Indulgence and Gilbert Baker, "the Betsy Ross of the gay community,"[14] joined with Holocaust survivors, gay activists and feminists to protest the policies of the Catholic Church.

Pope, I guess you know that we're upset,
About your influence on the world.
You're homophobic, pal, and you're friends with a Nazi.
And women all around the world are dying all of the time,
Because they have to get their abortions in alleys.

By the way, this body's mine.
What I'm doing ain't a crime.
It just doesn't fit with your dogmatic principles.

Pope, don't preach, you're in trouble deep.
Pope, don't preach, I hope you're not losing sleep.
I made up my mind, I'm terminating my pregnancy.
I'm gonna terminate my pregnancy.

We are the daughters and the wives,
You don't care much for our lives. I refuse to be a sacrifice.
So, for safety and for birth control,
I'll use condoms and nonoxynol.
I would die if I took your good advice.

[14] I first met Gilbert Baker, creator of the Rainbow Flag, at this event and we continue to collaborate. Baker was one of the original Sisters of Perpetual Indulgence.

Pope, don't preach, you're in trouble deep.
Pope, don't preach, I hope you're not losing sleep.
I made up my mind, I'm terminating my pregnancy.
I'm gonna terminate my pregnancy.

So, don't forget, this body's mine.
Your patriarchy's on decline.
We have had enough of your misogynist theology.

Pope, don't preach, you're in trouble deep.
Pope, don't preach, I hope you're not losing sleep.
I made up my mind, I'm terminating my pregnancy.
I'm gonna terminate my pregnancy.

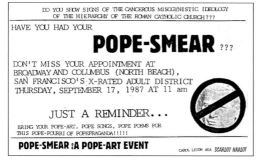
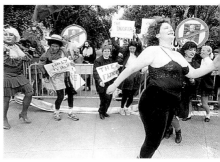

A series of theatrical protests during the Pope's visit in September, 1987, orchestrated by Sister Chanel 2001 (Gilbert Baker), Sister Sadie, Sadie The Rabbi Lady (Gil Block), Whitefeather (C. Whitefeather Daniels) and Scarlot Harlot

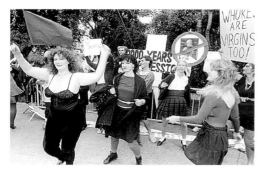
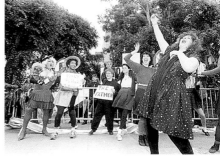

Scarlot and the Whores of Babylon sing in front of Diane Feinstein's house. Photos: Marc Geller

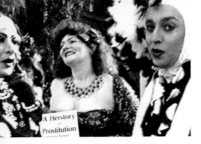

Video still from *Xmas Anti-Special*. Sister Sadie, Scarlot Harlot and Sister Chanel 2001.

Christmas in The Castro with The Sisters of Perpetual Indulgence, Unincorporated 1987

[Reprinted from Gil Block's *Confessions of a Jewish Nun*, Fog City Press, San Francisco, 1999.]

Scarlot: I've been reading this new book, *The Herstory of Prostitution*, and it seems like the Roman Catholic Church, actually the foundation, financially, was built on sex. Prostitutes. Women's bodies. So, I thought it would be nice to pay them a visit. I'm anxious to tell them of the obligation they now owe to us because of our sex money having funded them.

Chanel: Would you explain that? I never heard of this before.

Scarlot: Actually, many, many bishops owned brothels. In the 1100s, the 1200s. This lasted for five hundred years. It was common practice that prostitutes would have sex and give most of their money to the Church.

Chanel: Are you saying they paid for the Vatican?

Scarlot: Yes. Did you know that they would put them in little convents and make them wear nuns' outfits and call them nuns so that nobody noticed?

Chanel: Concubines.

Scarlot: Exactly.

Chanel: Sounds like slavery, not sisterhood at all.

Scarlot: It's very sad and we want to tell the whole world.

Sadie: You know, I keep listening to our Mary Magdalene, Scarlot Harlot, and I learn so much from her. Isn't it interesting that after all those hundreds and hundreds and hundreds of years doing things one way, the Church has been able to grow to this massive degree by condemning just those very things. Well, we're hoping that they'll continue that progression and remember that way in the past when they

first started to condemn people who loved each other, who happened to be of the same gender sometimes, that after all those centuries, maybe this time they'll learn to overcome that one, too, and grow even more!

Chanel: Do you really think the church is going to change at all? Get real. They haven't changed for a thousand years. The Congregation of the Doctrine of Faith (The Inquisition) calls homosexuality a moral evil. Now that just came out a year ago. They just finally got around to forgiving Galileo after 400 years. Finally they said, okay, maybe we were wrong, we won't let him rot in hell as a heretic.

Scarlot: Well, why not go out and tell the world!

Chanel: We have to reclaim Christianity for Christians and stop this campaign of hatred and lies and bigotry that's been going on for two thousand years! It's time for the spirit of Christ to come out and for people to love each other not about all this hatred, not about their goddamn Dress Code.

Sadie: Well, they got gowns; we got gowns. But, you know, over all those years, we weren't always here. Well, we were but we weren't free to speak out. But now we are and others are joining us all the time.

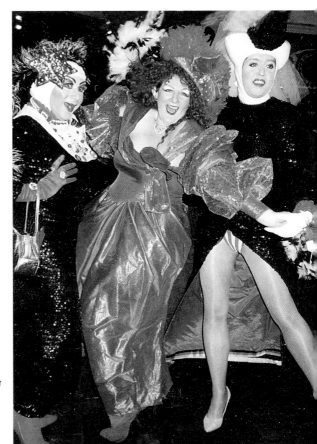

Photo: Augusta Glasser

Come Out Hollywood: You Can't Be Too Fabulous

Sadie, Chanel and I drove down to Los Angeles to attend the Academy Awards in 1989. Our theatrical romp was reported by the Los Angeles Times.

Oscar Fans Put On a Show of Their Own at Shrine

By CLAUDIA PU
Times Staff Write

Oscar show producer Allan Carr would have been proud of some of the folks gathered for hours outside the Shrine Auditorium Wednesday.

Although most of the more than 3,000 star-gazers jamming the grandstands outside the theater's entrance had come to catch a glimpse of the glitzy 61st annual Academy Awards festivities, some made efforts to embody the glamour themselves.

In front-row bleacher seats, three San Franciscans came decked out in elaborate period costumes a la "Dangerous Liaisons," and two young women spent the sunny day in shorts, only to don blue evening gowns just before the stars began making their entrances up the red carpet.

Two men dressed in drag— "Dangerous Liaisons" style—pronounced themselves members of "Allan Carr's fan club." Saying they represented a group called "Come Out Hollywood," the men— accompanied by a woman who called herself the Scarlet Harlot and was dressed in red 18th-Century finery—had arrived at 6 a.m. and spent most of the morning gussying up.

"You can't be too fabulous," said one of the men, who identified himself as Sister Chanel 2001.

In previous years, the trio had made a practice of coming to Oscar shows dressed as nuns with the moniker, "Sisters of Perpetual Indulgence."

Some of their fellow spectators agreed that the promise of a return to star-studded glamour had enticed them there.

*Two
"Sca*

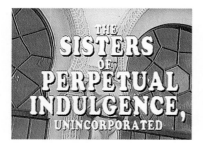

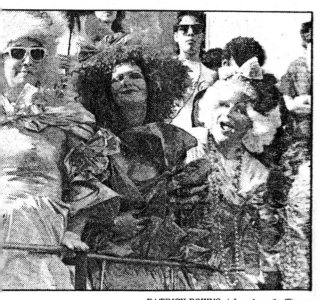

Los Angeles Times

Thursday, March 30, 1989

PATRICK DOWNS / Los Angeles Times

d *"Dangerous Liaisons"-style, flanked by friend
"You can't be too fabulous,"* said one of the men.

Below: Video stills from
Come Out, Hollywood!, 1989

 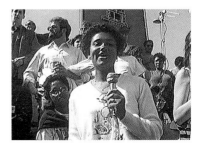

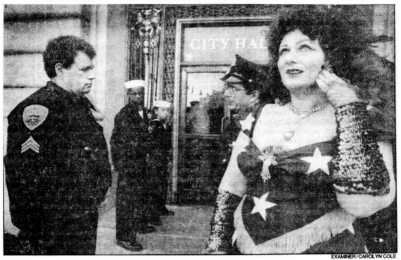

EXAMINER/CAROLYN COLE

Fleet Week at City Hall

"One wonders what goes through the mind of a young sailor from, say, the Midwest when the gangway goes down and he finds himself on liberty in San Francisco. And when this fresh-faced young fellow arrives at the mayor's Fleet Week reception at City Hall, he is greeted by a person known as Scarlet Harlot, who says she is there to 'welcome the boys home from the sea.' Toto, we are definitely not in Kansas anymore."

—From "Liberty and Justice For All," *San Francisco Examiner*, October 19, 1988. Photo: Carolyn Cole

As the Betsy Ross of San Francisco, Gilbert Baker was commissioned to decorate City Hall and provide the best trappings for the mayor's parties. This year Mayor Jordan hosted a bash at City Hall for Fleet Week. Gilbert assembled a team of decorators including Whitefeather, Sadie (and most of the people who lived at Dennis Peron's house) to hang the banners. As Sadie writes, "Charlotte Malliard, Mayor Jordan's Chief of Protocol, threw a fit when she saw Sadie entering and with Scarlot Harlot (Carol Leigh) in tow. We were all decked out in Americana high drag.[15] I can imagine the buzz in the mayor's office when they saw this photo and caption in the *Examiner* the next day."

[15] Block, Gil. *Confessions of a Jewish Nun*, Fog City Press, San Francisco, 1999.

 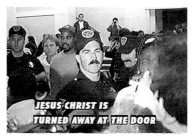

Video stills from *Spiritual Warfare: The GHOST Campaign*.. Top: Pink Jesus rolls a joint; Sadie and Jesus attempt to enter Larry Lea's Prayer Vigil. Bottom: Sadie reads about us in the Chronicle; the police block the entrance.

Spiritual Warfare: The G.H.O.S.T. Campaign
[Grand Homosexual Outrage at Sickening Televangelists]

"We're here! We're queer! And we're not going to church!" the crowd chants. "Bring back the lions!"

Scarlot: The harlots will get into heaven before the tax collectors and the hypocrites. I have come before you tonight because I had a vision. At 12:15 Larry Lea will walk out of that auditorium and come here and profilgate himself at my feet. He knows that I am a whore and he sees the divine whore of the whore goddess.

Larry Lea: Scarlot, Scarlot, I believe in the goddess. Take me into the folds of you. Take me into your church.

Scarlot: Yes, that's right, I am the goddess. See my divine light.

Larry Lea: Take me, I am yours, I give up Jesus.

Scarlot: Yes, of course, that's $162.75 with tax, but will it be Visa or MasterCard?

The crowd chants, "The people, perverted, will never be converted! No more witch hunts!"

Die Yuppie Scum

Die Yuppie Scum documents the 1988 Anarchist Conference in San Francisco, featuring the aftermath of the Berkeley riots. Generations of San Francisco activists discuss varied definitions of anarchy. Sex workers are abundantly represented. *Die Yuppie Scum* was widely screened at festivals and won several awards.

"Right now, it's a quarter of five. There's an orgy on the third floor called Wild Sensuality, a playful celebration of the senses," reports Rob Tofu. "It's not billed as an orgy, but it's pretty free form, and people are expected to get naked, and they're supplying condoms so that gives you a clue, but they're not going to let me tape that, so I'll go to TV: Totalitarian Technology."

The Blue Vulva Underground sing, "Drip drip drip drip, I wanna be menstruating." The title of the movie is taken from a song written and performed by the Yeastie Girlz, "You live in ostentation. You love gentrification. It's financial masturbation. Die Yuppie Scum. Your greed, your one-track mind, your quest for money makes you blind, to the problems facing humankind. Hope you choke on your cocaine and wine. Die Yuppie Scum!"

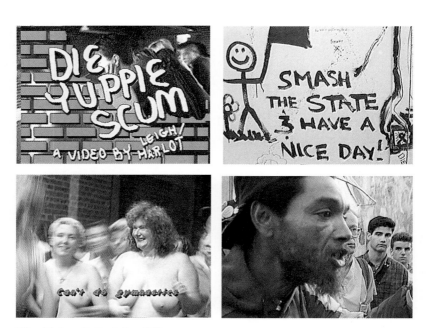

Video stills from *Die Yuppie Scum, 1988*

Video stills from *The Sisters of Perpetual Indulgence do The Star Spangled Banner, 1988*

Star Spangled Banner

Sadie, Sadie the Rabbi Lady, Sister Chanel 2001, Sean Dirks and I produced an anti-war version of the Star Spangled Banner, which we hoped to feature as a "public access" television station sign off. We dressed up in flagwear designed by Chanel (Gilbert Baker) and went to the military graveyard on May 30th, 1988. Gilbert knew the area well as he had been stationed at the Presidio Base in the 1970s.

We were stopped by the military police and detained (not actually arrested, or so they told us). The following is excerpted from the official police report:

> "Three of the individuals were dressed in American Flags which were made (sown) [sic] from the U.S. Flag. Two of those dressed in flag dresses were men. They had make-up on and white wigs such as a lady would wear. The third person dressed in the U.S. flag dress appeared to be a female but acted very strangely. In my opinion this person was/or used to be a man. [That's me, Scarlot Harlot!] Another man was carrying a camera and stating that they were making a movie to promote "FACISM" [sic] and freedom of speech. [They got that wrong.] . . . We did tell them that they were dis-grassing [sic] the United States Flag and that many men had lost their lives to defend that flag that they were so fashionably wearing."

Ultimately, the police let us go and we managed to finish shooting our movie. Our video was well-received, appearing at the Flag 1990 Annual Exhibition at the San Francisco Art Institute among other venues, although it has not yet become a popular patriotic station sign off.

Miss Haight Ashbury Beauty Pageant

Influenced by local comedians like Whoopi Goldberg, Jane Dorknacker, Dee Dee Russell and Nora Dunn, I created characters for my comedy act. Marabell Lee, lady steer wrestler, was a finalist in the 1986 Miss Haight Ashbury Beauty Pageant. The following year I went topless—as Scarlot Harlot. The Miss Haight Ashbury Beauty Pageant was billed as a contest with "virtually no rules."

September 27, 1987

David Armstrong from the *San Francisco Examiner* reports: "Third place entry Scarlot Harlot, who described herself as a sex worker representing COYOTE, the prostitutes' union, went topless in the swimsuit competition and sang a rock protest song called *Pope Don't Preach*. Although the event is produced in the spirit of fun, there were several serious moments. Scarlot Harlot's song about the pope was touched with awkward genuine anger . . ."

In 1987 actress Diane Amos won runner-up.

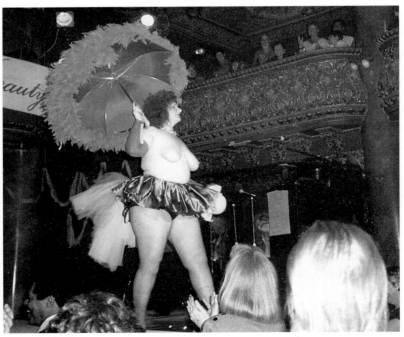

Scarlot at Great American Music Hall in *Miss Haight Ashbury Beauty Pageant,* 1987

My name is Marabell Lee
and I'm a lady
steer wrestler.
If I win
I promise
to bring more
steer wrestling to
Haight Ashbury.

It ain't a pig.
It ain't a cow.
It ain't a horse.
It ain't a mule.
It ain't a crocodile.
It ain't an antelope.
It ain't a parakeet.
It ain't a worm.
It ain't a penguin.
It ain't a caterpillar.
It ain't a ostrich.
It ain't a frog.
It ain't a vegetable.
It ain't a loaf of bread.
It ain't a volcano.
It ain't a termite.
It ain't a toaster oven.
It ain't a
net TV dinner.
It ain't tampax.
It ain't a douche.
It ain't a ticket
to the Monkees.
It ain't an
insurance policy
against earthquake.
It ain't million dollars.
It ain't an ant.

Jesse Helms' Nasty Ass Nieces

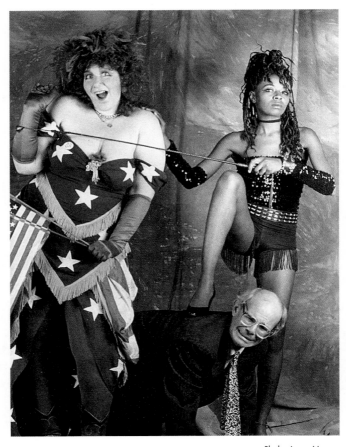

Photo: Laura Wagner

Scarlot Harlot's Nude Flag Burning

Jesse Helms, played by Stoney Burke, visits San Francisco and finds himself drunk, in the Castro.

"I need a woman," Helms whines, desperate to prove his masculinity.

"This sounds like a job for Scarlot Harlot," says Scarlot as she walks onto the stage at DNA Lounge. "Wait a minute! I know what you like!"

Scarlot pulls out an American flag and a lighter. Helms hands her a pocket full of money and Scarlot sets fire to the flag. Jesse is very aroused, and tears off Scarlot's dress. As the flag burns, Scarlot is completely naked!

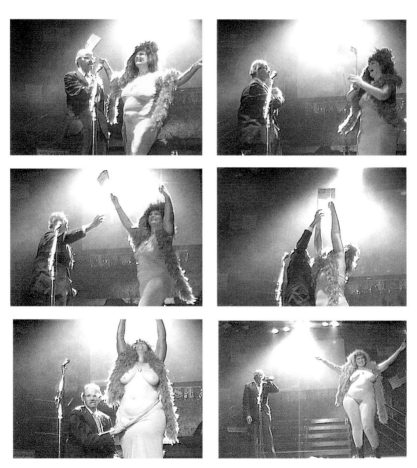

Video stills, Scarlot performs nude flag burning in *Jesse Helms' Nasty Ass Nieces,* 1990

Power Whore 1991–2001

In the '90s the new generation of sex radical feminist prostitutes found each other in San Francisco. COYOTE, led by Samantha Miller, started to hold regular meetings and produced a weekly TV show. I began organizing street demonstrations with other sex workers including Teri Goodson, Vic St. Blaise, Victoria Schneider and long time activists like Daisy Anarchy. Repressive new laws were proposed each year, such as legislation making it a crime to loiter with the intent to do prostitution. The "women's community" primarily responded by telling us that they weren't sure if prostitution was really a choice . . . whatever that had to do with the latest anti-loitering laws.

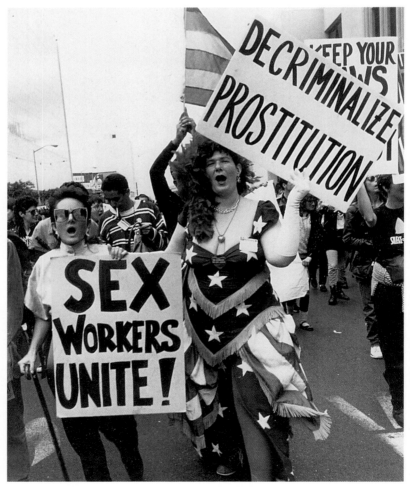

Prostitutes and supporters protest during the 1990
International AIDS conference. Photo: Tracy Mostovoy

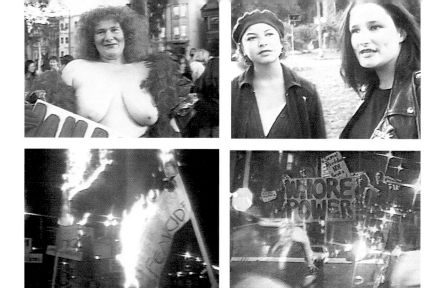

Video stills, *Sex Workers Take Back The Night,* 1990

Sex Workers Take Back The Night

I revisited this historic turning point in whore history in a documentary about San Francisco's December 1990 Take Back the Night march.

"A lot of us are nervous that Take Back the Night has a history of, uh, not supporting prostitutes, so what do you think?" Scarlot asks.

"We came here to say that we are sex positive sex workers. We are not getting coerced into it, and it's a fun, if only part time living for us. Censorship in the name of protecting women isn't actually protection at all. In fact, when it's done in the guise of protecting women against violent sexual imagery, a lot gets cut out, including women's sexual voices. There's a groundswell of feminist-produced pornography that's also getting silenced," replies Lily Burana, who later went on to write *Strip City.*

Another woman adds, "When you say something is degrading to women, it puts women in a really weak position. I don't believe that being naked in front of people is degrading."

"Well I feel degraded constantly in this culture, being fat, and I am 40. Life is one big degradation. For me prostitution has expressed aspects of that," replies Scarlot. "What's the hardest thing about the whole *schtick?*"

The hardest thing about the whole *schtick* is when people say that this is degrading to women. My mother said that to me, and I was really torn about it, but I realized that you are only degraded if you buy into those values, if you allow yourself to be degraded."

Art, Prostitution, Free Speech Form a Bizarre Brew at a Rally

BY THE NEWS DESK

One of the nation's most outspoken prostitutes, dressed in a gown made of the American flag, stood brazenly at the foot of the Wall Street statue of George Washington yesterday and solicited sex from wide-eyed stockbrokers in an act of civil disobedience.

A press kit handed out yesterday said Scarlot Harlot, a.k.a. Carol Leigh, a buxom performance artist and prostitute from Berkeley, Calif., "currently performs nude flag burning in the cabaret musical *Jesse Helms' Nasty Nieces*," and has appeared in two musical satires *Safe Sex Slut*," and "*Pope, Don't Preach, I'm Terminating My Pregnancy*."

"Sex workers are healing people," she said in the heart of the financial district, calling her activity "an adventure in free enterprise."

Police, present for what Leigh called a "performance art" protest, did not arrest her for solicitation.

Those assembled for the protest included members of the AIDS Coalition to Unleash Power (ACT UP), a homosexual activist group; Prostitutes of New York (PONY); a sadomasochistic dominatrix, and Annie Sprinkle, the porn star and performance artist, whose sexually explicit performance at the government-funded Kitchen theater last January touched off a congressional battle over obscene art and funding for the National Endowment for the Arts (NEA).

"I provide safe sex for sale, and I'm offering intercourse with a condom for $200," Leigh announced at half past noon.

"Did you know it is a misdemeanor to exchange sex for money?" asked the prostitutes' rights activist, who says she has sold her sexual services for over a decade.

Before she posed beneath the statue of the nation's first president, a crowd of Wall Street workers eating lunch on

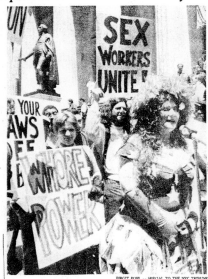

BIRGIT POHL. — SPECIAL TO THE NYC TRIBUNE

the steps of Federal Hall taunted her with lurid and loony remarks. However, when Leigh walked up the steps to the statue, the crowd scattered like pigeons, as news cameras followed in her wake.

"Most of you have cousins or brothers or golf partners who use the service of prostitutes, and we are being victimized by police and legislators" said Leigh, who called on the assembled crowd to "support your local hooker."

"I want to remind you to have compassion for prostitutes and let you know that we need prostitution legalized," she announced.

Leigh, who is a member of the National Task Force on Prostitution, said legalization would end the economic exploitation of women by pimps and end abuse by corrupt police officers who, she said, "rape" women who make money by selling their bodies.

Gary Johnson, the gubernatorial candidate for the Libertarian Party, which supports the decriminalization of prostitution, attended the performance, as did some clients of the assembled "sex workers." But others in the crowd were angered by the unusual event and screamed obscenities at Leigh.

"Pig," "slut," and other four-letter phrases were hurled at Leigh by passersby, and others simply shook their heads in disbelief. Some laughed, remarking that the protest must surely have been in jest.

Many men and women were visibly offended, and one man screamed loudly, "Take off that flag!", apparently outraged over the effort to wrap the unpopular, and illegal, cause of prostitution in the Stars and Stripes.

Protesters Not Joking

But Leigh and the members of PONY were not joking and said they were willing to go to jail in order to have prostitution decriminalized.

"I have ultimate jurisdiction over my body," shouted the Boston University-educated Berkleyite, who wore a button saying "keep your laws off my body" on her left breast.

"I am protesting State Penal Code 230 and I am defiantly offering" their sexual services, she proclaimed.

It is a misdemeanor in the state to solicit sex for payment, and Nevada is the only state in the Union with legal prostitution.

Johnson said he supported the decriminalization of prostitution but added "it is not my idea of an ideal career choice."

"It is ridiculous to outlaw sexual conduct" between consenting adults, he argued, saying that such laws are ineffective and actually keep the sexual profession out on the streets instead of indoors.

FRIDAY, MAY 25, 1990

Scarlot Harlot's Interstate Solicitation Tour

On May 24, 1990 Scarlot Harlot, along with members of ACT UP, PONY (Prostitutes of New York) and others joined together to protest prostitution criminalization at the financial heart of the nation, the New York Stock Exchange.

The street theater action became a stroll down Wall Street, interviewing hotdog gobbling businessmen and high school students.

"You can do what you want with your body," says one young woman. "It's a free country. If you want to make a living that way don't worry what anybody says. It's your prerogative."

Video still, *Interstate Solicitation Tour*, 1990. Hotdog-chomping New Yorker says he doesn't know or care about sex workers' rights.

Anti-Mapping

S.W.A.C. (Sex Workers' Action Coalition)

For Immediate Release

Event: Demonstration: Prostitutes and Supporters Oppose "Mapping"

Date: November 13,1992, Friday

Time and Place: San Francisco City Hall Steps at 1:00 PM

'Mapping,' is the term for the current plan by the San Francisco District Attorney to offer prostitutes reduced sentences through plea bargaining and as a condition of probation if prostitutes agree to stay out of certain 'zones' in San Francisco.

Efforts to utilize 'mapping' to discourage prostitution near Union Square, the Tenderloin and the Mission districts have been promoted by neighborhood and business organizations. This practice may be unconstitutional as it restricts prostitutes' right to travel and assemble. Arresting prostitutes in sweeps as public nuisances was recently declared unconstitutional. The proposed tactic, 'mapping,' is also a violation of our constitutional rights.

Obviously, 'mapping,' will be highly ineffective in curtailing street prostitution. Through 'mapping,' prostitutes will be arrested, detained and shuffled from neighborhood to neighborhood. This systematic attack on prostitutes is unjust and part of a general trend to disown the problems of disenfranchised groups by those unwilling to lend a helping hand.

Video still, Cynthia Sanchez from CAL-PEP protests "mapping" at San Francisco City Hall.

The public defender's office plans to challenge this practice on the basis that, although it is not uncommon to relinquish one's rights in the course of plea bargaining, the activities curtailed in plea bargaining arrangements must be directly related to the practice of the 'crime.' Insofar as prostitution may be practiced in any neighborhood, restricting prostitutes from a particular neighborhood is not in keeping with this requirement.

"PORN'IM'AGE'RY: Picturing Prostitutes"

In 1992 my video, *Outlaw Poverty, Not Prostitutes*, was part of an exhibit that was censored at University of Michigan Law School. This was ironic to me because I made this movie especially for students: there was no sex, no explicit dialogue, just talk about prostitutes' rights.

I first became involved when the exhibit's curator, Carol Jacobsen, contacted me. As she describes in "Who's Afraid of the Big, Bad Sex Workers?" (*Exposure* magazine, Volume 29, Number 2/3), she was asked by the students to put an art exhibit together about prostitution for the conference, (ultimately titled) Prostitution: From Academia to Activism. She told the students that she was very hesitant because she knew that many prostitutes' perspectives would not be welcome. Catharine MacKinnon was on the faculty. The conference would, surely, be aligned with Professor MacKinnon's point of view. The students insisted that Jacobsen's work would be welcome.

Despite the students' assurances, Jacobsen's exhibit was censored after an "unfavorable review" by anti-porn elders including John Stoltenberg, as well as students of MacKinnon. According to Jacobsen's article, MacKinnon justi-

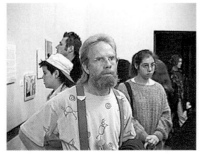
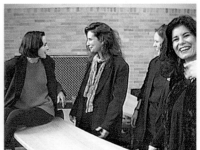

Video stills, reinstatement of PORN'IM'AGE'RY. Top, left to right: Carol Jacobsen; phone booth cards/sex ads strewn on floor. Bottom, left to right: exhibit attendees; Veronica Vera smiles.

from *Outlaw Poverty, Not Prostitutes,* video censored in PORN'IM'AGE'RY exhibit. From left to right: Gabriela Silva de Leite of Rede de Nacional des Prostitutas; Margo St. James of COYOTE; Gail Pheterson from the International Committee for Prostitutes' Rights; a slate from the World Charter for Prostitutes' Rights.

fied the banning of the exhibit, claiming that the artists and our supporters were were pimps. Fortunately, Jacobsen was outraged at this censorship and obtained the support of the ACLU.

I was outraged at the conference in general. How could a university present a conference about prostitution activism without including anyone from the prostitutes' rights movement? In fact, long-time activist Gail Pheterson explained to me that Kathleen Barry, another speaker at the Michigan conference, had long maintained that prostitutes should be excluded from speaking at conferences in these public forums. And this censorship is acceptable in the academy?! But this time they went too far . . .

Marjorie Heinz from the ACLU represented the artists and won. The University of Michigan Law School reinstated the exhibit in 1993.

At a forum held during the reinstatement, Carol Jacobsen explained the mood of the academy:

"Anti-porn feminists used to say we are not feminists. They can't get away with it anymore. It's too ludicrous, so now they call us liberal feminists. They are angry that we didn't go quietly into the night after they censored us. Because we are pornographers, they say, and pimps. The students say that. The students say that Marjorie Heinz from the ACLU is culpable because she represents criminals and prostitutes."

Jacobsen's refusal to allow the censorship of sex worker perspectives was an historic challenge and turning point. Newspaper headlines and academia acknowledged that we had been excluded, censored and given a bad rap. It was out in the open, a step toward the possibility of change.

School for Johns

The "John's School" (AKA the First Offender's Program) was first developed in San Francisco and has emerged, in various forms, around the world. Administered by the Police Department and the District Attorney's office, female police officers pose as prostitutes on street corners (offering great deals on sexual services), arrest suspected clients, then forward these names to the District Attorney's office. The District Attorney's office writes a letter to alleged client, asking for a fee of $500 and an agreement to attend a day-long educational session. In exchange, the District Attorney agrees not to prosecute their case. In fact, many or most of the cases lack the evidence that would make them "prosecutable." The alleged clients comply with this offer because of their fear of prosecution and embarrassment. If this practice sounds illegal and a violation of the rights of the alleged clients, many believe it is, but no one has yet brought forth a constitutional challenge.

As Canadian criminologist, Professor John Lowman of Simon Fraser University explains, "this trend to 'hold men accountable for prostitution' can be traced back to the late nineteenth and early twentieth century moral crusades, the crucible in which Canadian prostitution law was formed. . . ."[16] Lowman explains that the thrust of the John's School represents the current trend by some to cast the john as folk devil, male sexuality as a demon spirit.

In the all-day seminar the client is portrayed and pathologized as a sex-addicted nuisance. He is harassed and insulted by former prostitutes and anti-prostitution neighborhood group members. A San Francisco newspaper story quotes one ex-prostitute, "You're a f--ing scumbag!"[17] A TV news segment showed one ex-prostitute throwing an eraser at a client. Stipends are paid to these women, some of whom may still be working as prostitutes.[18]

Of course, *some* clients deserve insults and worse. The reality is that there is a range of men who use the services of prostitutes, many of whom are benign

[16] Lowman, J. "Prostitution Law Reform in Canada." *Toward Comparative Law in the 21st Century*, pp. 919-946. Edited by the Institute of Comparative Law in Japan. Tokyo: Chuo University Press, 1998.

[17] Minton, Torri, "School For Shame," *SF Chronicle*, December 8, 1998

[18] This was explained to me by one of my politically ambivalent friends. She worked as a prostitute and presented at the Johns' School during off-hours (against official policy, I'm sure).

and engage these services because they have few other options. The implication of this approach is that men should be either abstinent, married or "trying to score free sex" from dates. No thanks! Police would do better to spend their time hunting down and arresting violent predators.

Another skewed aspect of these programs is that John's Schools target only the male clients of female prostitutes. According to J. Marlowe, an activist from a Canadian sex workers' organization, SWAV (Sex Workers Alliance of Vancouver), "No male client of a male prostitute has gone through the program, nor has a female client of a male or female prostitute. This suggests that there is an underlying moral agenda to the program: female sexuality is something to be protected by the state, while male sexuality is something to be repressed by the individual. Such antiquated attitudes have no place in government-sponsored initiatives, and serve only to reinforce outdated stereotypes, which have traditionally served to deny women's sexual autonomy." [19]

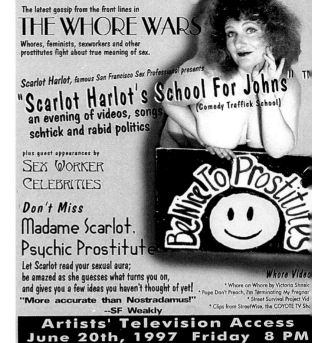

When johns are arrested for "communicating for the purpose of prostitution" with an undercover officer, they are given two choices:

1. Pay $500, sit through a lecture for a day, and most likely, never hear about this incident again, or;

2. Find a lawyer, agonize over the potential outcome of going to court, facing a judge and publicity, and possibly incurring a permanent criminal record.

Which would you choose?

[19] Marlowe,J.. "What's wrong with John's School?', Sex Workers of Vancouver website, http://www.walnet.org/csis/groups/swav/johnschool/johnschool.html, August1996.

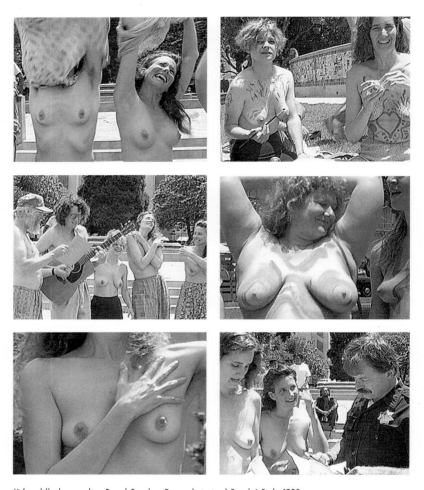

Video stills documenting Breast Freedom Day and picnic at People's Park, 1992

Breast Freedom

This was one of the annual top-free picnics at People's Park in Berkeley in June of 1992 by the X-Plicit Players, Debbie Moore, Nina and Bob Schultz, Marty Kent. Filmmaker Maria Beatty from New York also participated, among others. The police did not shut the event down. The Berkeley City Council tried twice (as of 2003) to construct a city ordinance banning nudity and bare female breasts in public; the first ordinance was found to be unconstitutional and the second has yet to be reviewed.

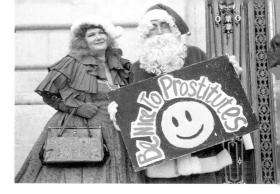

Gilbert Baker (as Santa) and Scarlot at Christmas
protest at City Hall in 1992. Photo: Jane P. Cleland

Fascist Laws Are Coming To Town

[medley to the tunes *Frosty, the Snowman* and *Santa Claus is Coming to Town*]

You better not think, you better not be.
And don't cross the street past a quarter to three.
Fascist laws are coming to town.

They're making a list, they'll put you on twice.
If you complain they'll call in the vice.
Fascist laws are coming to town.

They know if you've been bad or good.
They won't give you a break.
So they can keep their rentals up until the next earthquake.

Frosty the snowman,
May be dealing drugs.
But the War on Dope's just a racist plot,
Where the cops are cast as thugs.

You better not wave, you better not frown.
You better not note who's white and who's brown.
Fascist laws are coming to town.

You better not squint, you better not burp.
You better not or your rights they'll usurp.
Fascist laws are coming to town

They'll round up your relations,
And tap your telephone.
and if you aren't homeless yet,
they'll take away your home.

They call it "mapping."
They want to have a zone,
And they will find a place for you,
up there with the ozone
(and you know what's happening to the ozone layer!)

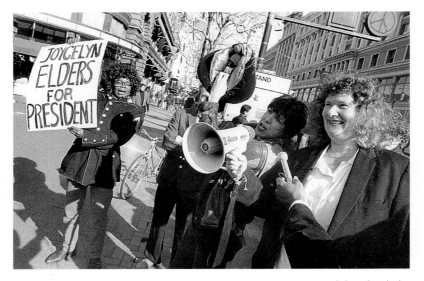

Photo: Rick Gerharter

Joycelyn Elders for President

In 1994 Dr. Joycelyn Elders was forced to resign her post as Surgeon General because she dared to suggest that masturbation might be a healthy practice. On December 21, 1994 San Francisco fans gathered to support Dr. Elders at the cable car turn around at Powell and Market. Dorrie Lane (from Vulva University) provided sex education with the aid of her Wondrous Vulva Puppet. Dee Dee Russell as Dr. Elders solicited donations for The United Negro Pizza Fund.

Don't Cry For Me San Francisco

This song expresses my frustration at the recent influence of repressive forms of feminism. Now, when we are arrested, we are placed "at the mercy of" organizations funded by the state to reform us based on anti-prostitution ideologies.

[From *Evita—Don't Cry For Me Argentina;* inspiration by Madonna; lyrics by Scarlot Harlot]

It won't be easy.
You'll think it's strange.
When I try to explain how the times have changed
for the worse for the whores
after all that we've done.

It makes me queasy
to think of the cops and the neighborhood groups
now joined by our feminist friends,
the Dworkin-MacKinnonites.

I had to let it happen.
It had to change.
Couldn't stay all my life sucking dick,
and wearing a dress,
although I got paid.
We joined the union,
and sued the police and legalized pot.
Now each slutty girl,
if she please,
can jill off to porn,
with a ring in her twat!

Don't Cry For Me San Francisco!
The truth is they may arrest you,
You'll get probation.
It's no vacation.
They've got you marked for incarceration.

And for salvation, you'll go to SAGE.
The courts will escort you.
Ex-whores will report you
if you don't say you're sorry and blame it on men.

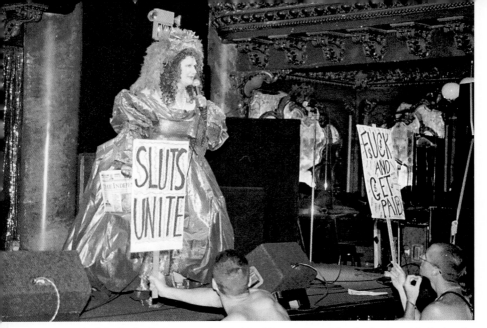

Don't Cry For Me, San Francisco performed at Great American Music Hall in San Francisco at the book party for *Whores and Other Feminists*. Photo: Layne Winklebleck.

They are illusions,
They are not the solutions they promised to be.
The answer was here all the time,
My body, my life and my right to decide!

Don't Cry For Me San Francisco,
The truth is they may arrest you.
If you are Asian,
Black or Caucasian,
You are the target,
of their persuasion.

I think I've said enough. The situation's tough.
The rest is up to you.
All you have to do is get popped for having sex.
You'll know these words are true.

The Final Days of the Taipei Licensed Prostitutes

"To fight for the rights of sex workers is in fact harmful to them."
 — Taipei Women Rights Promotion Association, March 8, 1998.
[Opposition statement published in *World Action Forum for Sex Work Rights*—
May 1998: Handbook and Reference Materials]

In 1997 Taipei Mayor (later Taiwan President) Chen Shui-bian announced his intention to abolish the legal prostitution system in Taipei and put a couple of hundred middle-aged brothel workers out of work. The city finally offered an insignificant subsidy to help these women find "decent work." Mayor Chen asserted that Taipei would then conform to progressive global trends.

In an article in the Taipei Times on April 14, 2001 reporter Huang Jui-ming explained, "Chen said that prostitution must be strictly prohibited if Taipei was to become a progressive city. Chen said 'We mustn't ignore more than a hundred advanced countries just to follow a minority of twenty or so countries.'"

"This was perhaps a misconception," Huang continues, "The so-called advanced countries that ban prostitution are actually in the minority and they include Afghanistan and other Muslim countries."

Taipei sex workers did not take their criminalization lying down. The licensed prostitutes began organizing, and then were joined by a labor union, the ICLE (Information Center for Labour Education). In fact, the 90s were an

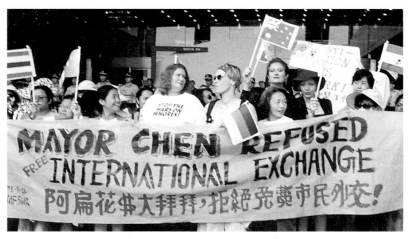

Leigh, Christine Droessler (Germany), and Lin Chew (Hong Kong), Taipei City Hall, 1998. Photo: Augusta Glasser

Video stills, left and center: COSWAS (Collective of Sex Workers and Supporters) including activists Rose, Wang Fang-Ping, Hsiao Jing and Kuan Jian, May 1998. Right: Scarlot and Rosinha Sambo (from Sweden) in Taipei, Taiwan at a street theater performance in conjunction with "100 years of Taipei Legal Prostitution, 2001." Photo: Chen Cheng-Chang.

exciting time for activists in Taipei. In 1987, 40 years of martial law ended and optimism infused the scene. As a political pawn for China, Japan and the U.S., Taiwan labor organizers were very sensitive to paternalistic postures in social policy. This climate gave rise to a movement of students, academics and sex workers with no patience for ambitious politicians curtailing women's rights to protect them.

Organized by the ICLE, COSWAS (the Collective of Sex Workers and Supporters), worked in collaboration with the licensed prostitutes. COSWAS demanded a two-year extension period for the licensed workers. This strategy was decided by the sex workers who opted to fight for something attainable, rather than ideal. Over the next year they held over 100 public demonstrations and the mayor finally acceded to their demand. During this transition period COSWAS educated the public about decriminalization and continued working for the licensed prostitutes.

I attended several events in Taipei including the "World Action Forum for Sex Work Rights" in 1998, and the "2001 International Sex Worker's Culture Festival." That event culminated in a show at Ta-an Forest Park stage, a middle-class neighborhood venue, chosen by COSWAS to "bring an awareness of the plight of the sex workers to Taipei's middle-class." Performers came from around the world including Rosinha Sambo, a saxophone player and activist from Sweden, Erochica and Victoria Schneider (the San Francisco sex worker who travels the world, funded by a lawsuit she won after her mistreatment in jail).

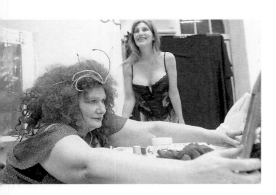

Victoria Schneider and Scarlot prepare for performance. Photo: Chen Cheng-Chang

詩人妓女卡若李　譜下傳奇「性」一生

她是文學碩士　在學院教授錄影藝術　她爭妓權　為娼妓正名為「性工作者」

陳文芬／專訪

許多偉大文學小說都曾以妓女為描述的題材，如老舍的「月牙兒」、黃春明「看海的日子」，悲憫妓女身處底層階級的痛苦。這次日日春關懷協會主辦的「國際倡伎文化節」卻有一位知名的舊金山性工作者、妓權運動人士卡若李（Carol Leigh），本身就是詩人、藝術家。

初見五十歲卡若李，大概都會對她一百五十公斤豐滿的體態留下深刻印象。

卡若李唸完英美文學碩士後，找不到如意的工作，為解決經濟難關，廿八歲那年從娼至今。

卡若李說，年輕時也曾身材窈窕，身材變樣後，她發現，男人其實更喜歡豐滿的女人，只是不方便說出口，以免被視為有「戀母情結」；而她這個行業，胖女人比瘦女人能賺更多的錢。卡若笑說，她有個交往十年的男友，「也是胖子啦」。

卡若李做妓女與寫詩用的是藝名思嘉（Scarlot Harlot），她曾以在舊金山按摩院工作經驗為本，跨入舞台演出「妓女思嘉歷險記」單人脫口秀，巡迴美國各地表演，屢次獲獎，也製作過女性、同性戀議題紀錄片。去年她在加州監獄拍攝完成「瞎眼的正義」──加州遭監禁的

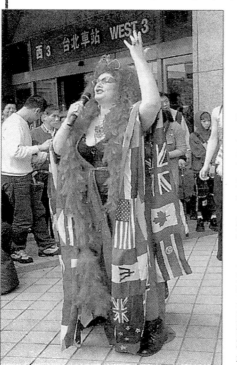

HIV帶原女人」，她把自己定位在多媒體藝術家，在舊金山哈維米克學院、舊金山社區電台教授錄影藝術。

卡若李在國際妓權運動有重要地位，她在七十年代最早為娼妓正名為「性工作者」。她表示：「很多女人從娼，卻從不能說出口，我就不害怕被污名化。」

她說，舊金山禁娼，政客與警察防堵性交易嚴密，舊金山也有一批強悍的性工作者，願意保護自我的權益。這幾年，她與夥伴們聯合發起組織性工作者的流浪之家、支援網路，提供阻街女郎保險套與衛生、安全資訊。

卡若李現在是舊金山市政府所聘的性產業政策研究委員會的委員，也常在電視新聞上為性產業「除罪」做公開辯論。她說，像她這樣「出櫃」的妓女，被警察逮捕總是不好，所以她現在只能做熟客人，不開發新客人了。

卡若李與母親感情極好，她來台北，母親如影隨形陪伴在身邊。她說，母親對她所做的事情總是很支持，但社會總是歧視性工作者，她自己賺錢自己花就算了；母親遭到白眼，她好抱歉。

來自美國的性工作者兼妓權人士卡若李在台北車站前，以歌舞方式與國內民眾見面。（金燦偉攝）

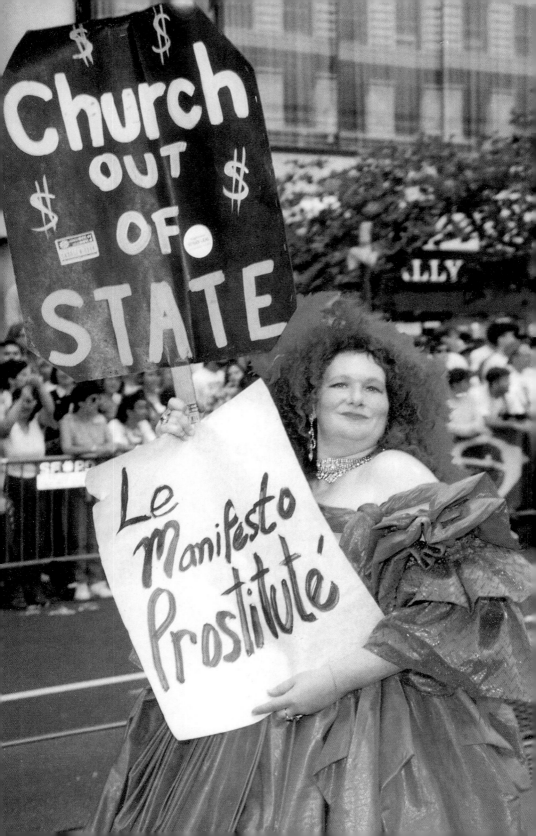

Pornocracy Now!

International Lesbian and Gay Pride Celebration, 1992. Photo: Nance Paternoster

Thoroughly Modern Madam:
An interview with Rebecca Rand, Part 1

[Reprinted from *Gauntlet, Exploring The Limits of Free Expression, In Defense of Prostitution*, Volume 1, Issue #7, 1994.]

I was very excited to meet Rebecca Rand during my visit to Michigan for the rein-statement of the censored PORN'IM'AGE'RY Exhibit. Charming, brainy and polit-ical, she is very much the "woman-next-door." This interview, in two parts, is a gen-erous and detailed lesson for others who own similar businesses, and for those who don't understand the workings of the "justice system."

Scarlot: First of all, Rebecca, how would you like to be thought of–as a madam, as a business owner?

Rebecca: I think the notion of madam is a little old fashioned and it brings to mind the idea of a house, and the owner of the bordello has control over the women who live there because they become not only workers but boarders and the owner becomes *in loco parentis*. That's not the modern day model. They work eight hours a day. They go home. Six or seven hours a day at my place. So it's an employer/employee situation.

Scarlot: What about sex business entrepreneur or agent? I know Dolores French[20] emphasizes that her employers at escort agencies are like talent agents. In your case were they independent contractors or employees?

Rebecca: If it were a legal business, they would just be employees but it's not. I don't keep records of my employees because it wouldn't be safe for either of us.

Scarlot: So, let's cover your case from the beginning? When did you start working?

[20] Dolores French is director of HIRE, Hooking Is Real Employment in Atlanta, Georgia.

Rebecca: I've been working as a prostitute since 1972 in the Twin Cities and I bought a sauna two years after I started working, so I had owned and worked in a sex business for almost twenty years at the time of the big attack. I had already been to prison once. What had happened during those twenty years, they kept increasing the penalties. You can't get the kid to eat the peas, you have to beat him harder. Drug wars are the same thing. Sentencing guidelines were relatively low for prostitution and prostitution related crimes, if they did not involve force. If you were promoting prostitution, that's a felony, but a felony that you would get probation for up to the sixth offense. The first time I went to prison was because I violated probation by going back to my business, and so I was sentenced to a year in prison.

The reason I ignored it is because I didn't take it seriously. People are working as prostitutes every day, seven days a week and nothing ever happens. Part of the reason I went to jail is because I'm an activist. And because I rub their noses in it. I thought they really had more dangerous people to fill up the prison with than me.

I just went back to my business. I was drawn there because this is my lifeblood. I put in huge numbers of hours. I cared about it, in a way that somebody wants their restaurant to be the best restaurant, to have the most interesting menu and perfect service and I wanted my massage parlor to be like that.

I ended up going to prison for a year, but even though I'm in jail the business keeps operating and the other women are free to go to work every day, and the manager, my right hand woman, just ran it for me until I came back. Right before I went to prison I'd just bought another place. So I had two businesses. This is how it works in prostitution. Nothing happens, then something occurs, whether somebody decides to hold a nominating convention in your town, or a certain person gets elected mayor with a streak of Puritanism.

Well, one of the things that occurred in Minnesota was that we got a racketeering law based on the federal law. Those laws allow the government to confiscate the property of a person engaged in an ongoing criminal enterprise. They were written, originally, by the federal government for the Mafia and they subsequently began to be used mostly against drug dealers. I never worried about that law, because there are no federal laws against prostitution. It didn't apply to me. Well, they wrote a state law based on the federal law. They're called baby RICO acts, and the Minnesota Racketeering Act is sort of like the federal act except it says that anyone who is guilty of breaking a state

law in an ongoing business is guilty of racketeering and you can take all their money and all their property. I was the first person they used it against.

St. Paul decided to crack down on massage parlors. They would post the cop outside the door and they would talk to the customers as they were coming and going and say, 'I'm Officer Friendly and I'm just doing a survey here. Can I take a moment of your time and ask you some questions? Have you been here before?' I couldn't do anything. Anybody can stand on a street corner and ask questions. But the fact that they were in uniform was somewhat intimidating.

Scarlot: Did you want to respond or try to organize?

Rebecca: There had been a law written that allowed the city to close down any business that had three or more misdemeanor convictions on the premises. They could use it selectively. Of course if there were three shoplifting convictions in a department store, that law would allow them to close down the department store as a public nuisance. If there were three prostitution convictions in a motel, because the police use the motel to call people from an escort service in a sting operation, they wouldn't close down the motel. They would choose to use this law against massage parlors and against X-rated bookstores. These stores are places where they arrest a lot of gay men. So our first thought was that they were going to try to use this law on us. Now, in the time I had been in St. Paul, which was eight years, I had only one prostitution arrest.

Scarlot: You mean they don't make the rounds at the parlors and bust people regularly?

Rebecca: Well, they do, but I avoided it. My people were trained exceptionally well. I was really good at that.

Scarlot: I always hear that you have to bribe police to avoid arrests. Was that ever expected of you?

Rebecca: I would never do that. But some people do. I talked to a madam who told me she did. I personally have never been approached by anyone who expected me to do it.

So, anyway, then some politician makes an announcement, we're going to close down all the saunas in town. So, now, we have nice friendly cops in

uniform, sometimes they sit in their cars, and they'll stop a guy driving by. Sometimes they stand out in front and they have a questionnaire. And we decide to approach it by telling our customers just to say, 'no, thank you.' We had our lawyer write an ad in the *Forum*, which is the adult newspaper where we advertised. The title of it was *Just Say No To Cops*. When a police officer stops you, you are not required to answer any of his questions. You are required to identify yourself and that's it. But the police have intimidation on their side. They just say, well, would you like to talk to me here, or would you like me to stop by the house later. I mean, that's all they have to say and the guy will tell him anything. So we tried really hard to educate the clients. We told them to be very polite and say, 'sorry, I'm in a hurry, I don't have time to talk to you now.' Or, 'I already talked to the guy yesterday.'

They were also counting customers, and they were astounded by the amount of business we were doing. We were open from 8 in the morning till 4 am, so even if you have a lot of business, it's not real noticeable. Well, when they started counting they realized that we were making more than what the other six places made together. So, I think that they went 'click, click' . . . This is a good case for the racketeering law. She has some money. The first raid six or eight cops came crashing through the door.

We were just mystified because there had been no prostitution enforcement in the last years. So I got an attorney and called a meeting of the other sauna owners. These people are worse than hookers. They don't talk to each other. Their idea is that if somebody gets knocked out of business, it's so much the better for them. It's like trying to organize farmers. But they did come to the meeting.

So I said, I don't know if they'll go after all of us together or they'll pick somebody out. But I'm kind of feeling very confident, because if they're

going to use this business nuisance law, what it means is that they close the building down for one year, but you don't forfeit the building. So all it means is that you have to have some money to move. But that's no problem. I had lots of money. I could buy buildings up the yin yang.

Scarlot: Weren't you worried that they would go after you for pimping?

Rebecca: Pimping is a minor felony that I would get probation for. I didn't care about that.

Scarlot: That's interesting that you say that because a lot of women I know are very afraid of being charged with a felony.

Rebecca: I already had a felony. I didn't care about it, but I did care about them putting me out of business. I put a lot of money into the business, so I will do everything I can to avoid getting three convictions in one year. I train the people really well. I pay a lawyer to fight a bad case. I could have two people plead guilty within a year. After that, if anyone gets arrested, they cannot. These are just misdemeanors, so they cannot extradite you from another state. I was even willing to go so far as to relocate somebody in another state and pay to have them move there, and pay to have them live there, and retire until the year is up.

But the first line of defense is to not get an arrest at all. It's not that difficult to do, because prostitution involves money for sex, and if you remove either element it is no longer prostitution. So all that's really necessary is to not charge anybody you don't know. So if a stranger walks in and you have sex and you never allow him to talk about money, you just ask for the money afterwards.

Scarlot: But police do that all the time, have sex with a woman, pay for it, then come back another time and bust her. That happens everywhere.

Rebecca: No. Not in St. Paul, they can't. And I was willing to do that because I knew it would be such bad PR for them if they had to go to trial. The police aren't really looking to do that because, mostly, they can go into a place and say, 'I want a blowjob. How much will it be?' and the girl says fifty bucks and they bust her.

Now, I hadn't had a prostitution bust in eight years, but they got a search warrant saying that there was a place of known prostitution.

Scarlot: You'd think you could have had it thrown out based on that.

Rebecca: Well, another sauna did. It actually never came up for me. So they came over, kicked the doors down and terrorized everybody. And took the rubbers out of the girls purses, and take the daily sheets (I would only keep records for one day at a time). They took things like videos, just things that you could rent in any video store. Things that you could get anywhere became some kind of illegal thing when they were at my place. And this woman, the head of the Vice Squad, Detective DiPirna . . .

Scarlot: A woman, oh, no!

Rebecca: She's walking around with her hands on her hips. And she said, 'this is an illegal business. We're closing it down.'

So this heat continued and went on all summer. On September 30th in 1990 at 6 o'clock in the morning, they kicked in my door of my house and raided the house.

Scarlot: Who was there?

Rebecca: Me, my boyfriend, it was horrible, just horrible. My son was 10. Two college students who rented a room upstairs. And they bring us all down to the dining room table. And you know, there's a guy with a gun on you and you sit there while they tear your house apart, from the attic to the basement. They were there about three hours while we just sat around the dining room table. It's really humiliating and terrifying. I mean, you're in bed naked and some cop with a gun is pulling down the covers going, 'Get up.' It's really horrendous that our society ought justify that kind of police behavior over consensual sex. Not only did they do this at my house, but at the exact same time they went to five different managers . . . now they are going into people's

homes while they're asleep, kicking the doors down of about five women. My sister-in-law was the cleaning lady and they charged her.

All the other issues that we worry about, about force, violence, childhood prostitution, drug selling and all that were not issues in this case. There was never any allegation of any minor in twenty years ever working in my business. Obviously some of my employees used drugs sometimes. You cannot run a prostitution business and not have that happen.

With the drug war, it's happening to a lot of people, and it's really, really ugly. The fourth amendment says that people should be secure in their homes, and I recognize the government's need to conduct searches, but they should not be for the most minimal reasons that they now use them. You can get search warrants that can only be served during the day, you can also get knock warrants, where you can knock on the door and say you have a right to search. I don't think there was much excuse for a no-knock nighttime search. What they were looking for were business records. It's not like drugs that you can flush down the toilet. There was no reason outside of intimidation and harassment.

Scarlot: Did you want to take them to court on that?

Rebecca: No. I'm concerned with the fact that prostitution's illegal. That's what it all stems from.

Scarlot: If we took them to court at every opportunity, and made it more expensive for them . . .

Rebecca: Believe me, I made this quite expensive for them. But when you make it expensive for them, it's also expensive for you. They did this three times.

This woman who worked for me, we had been friends since before either of us had gotten involved in prostitution. We've worked together for twenty

years. When they kicked her door in she was almost fifty years old, but she was a single mother. Her daughter was very young. She had no one to leave the child with when she went to jail and they really terrorized her about putting the child in foster care. You know women can't work at that age unless they're good. They have to have some care and concern for the customers.

Scarlot: That's not always true.

Rebecca: Well, in this situation, she was not a beautiful woman, but her customers, they came to see her and they never saw anyone else. They came to see her for fifteen to twenty years. It was like they were married. It was weird.

Scarlot: Oh, that's how it is with my clients. That's how I work pretty much. I've known my clients for around ten years.

Rebecca: She was a manager. She got paid a good salary for that, plus she had regulars. She didn't want to quit, but they just terrorized her so much that she virtually hasn't spoken to me since the day it happened because she's afraid.

I had my attorney call and ask what they want. If they want me to go out of business, I'll do it. If I have to go to jail for a while, I'll do that too. But they gotta leave all these other people alone. They are not the masterminds of this criminal organization. They are employees. One of them does nothing more than clean the showers and vacuum the floors. They wouldn't talk to me.

Scarlot: They didn't talk to you because they wanted your money and they didn't want to warn you?

Rebecca: When they search your house, they tell you what they're looking for. I recognized that this was not a normal prostitution bust, so I said to my lawyers, 'Do you think they're going to try to use the state racketeering law against me?' He said, 'No, they wouldn't do that.' He thought that was really far-fetched. He's a very conservative attorney, but I was worried enough about it that I immediately emptied all my bank accounts and liquidated anything I could. I had some money in real estate. I was still stuck with some property that I couldn't sell fast enough before they glommed onto it. They were kind of stupid. You can't knock down their door at four in the morning with a search warrant that says you want to know about their bank accounts. If they had never kicked my door in, I would have never liquidated anything. It would never have occurred to me that they were going to do a RICO on me.

The messiest, ugliest part, they keep making arrests and women keep going to court and they're leaning on people and I have to move several women out of state. Normally you don't look for people on a misdemeanor. You wait till they get picked up on a traffic ticket, but they did send them out for her. She was in jail, and she was terrified, and I thought, okay, I think we better find Texas or some place. So it was just hysterical because here's this woman, she's thirty years old. She worked in a factory all of her life. She happens to work in the same factory my mother did, and read about me in the paper.

Scarlot: Your mother worked in a factory?

Rebecca: A canning factory in a little town. There used to be 200 women who worked there and every year automation pushes them out. Anyway, she knew that my mother was the mother of Rebecca Rand. So she went up to my mother and she said, 'you know, I'm really sick of working in this factory. Do you think your daughter would give me a job?'

So the woman called me. I mean, she was totally into sex and she had never met men she thought were as fascinating because, after all, she worked in a factory her whole life. She thought she'd died and went to heaven to end up in the sauna. And having sex all day, with guys telling you interesting stories about their life and then giving you a hundred bucks.

It just happened that they had a wiretap on just at this period when my mom had called me and said, 'There's this woman and she'd like your phone number.' Anyway, a threat was made—well, maybe threat is the wrong word—a suggestion was made to my lawyer that there would probably be a charge brought against my mother.

Scarlot: That's typical.

Rebecca: There was a guy who was a private investigator. He didn't have a girlfriend and he hung around a lot. Every week he'd spend some money and see somebody, but he'd stay three or four hours, and he was always driving everybody crazy. He was always bugging me for work. One time he came to me and he said that he could get a picture of . . . well, there was one certain police officer on the vice squad who was notorious because he lied, and there was this allegation among different women, not who worked for me but at other saunas, that he would have sex with you, and he would not arrest you that day, but what he would do is come back on a subsequent

occasion and, you know how you would faintly recognize them, you know how you would say to yourself, 'Yeah, that guy's okay?'

Scarlot: Yeah, definitely . . .

Rebecca: You can't totally place him but you remember him. And then he would proposition and arrest them. He would wait long enough so he would be familiar and they wouldn't be careful, and then, of course, there would be no proof. The woman would say, 'But I had sex with you three weeks ago.' He would say, 'Yeah, you're crazy.'

So we were trying to get this guy and none of my employees thought that that had happened to them, but there were other women at other places who saw his picture and thought that he'd done this. So this private eye tells me that he can get a photograph of the cop and wants me to pay a thousand dollars for a photograph and a description.

So he staked the guy out and got a half way decent photograph and a description, his height and weight on the back and it got put-up in the dressing room. On September 30th, when he raided the place, they found the photo. Now they go crazy. It made them really pissed at the guy who took the picture. So they had a phone tap on my phone and they had heard me making this agreement with this private detective.

Because of the photo, they get a hard-on for this poor private investigator, who's just a nobody, who has no money and basically nowhere to live. I did hire him. Here's how I used him.

When a woman came in looking for a job I would say I'm going to have you do an interview with a very regular customer here. Jim comes in here all the time. He's a nice man. He's not going to ask you to do anything. Whatever you do is up to you. It's an interview. I will pay you for the interview. Then

the instructions to Jim were to absolutely say nothing. Just lay there. Don't do anything. Don't open your mouth. Don't say anything. Don't touch her. And the woman is supposed to figure out, if she wants a job, she's gotta do something. But they know. They know what they're coming to apply for.

So it turns out, they send a police officer who was a woman to apply for a job, and I remember her. I never said anything to her at all. She went into the room with Jim and she said something like, are they allowed to use condoms here, and I think he said, 'I don't get involved with that.' She said, 'I'm going to have to go home and check on my baby-sitter. I'll be right back.' And she left. And she never did anything. They made a case out of that. That he was promoting the policewoman's prostitution. This man had nothing to do with my business. I said, 'If I'm running a restaurant and I put a new dish on the menu and I tell somebody to try it and tell me what they think of it, that does not make them a partner in the restaurant.'

The problem with the racketeering laws is that you can charge anybody, because anyone that does anything to further the business which, if you want to stretch it could mean any newspaper you run an ad in. In the most extreme case they did that with my daughter who had never, never been to the sauna anymore than to sit outside and pick me up once or twice when my car was in the shop.

Scarlot: Your daughter never came over? That's odd. I would think she would be curious about what your business was like.

Rebecca: Both my kids were totally aware of what I did. But you don't know who'll say something. I mean you got twenty guys coming in and nineteen of then will be perfect gentleman, but what if one of them makes some remark to her or something. And it's the same with your employees. You always have

the ones who are going to be inappropriate or tease her and say, 'Why don't you come into the room and watch,' or something.

My daughter was older, but as soon as my son was old enough to notice, around six or so, I never had him around. He started noticing the women too much. He'd say, 'Mom, why did that man pick her?' He goes, 'Mom, who makes the most money here?' I said, 'Well I do.' He goes, 'But why? You're not the prettiest.' Thank you very much. I know that. Thank you for reminding me. I said, 'Well, I'm the smartest.' He says, 'But mom, guys don't care about that.' He's ten years old. Even he knows that. There comes a point when they're curious. I wasn't ashamed and they knew it.

My daughter, Lehrer, was twenty-four. She had just gotten married and she was in her first year in law school, but she'd been at college four years before that. There wasn't any reason for the cops to go after her.

Scarlot: It sounds like you have a good relationship with your kids. Do you have a special relationship with your daughter around the way women are oppressed? It was like that for me with my mother.

Rebecca: There have been points along the way when I think she was sort of angry at me about the stigma. She got from me a really open attitude about sexuality, that it wasn't a stigmatized activity and you can just do it. And then she realized that without a lot of social condemnation, you cannot do that, not because of the men but mostly because the other women talk about you, call you trash and slut and all that stuff. I said it was the same when I grew up and I ignored it. She goes, 'I resent it, but it's easier to go along with it. I can't fight it.'

Then my lawyer came to me. He said, 'They told me today they're going to charge Lehrer.' The whole thing came down to that when she was a child, my attorney listed her as a corporate officer of my subchapter S corporation. This is completely conventional. Nobody else owns any shares or anything, but you still need three different officers, so everybody lists their families. Usually you put your wife's name down, your kid's names. It's legal and extremely common. There was no chance in hell at a jury trial that she would ever be convicted, by no stretch of the imagination, but they obviously did it to put additional pressure on me to capitulate to whatever their demands were.

The raid happened September 30, 1990. I finally went to jail in the spring of 1992.

Finally, the eventual agreement that was made is that I had to hand over my building to them, close my business, go to jail for four months and pay them $200,000. In the meantime, I had paid out huge amounts in legal fees. The cops had arrested I don't know how many women and terrorized them during this period of time and wasted all this money. They were stupid. Why didn't they make a deal?

Scarlot: They could have gotten you and your money and not spent so much! They could have spent a few hundred thousand on social services to reform prostitutes. Yeah, right . . .

Rebecca: My lawyer said that they didn't make a deal earlier because they were waiting to find out how much money they could get their hands on. And even after all the bad publicity coming from the sex phobic columnists around, one at least wrote, 'It doesn't make sense that you charge somebody with a major felony and then dismiss it because somebody else pays $200,000. If you charge somebody, it should be because you have some evidence. If you negotiate their case, it should be a plea-bargain with them, right. If you take money for dismissing a case, that's just extortion.' It was just a really sleazy, slimy thing to do, and the prosecutor who did it, I just read in the paper, is going to make a run for Senator.

And now, I just got a call from Lehrer. The Michigan Bar is messing with her about this case. She has to hire a lawyer in Michigan, and appear before the bar, and try to convince them that she's a fit person to be an attorney. It was dismissed! What more do you want?

Scarlot: Has she read that George Bernard Shaw play, *Mrs. Warren's Profession?*

Rebecca: Mrs. Warren was too ashamed of it. I will not take the position that it's a regrettable, unfortunate necessity that we have to tolerate. No! I went to jail for months and had to deal with Evelina[21] and the other sex phobic feminists.

[21] Evelina was director of Minneapolis' anti-prostitution organization, WHISPER, (Women Hurt in Systems of Prostitution Engaged in Revolt). As of this writing, WHISPER is defunct. Evelina (according to the *Minneapolis Star Tribune* June 27, 1997) was accused of sexually assaulting one of women who worked for her. According to the article a number of employees had similar complaints.

Scarlot: Did the feminists support you when the cops broke into your house arresting all these women? What about your mother, and your daughter or anything?

Rebecca: My employees threw this big huge party for me the night before I went to jail, which got in all the papers and really pissed everyone off because they're trying to give the image that I was so bad.

Evelina came to the trial and held little press conferences. She just pranced back and forth in front of the cameras and ran her hands through her hair announcing, 'Well, at least one pimp has gone out of this city and the women will be safer.'

And the prosecutor's saying, 'Well, I hope these women can get on with their lives now that we straightened them out. They can do something more constructive.' So, they took the typical WHISPER view, that I am not a woman. I am a pimp and an exploiter and an apologist for the patriarchy or something. And that the women have been liberated from their slavery at the sauna. None of them ever talked to the women who worked there. Nobody ever asked them if they wanted to be liberated. There's so much dishonesty in their ideology. It presupposes that the reason a person stays in prostitution is force when the reason is economics. If you have a better job to offer them, you won't have to take their job away. They will walk away if you can offer them something better.

Scarlot: I want to get back to your charges now. What were they exactly?

Rebecca: There were about seven or eight felony charges. There were repetitive, things like promoting prostitution, receiving earnings from prostitution, hiding the earnings of prostitution. Before the raid I had nothing hidden. It was all in the bank, in real estate and stocks. But when they raided my house, I liquidated and hid it. If someone says they're going to take your money, it's natural to hide it.

I told my lawyer I would gladly plead guilty to promoting prostitution. I've been promoting it for twenty years, and I'll keep on promoting it. So then you have to go into court. The only problem was that when you plead out you have to say that you are freely doing so and you have not been bribed or coerced. It's really dishonest. There's nothing that has destroyed the criminal justice system more than the existence of plea bargaining, because nobody makes a plea-bargain who hasn't been promised something.

Scarlot: So what's your solution?

Rebecca: The government should be in the position of only charging people with things that it could prove in court. What plea bargaining allows the government to do is charge us with exaggerated crimes that you didn't do that are way beyond your actual crimes, but the threat of the punishment of those additional crimes is so great so that to the individual, it makes me accept the plea-bargain. It robs a person of their right to a trial. In order to get your right to a trial, you have to be willing to risk a punishment far greater than you deserve. In the mind of the public, plea bargaining is an advantage to the accused. It's overwhelmingly an advantage to the government. There should be a minimum standard of proof to charge someone. If they have to go to court, they're in a much weaker situation because they are dealing with a high standard of proof. I hate plea-bargains, but I've made them every time. Part of it is that I can't possibly win a trial, because I am guilty, because I have openly said that I am a prostitute and that I'm running a brothel many, many times.

So I got a five-year sentence, which they made into a twenty-year probation. My case was the first time the RICO laws were used and the way they applied it was not fair. They took from me things that I earned before the racketeering law existed. They had only been adopted two years before my case. They took the money, plus both of the properties, which haven't been sold. They are both still sitting empty. I paid $175,000 for one and probably put half a million into it. And the other one, I paid about ninety thousand for and put about an equal amount. Basically, the government destroyed a viable business that was kept up. The sidewalk was shoveled. It was neat. It was clean. The taxes were paid.

I had to plea for a few reasons, but the major one was my daughter. My lawyer found a probation officer to make a recommendation to the judge,

which is usually done after the trial, but we arranged to have one before. He recommended probation and in a private conversation. The judge indicated to my attorney that even if I went to trial he was unlikely to send me to prison. So if my daughter had been cut out of it, I would have been likely to go to trial and I wouldn't have had to pay them the money. So charging her really was an extortionist act.

I'm not saying that I wouldn't have paid it, because I might have to avoid the risk of more jail time because it was only a matter of a few months or a year, but the person I live with was also pressuring me a lot. I didn't want to be in jail, but he really didn't want me in jail. If I didn't live with him, and if they didn't charge my daughter, then there's no way I would plead. Because jail's not that hard to duty for me. It doesn't scare me that much. There's something in the outside world that I have to miss but I read books a lot and I write letters and do Jane Fonda workouts and you have your own room and you can go and sit in it and be alone whenever you want. It's not horrendous.

We're stuck in a thing where incarceration is our only punishment. A punishment that punishes other people as much or more than the individual who commits the crime is immoral. We should think about some other punishment, like a contribution to the victim or their family.

Scarlot: I don't think punishment is the right angle for criminal justice, anyway. Punishment is just revenge by the powers that be.

Rebecca: I think there are some people who we need to be protected from. As long as they're locked up they're not a threat. But this system does not work as a deterrent. I've met a lot of women in prison who'd rather be there. I think we should try to get the best judges we can and let them have a little more leeway in sentencing. Punitiveness is very expensive and not effective or useful. Twenty years probation might be more offensive to me, but it's more effective. At least society is doing something that's cheap, and getting what it wants. I'd be sixty-four when it's up.

Scarlot: That's a great time to open up a brothel. By then we could make it legal.

Pretty Women: Sara Simple and Lucy Lunchmeat

[Reprinted from *Gauntlet, Exploring The Limits of Free Expression, In Defense of Prostitution*, Issue #7, 1994.]

I began doing street outreach in San Francisco's Tenderloin in the early '90s, providing condoms, legal referrals and other information. As a call girl, I initially felt frightened by, and removed from, the street scene. My early attempts were very awkward.

As a prostitute rights activist, I wanted to know about sex workers in various prostitution venues. On one hand I wanted very much to talk to the women. On the other hand, I understood that prostitutes are "used" by journalists and researchers with no compensation. The researchers are funded for their work and time, but they often expect the "subjects" to donate their time (although these ethics have changed, to some extent, over the last decade).

As an activist and journalist, I believed that any ethical approach to this sort of research should include an offer to pay for their time, and a commitment to portray them in keeping with their self-image, and with an emphasis on their priorities, rather than my own interpretation. As a prostitute I expect to be paid for an interview, even if it's nominal

I teamed up with a friend, Allie, who wanted to interview street workers for a school project. We drove to the stroll on Geary near the theatre district looking for "real, honest-to-goodness street prostitutes."

I was very nervous and giddy.

Scarlot: This seems very risky. Someone could take offense and murder us. Plus, you told me that you have a cold. I could catch it. God, I'm taking a lot of risks. Wait a minute. I don't even see any prostitutes. Nothing's happening. These people are just innocent people hanging out.

Allie: No way.

Scarlot: Yes, they are. Just because they're poor, doesn't mean they're not innocent. I don't know. Maybe there are no more street prostitutes. The women's movement . . . maybe it finally hit. Just kidding.

In a few minutes, Allie and I reached the short two-block stroll, the high track in San Francisco's tourist district near Union Square. We spotted two women, smiling and conservatively dressed. They looked friendly, I thought. We pulled over and

parked. We approached them, with our offer, told them how much we had to spend, they agreed to talk with us for a while in a nearby bar.

Shari: Okay, go ahead. [Giggle.] She's good people. Okay, what's up? Where were we?

Kris: We're nice, but we're mean. Because you don't get shit unless you spend money.

Shari: No money, no honey.

Kris: We're not freestyle hookers. We gotta have money. We need money for everything.

Shari: You pay us, or you don't get no information.

We paid up front, of course, and found a quiet table in the corner. I noticed the only other women in the bar were dressed like tourists. There are a few bars in the city that allow working girls, but they are not located on the stroll, as far as I know.

I worked in a bar on Spring Street in San Francisco, frequented by financial district insurance brokers, bankers and a few mobster types. It occurred to me that bar owners were probably under a great deal of pressure NOT to allow women to work out of bars on Geary Street.

I was determined not to ask the stereotypical and stereotyping questions. I talked about my own experience. I hoped to encourage the women to reveal themselves in the way they wanted to portray themselves. The following transcript is verbatim.

Kris: I've been working five years.

Shari: I've been working seven years, and I'll say . . . Honesty? Okay, honesty. I've had . . . I'll be honest. I'll be real honest. Me and her went on a date together. Two weeks ago. Oh, it was really good.

Kris: Yeah, it was funny.

Shari: Okay, boy wanted to spend only fifty dollars a piece.

Kris: But what did he end up spending?

Shari: But when we get to the room, he spends a hundred dollars on her, a hundred dollars on me, twenty dollars on the room. Then he gives us, what . . . about a what . . . twenty dollar tip?

Kris: Was it twenty? Twenty or thirty.

Shari: No, it was thirty, you're right. It was thirty.

Kris: She's such a sweetie and I want to take her home with me. I love her.

Shari: I know you do, babe.

Kris: We've made so much money together.

Shari: I have Lucy Lunchmeat written on my butt.

Kris: Sara Simple.

Shari: She says Sara Simple. I say Lucy Lunchmeat.

Kris: Pussy Plum Plum.

 [Both giggle]

Shari: There was this guy in California, down in Hollywood. Oh, he was a fine babe. Babe looked good.

Kris: There was this dude here, girl. It woulda tripped you out. There was this white boy, girl, fine.

Shari: Really.

Kris: Fine, white boy. I used to call him 'Swafe' 'cause he was suave. So he comes and gets me.

Shari: Uh, huh.

Kris: His girlfriend was at his house.

Shari: Oh, no.

Kris: Check it out. His girlfriend throws seventy dollars. And tells him have a good time.

Shari: That's strange. See, I've never had anything like that happen.

Kris: I had that happen to me in San Diego. It was such a trip. The couple gave me two hundred fifty.

Shari: Really.

Kris: His wife to watch her husband.

Allie: How did you get started?

Shari: How? Me, myself, I was twelve years old.

Kris: She's been doing this longer than me.

Shari: I've been doing this for seven years.

Kris: I've been doing it for five.

Shari: I was twelve years old. I ran away from home. My mother was with this guy I didn't get along with. I met this girl. Her boyfriend's aunt was a hooker. She hooked me up with one of her regulars. And that's how I got started.

Scarlot: How did you start?

Kris: I just met this pimp.

Scarlot: And he turned you on to it.

Kris: Right. He turned me out. That's what they call it. You know. I was wild, anyway. I was a runaway, anyway.

Shari: The second time I had sex, I got paid for it, and I've been working ever since. I was twelve years old. I am twenty years old now.

Kris: A lotta stories. A lotta hookers tell you they was raped, they was molested. I was a good girl. My family, my mom worked three jobs to support us. Worked very hard.

Shari: My mom worked in a bar all her life. My mother never beat me. My mother never beat me . . . I'm gonna tell you something. When I was in the first grade, I remember my mother coming home one night. I was asleep when she came home, but I remember a man coming into my room and the man came into my room past my mother's room, past my room, kitchen and then there's the bathroom. You go back. My room's before my mother's room, coming from the bathroom. This man came in and started feelin' on me and stuff and I know he doesn't think I'm my mother. I mean, my mother was heavy set. I'm a little, skinny, young girl. I was only in the first grade. And then he started feeling on me. I said, 'Hey, you're in the wrong room.' I said it just like that, like I knew something. I mean, I got devirginized. The second time I had sex, I got paid for it. And this is all I know.

Kris: I got a different story. I was a good girl, you know, up till the seventh grade I had straight 'A's. A good family, a really tight family . . . My mom raised me

working three jobs. She worked really hard. She was a good mom. It's just that I was a wild kid, I guess. I don't know.

Kris: My mom worked three jobs, so we had money. That's why I say a lotta girls, working girls always say that they was raped. Me, I wasn't. It wasn't like that. It's just that it was my choice. My choice to do this.

Kris: It wasn't anything bad. It's just, I wanted to do this. I think it was my destination. My destiny. When I was 13 years old, I met Filipino Bobbi. And he put me out on the street and I didn't make no money. I got busted. Went to jail. Went to the Youth Center in Seattle.

Scarlot: I don't really like to be out there. I mean, I never worked on the street. I worked in a massage parlor in the Tenderloin.

Scarlot: What about bad things cops have done? I love those stories.

Shari: I just talked to a cop just now, on the corner. He came up to us. He was ready to date us.

Scarlot: Did he have a uniform on?

Shari: He was in a uniform, black and white car. Yes. If he hadn't been in that uniform and black and white car, he woulda paid us.

Scarlot: What did he say?

Kris: He even told us to take the two guys that were on the corner. He said, those look like good dates.

Kris: Sergeant Smith, asshole. Sergeant Smith, total asshole.

Scarlot: What's wrong with Sergeant Smith?

Kris: He'll take you to jail, quick, for just being, looking like a ho'.

Shari: I wasn't even looking like a ho' I was wearing jeans.

Kris: You know, I was wearing jeans, too. He pulled me over, made me take my shoes and socks off, took my money. And only I had three hundred and seventy five dollars.

Shari: What!

Kris: Three hundred and seventy five dollars. He gave me fifty dollars to catch a cab home.

Shari: What! Oh, I woulda went off. I woulda kicked him. I woulda.

Kris: He took three hundred seventy-five dollars from me.

Shari: I woulda went off . . .

Kris: Is this a good story?

Allie: Yeah. It's a great story.

Shari: I just got back from Hollywood today. I had two vice stop me. The first vice stopped me. He was a white dude. He acted like he had an accent. Then he stuck his hand in my bra. Touched my skin. He says, 'What's wrong with your breasts?' I said 'I have two children.' He said 'I really am a cop, but I'm gonna let you go. Don't work Sunset. Especially not tonight.'

Scarlot: What about other things, like your favorite things to do? Like movies. Do you like to watch TV? What about the rest of your life? Like what do you like to do the best?

Kris: I like to read Stephen King books. I love Stephen King.

Shari: He's good.

Kris: He's real good. I love him. I like movies. I take my daughter to the zoo all the time.

Kris: You know what was a really good movie? What was it called? *Pretty Woman*.

Scarlot: *Pretty Woman* was a good movie.

Shari: The only reason I didn't like *Pretty Woman* was that she did not get paid enough for the week that she was with him.

Kris: *Pretty Woman*. It's a good movie. It can happen. It really can happen.

Scarlot: What I didn't like was that, every girl's fantasy, okay, you find this rich sugar daddy trick. This perfect, great trick. That was my dream too. It happens to a lotta girls . . .

Kris: But it doesn't happen like that. If you're gonna meet a trick like that you're gonna have to at least spend two weeks with the trick for him to do you like that. Trust me. It's not gonna be an overnight sensation.

Scarlot: What about Anita Hill?

Kris: I wish I was Anita Hill, 'cause I woulda got paid.

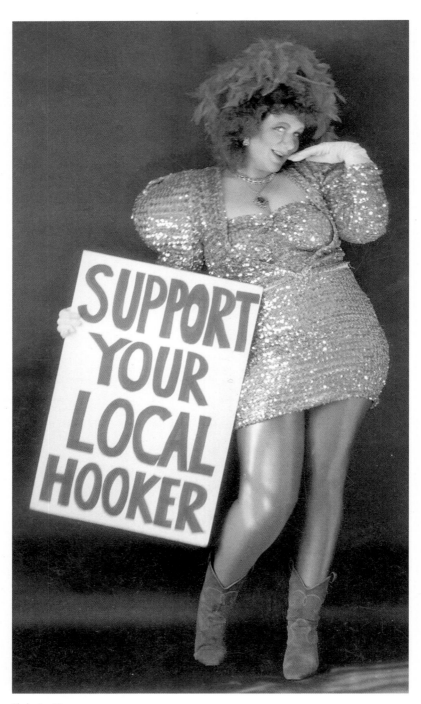

Photo: Jan Weaver

Scarlot: What do you think about the sexism in music, the way women are referred to as Bitches?

Kris: I love it. I love it. Because I'm used to it, though. Bitch and whore and ho' don't bother me. Slut irks me.

Shari: They call me a slut. Yeah, I get paid for what I do so I'm not a slut.

Kris: Whores get paid.

Shari: I don't even like the word whore. Call me a hooker. I'm a hooker.

Scarlot: I love whore. I don't like hooker.

Kris: I don't like prostitute. Prostitute sounds like a disease. [Giggles]

Scarlot: What about sex worker? Have you ever heard the term sex worker?

Kris: Sex worker. I'm a good sex worker.

Shari: We need more money. We're giving you a good talk here.

Kris: So can I ask you what this is for?

Scarlot: For a school project.

Kris: So, they're gonna hear us talkin'. What do you think they'll think? Okay, I'm gonna ask 'em. What do you all think of us? The last question of the day is, 'What do you think of hookers?'

Pathologizing Prostitutes

In the early 90s I attended a national meeting of social workers, held in San Francisco. My friend Lacey Sloan, a professor and former stripper, enlisted some local sex workers for a panel. At this conference there was a resolution circulated stigmatizing prostitutes as quintessential victims. The resolution below contains my paraphrases of the points made in that document. You may notice the condescending attitude towards the pitiful prostitutes. Following that resolution is a satiric resolution, which I wrote and circulated as a pointed critique of the prejudices conveyed in the original.

WHEREAS, The "X" Association of Social Workers is dedicated to the concepts of social and mental health, development of human safety, as well as the end to all forms of abuse; and

WHEREAS, Most individuals in pornography and other forms of sexual exploitation are recruited when they are very young; and

WHEREAS, Persons in the business of commercial sex will likely be exposed to AIDS; and

WHEREAS, Individuals in commercial sex including pornography and prostitution very often are sexually abused by strangers, teachers, family friends and family members; and

WHEREAS, Persons used in commercial sex suffer a high rate of sexual problems and diseases; and

WHEREAS, The frequency of mental disease, depression, anxiety syndromes, dissociative syndromes, self-inflicted abuse, and suicide is very common in these industries; and

WHEREAS, Heroin, crack and other illegal substances will be used by such individuals to numb the physical, emotional, and psychological pain concomitant with prostitution; and

WHEREAS, Women in the sex industries have crimes committed against them much more often than other individuals and groups; and

WHEREAS, The conditions that create and perpetuate the sex industry, including lack of money, racism, classism, homophobia, sexism, sexual exploitation, and misery, often force people into this industry; and

WHEREAS, The pornography and sexual exploitation of women, girls, boys, and homosexuals is estimated to earn pimps at least 18 billion dollars a year; therefore, be it

RESOLVED, That "X"ASW take a public stand reflecting the above considerations.

Submitted by "X" (Name Omitted)

A Response: Satirical Association of Sex Workers Resolution on Social Workers (Scarlot's Mock Resolution)

WHEREAS, The Satirical Association of Sex Workers (SASW) is dedicated to the satirization of all prejudices and bad attitudes about sex workers; and

WHEREAS, Most individuals in social work are recruited at a vulnerable time in their academic careers; and

WHEREAS, Persons in the social work industry constitute a very high-risk group for pathologizing people and abusing their power with clients; and

WHEREAS, Individuals in social work frequently have a background of mental, and sometimes physical abuse; and

WHEREAS, Persons used in social work suffer a high rate of sexual dysfunction and mental disorder; and

WHEREAS, The rate of careerism, failed marriages, abusive personality disorder, abuse of children, self-righteousness, reductive reasoning, racism, sexism, classism and moralism-disguised-as-concern is very high among individuals in social work; and

WHEREAS, Food, drugs, cigarettes and alcohol are commonly used to numb the physical, emotional, and psychological pain concomitant with social work; and

WHEREAS, Those in social work are victimized by low salaries, and a classist, sexist and racist hierarchy that determines promotions, at an immensely higher rate than other population groups; and

WHEREAS, The conditions that create and perpetuate social work, including poverty, racism, classism, homophobia, sexism, sexual abuse, bigotry, and despair, often force people into social work; and

WHEREAS, Social work as practiced on women, children, and men is estimated to net middle class bureaucrats and their flunkies 18 zillions dollars a year; therefore, be it

RESOLVED, That SASW take a stand to stigmatize and satirize social workers as much as possible.

Submitted by Scarlot Harlot, Whore National Chapter

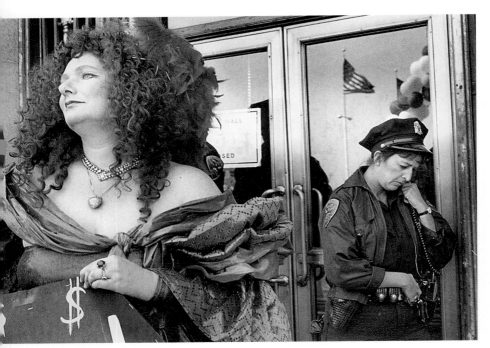

International Lesbian and Gay Pride Celebration, San Francisco, 1992. Photo: Jane P. Cleland

P.I.M.P. Prostitutes in Municipal Politics

[Originally published in *Policing Public Sex*, edited by Dangerous Bedfellows, South End Press, 1996.]

Imagine growing up a girl in late 20th-century America. You may have been a victim of some type of molestation or the target of unwanted sexual advances. Or maybe you were just subjected to the usual propaganda about sex: sex is really for boys, and girls comply to find love or to get attention.

Female sexuality is used to sell everything from autos to window cleaner.

You leave home at an early age, very often (though not always) because of abuse. You become involved in prostitution because of some combination of the following:

1) someone talks you into it, sometimes coercively, sometimes not.

2) your friends and/or family do or did it.

3) there are few jobs through which you can support yourself, and it's hard to survive.

4) rebels don't fare well at McDonald's.

Even if you are over 18, if you are living in the U.S. with little education and few job skills, or if discrimination against your race, gender identity, sexual orientation, etc. means you probably won't get hired in a straight job or even an indoor prostitution job, or if everyone you know works or hangs out on the streets, or if that's the only kind of prostitution you've ever heard about because that's what you see on the cop shows, talk shows, or TV news, then you might wind up working on the street.

If you are under 16 or 17, the child labor laws can keep you from finding another way to support yourself when you are on your own. Many young women and young men engage in occasional prostitution and more casual forms of survival sex. Attitudes are diverse. I have spoken with a number of prostitutes who worked in their teens and do not think back on this part of their lives with horror. I have met others who do.

Some extricate themselves from a life that they portray as horrific, while others have come to embrace this particular sexual culture. Against a backdrop of paradoxes and contradictions, public prostitution combines the defiance of public sex with the drama of social hypocrisy.

A Public Woman

In the late 1970s I began working as a prostitute. Today I continue working, while advocating for prostitutes' rights. Early on in my career I came out as a "public woman," as prostitutes have sometimes been called. As an artist, I was (and continue to be) a participant in public life. Making art is cultural work. As a life artist, I document my life as a prostitute through video, performance, and writing, as well as street theater, civil disobedience, and other types of public participation.

As a prostitute, I have publicly announced my availability in an ordinary manner, mostly through newspaper ads. I committed civil disobedience by standing in front of the New York Stock Exchange and announcing my rates, soliciting to the amusement of stockbrokers, local ACT UP activists, members of PONY (Prostitutes of New York), and the police: "Safe Sex For Sale. Fifty dollars for digital intercourse. That's a hand job . . ."

"Street Prostitution"

In the 1990s, the policing of streets in the United States has emerged as an urgent municipal concern, interpreted by some as testimony to social dysfunction and class inequities, or as testimony to the unruly characteristics of the poor and young. The sex industry has become a primary target of law enforcement, with street prostitution attracting the brunt of attacks on public, paid sexual expression.

In San Francisco, neighborhood merchant NIMBYs (Not In My Back Yard coalitions) have been fuming, conducting letter writing campaigns to San Francisco Supervisors to increase enforcement of laws against prostitutes:

> "San Francisco's residential neighborhoods have been overwhelmed by street crime in recent years. Chief among these life-endangering criminal activities is street prostitution. It is the nature of the act itself which destroys neighborhoods."[22]

Never mind that most of those whose lives are endangered are prostitutes themselves.

COP Watch

In the early 1990s, after many years of coalition building in San Francisco, I began organizing with a group of San Francisco progressive activists and community-based health service providers. We formed a group devoted to advocacy for the rights and needs of prostitutes, particularly street workers. Our network included feminists, sex workers from various venues, attorneys, health service providers, and employees of alternative criminal justice programs. We distributed condoms and legal information, and networked with prostitutes on the street. Police abuse became one of our primary concerns. We called ourselves COP, the Coalition on Prostitution.

For the last few years COP has been doing outreach on one of the prostitution strolls. I have been going out regularly, basically getting to know people on the streets while passing out condoms and info. I regularly survey

[22] San Francisco Board of Supervisors Task Force on Prostitution, *San Francisco Task Force on Prostitution Interim Report,* Neighborhood Issues Committee Report: Exhibit E, "Perspectives on Street Prostitution in The Neighborhoods," 1994, p. 4.

women, asking about needs for services, opinions about the laws, and information on arrest patterns.

"It isn't fair," some complain. There will be one woman in a miniskirt on the corner, standing next to a group of five drug dealers. Passersby will be tooting their horns, calling out, even throwing things from car windows, and the police will arrest only the prostitute.

Quite a few women working on the street tell me that they understand their rights. They know that they have the right to simply stand or walk on the street. They know that they have a right to dress however they want. Some insist that they do not step out in traffic or make noise. They just stand there. Standing on the street corner just can't be a crime, some tell me.

According to my understanding of the law as of 1996 in California, standing there *can* be a crime, depending on what you are thinking at the time. For instance, if you're thinking, "There's no food at home and the kids are hungry. I better pick up a date tonight," then "standing there" is a crime.

The WIPS (Women in Public Spaces) Project

As a prostitute I had always envisioned tough female activists standing on street corners in short skirts as an act of civil disobedience. I mentioned this to some fellow activists who seemed to have an interest. In conjunction with her Ph.D. research project, Esther Rosenthal, a feminist sociologist, took me up on it. My goals dovetailed with her project, which was to get a closer understanding of street prostitution. Another activist friend, Carol Draizen, was a social worker and former "officer of the court" (a diversion counselor for prostitutes who had been arrested). Through her work within the legal system, Carol had witnessed the adverse effects of criminalization on prostitutes over the years. It became clear that through this project we could at least make an effort to monitor the conduct of the cops.

"This is all about how women occupy and are prohibited from occupying public space," said Rosenthal.

I called this project WIPS. Women in Public Space. We planned that three of us would go out to the stroll, with two of us sitting in a car with a video camera and wireless mike attached to the third woman, who would stand on the street.

Prior to engaging in the project, I had been doing outreach on this stroll for over a year. We conferred with a number of the women I knew working on the streets, proceeding on the basis that the project would be welcome. We

were surprised to find that there was a great deal of enthusiasm for the project. When we said the phrase, "looking for police violations of prostitutes' rights," a number of women replied, "You want to know about our rights being violated? My rights are violated every day."

We stationed ourselves at the most public and patrolled sector of "High-track," San Francisco's hotel district, where prostitutes share the streets with tourists, landmark theaters, and pricey fast-food joints. Before starting the project, we consulted with a number of attorneys, including the Sex Workers' Rights Committee of the National Lawyers Guild. Through this ongoing project we are able to obtain documentation of abuses of citizens who are usually considered beyond the scope of human rights advocacy.

Esther stood for hours among the other women, turning away the tricks, being videotaped by passing cars of teenagers, waiting to see how the police would treat her. She wore high heels and a hemline that exposed her thighs. I parked a few feet away with my video camera and monitored her.

Police cars circled the block regularly and instructed Esther to move. She would insist that she was not doing anything illegal. They threatened her, "If you are still here when we return, we will take you down to the station."

"For what?" Esther asked.

"For solicitation."

"But I'm not soliciting. I'm just waiting for someone."

"You heard what I said. You'd better not be here when I come back."

Laws Against Prostitution = Violence Against Prostitutes

Gina is a Native American transgendered woman, warm, funny, and very intelligent. She had just gotten out of prison when she had a run-in with the police. She told one of the outreach workers on the street, who called me at COP.

When I met her she said over and over that she hadn't done anything wrong. She felt that, because she never agreed verbally to accept money for sex, she should not have been subject to arrest. She did take money from the officer, whereupon:

> In a few seconds he flashed a brown wallet and tells me I'm under arrest for prostitution.
>
> 'No, I'm not. I didn't do nothing. I did not agree to anything verbally.'

'Get up against the wall. You're under arrest.'

'Why should I? For what reason? I did not do nothing wrong.'

He grabbed me. Since I did not get a clear look at any type of badge, I got scared and I thought I was going to be raped and robbed. [Gina also told me that an incident had happened a month or so prior in which a rapist showed her a phony badge, said that she was under arrest, then tried to rape and rob her.]

I tried to get away, but he grabbed me by my hair and slammed me against a brick-building wall. I started struggling with him for fear I would get hurt. He grabbed me by my hair and forcibly dragged me for about three meters. He then called for assistance.

My head was stepped on aggressively while my right arm was being twisted. I asked them to stop, that I was hurting. They both informed me that I shouldn't have resisted, that if I would have cooperated, none of this would have happened.

'We're going to let you know to cooperate the next time an officer says you're under arrest.'

I told them once again that I did nothing to be treated like this. 'When I say you're under arrest, I mean for you to shut up and put your hands behind your back. Let this be a lesson to you and the other individuals not to resist.'

I was then handcuffed and physically beat with their fists in my chest and ribs. I started to cry and asked if they would please stop. One of the two insisted I turn my back towards them. When I did this I was told, 'Bitch, this is for you,' and I was repeatedly kicked within my upper right side chest.

One officer said he would call for transportation, and the other officer kept telling me that he would like to take me north somewhere and he would beat the shit out of me and leave me for dead. He then told the other officer that the next person who resists should be shot, and I told him to shoot me and just get it over with.[23]

[23] From a statement written by Gina, which she intended to submit to the Office of Citizen Complaints. This report is representative of quite a few I have heard from prostitutes in San Francisco and other cities. Transgendered women and women of color, in particular, have told me many stories of police misconduct and abuse.

She said she was yanked up, and then forced to the ground again, when the transport arrived. She asked to go to the hospital, and they told her to shut up. They took her on a frightening ride over the steepest hills (apparently this is a frequent tactic) and did not give her a seat belt. The following day she went to the hospital on her own and was told that her ribs were crushed. She said she suffered additional injuries, which were sustained by the bumpy ride.

Institutionalized violence against prostitutes is familiar to me as well. In 1979 I was raped while working at a massage parlor. The effect of criminalization on prostitutes' safety became apparent to me as I realized that there was no way I could call the police. The fact was, the police would bust our massage parlor, and my co-workers would be out on the streets. These same rapists had been to several parlors in town, and there was little I could do to stop them. I vowed to devote my energies to changing the laws and working with prostitutes to organize to protect ourselves.

I am appalled that the state assumes jurisdiction over my sexuality. To me, cops seem like rapists with badges. I read the newspapers: "Ex-Cop Linked to Hooker Slayings" and "Rapist Lures Prostitutes with Phony Police ID." The serial killers are the police—or at least there's no way to tell the difference.

In 1992, Toronto's Prostitutes' Community Project performed a study of violence against prostitutes. Of 100 cases of reported rape and battery, five percent of the rapists identified themselves as police in order to "disarm" the prostitutes. (This does not include those who actually were police.)[24]

Prostitution busts are a form of rape. When an emissary of the government (a cop) coerces me to engage in fondling and petting through fraud (pretending to be a client), then arrests me for my sexual behavior, I call that institutionalized rape. My mantras:

LAWS THAT PUNISH PROSTITUTES ARE CRIMES AGAINST WOMEN.

THE ARREST AND INSTITUTIONALIZED HARASSMENT OF PROSTITUTES ARE ATROCITIES.

[24] "Police Response To Reports of Violence Against Prostitutes," from Maggie's: The Toronto Prostitutes' Community Service Project, submitted September 25, 1992, to the Police Services Board, Toronto.

Punitive Legislation Increasing

During the late '80s, Democrat Willie Brown, then California's Speaker of the House and later the mayor of San Francisco, sponsored a bill (which is now law) requiring mandatory HIV testing for prostitutes and a felony sentence if one tests positive and engages in prostitution. The way the prostitution laws in California have evolved, it is now a felony to *agree* to do a hand job if one is HIV positive. Since treatment for HIV-related illness is almost nonexistent in prison, a felony conviction can be tantamount to a death sentence. Twenty-eight states have similar legislation.

"Civil remedies" have become a recent trend in enforcement and litigation. This tactic has been promoted by lawyers-cum-legislators, cities, police, and anti-prostitution feminists as the "new tool for public order." Civil suits can be used punitively (by the government and individuals), and require less of a burden of proof than criminal law. Seizure of property is the newest legal remedy for such offenses, and provides a way for the state to extract their share of the profits by confiscating all earnings based on so-called crimes. This includes drug offenses as well as prostitution. With these economic incentives, police are highly motivated to hunt down "recalcitrants." These incentives also tend to trigger greed and over-enthusiasm. Officers who are ordinarily restrained by constitutional prohibitions on illegal search and seizure under criminal law wield much greater power under these new statutes.

Contemporary prostitution-prohibitionist feminists working within the criminal justice system in San Francisco are breeding a new set of "retraining centers" for johns. Here, the police "blackmail" the clients upon arrest, presenting the D.A.'s offer not to press charges if the john takes a $500 seminar. "Johns' School" is very educational, including testimonies by ex-prostitutes about how much they hated prostitution. Personally, I have a few choice words I'd like to share with some of these clients, but they shouldn't arrest them.

Arresting clients is usually more of a propaganda campaign for the police than a real priority. Client arrests have gone up 25% in the mid '90s (according to the local police department) but many of the prostitutes tell me that women are still being detained, but without the paperwork. In the '70s there was a similar rash of news stories about an increase in the arrest of clients. However, this had no long-term effect on the arrest ratio—prostitutes are still arrested much more often than clients. If the police department were comprised of a majority of women the figures might change, but some prostitutes say that women cops can be worse than males. While some male officers are

friendly and actually supportive, women report that female officers may be less friendly and less likely to let a known prostitute continue working. And there is an underlying problem regarding re-educating johns in order to take away a hooker's business: it causes many prostitutes to work longer hours and take extra risks to make the money they need.

In 1994 in Minnesota, a group of prohibitionists created legislation (Chapter 611A.80-88) prescribing civil remedies within prostitution, bypasses the proof required in the criminal justice system and stretching the meaning of coercion to include a wider range of circumstances than usually exists in the legal definition of coercion. Promising unionization, for example, is listed as one of the "sins."

Organized prostitution is a prime target of the law. Living off the earnings of a prostitute (aka pimping) is a felony in most states. Although police should enforce laws against persons who abuse, coerce, force, kidnap, or commit violence against prostitutes, criminalizing "living off the earnings" makes it impossible to spend one's money on family, friends, or lovers, This strategy increases the marginalization of prostitutes by criminalizing their relationships.

These laws apply to me, and I take them personally. As a call girl, it is almost impossible not to share a client's phone number with a friend. Prostitutes work together, giving referrals and sharing apartments as a way to organize to protect ourselves. In fact, prostitutes' rights groups try to make the sex business safer by encouraging communication between sex workers. Laws against pimping threaten all our communications and supports.

Prostitutes, especially the most visible prostitutes working on the streets, are again emerging as primary symbols of suffering and need, of the mythic malevolence of women, of "criminals and deviants." Society, the laws, and the police attack the public display of women's sexuality and sexually assertive presence. Erotic performers and prostitutes, as well as any public erotic image, are cast as a prime enemy of an idealized social order that is based on middle-class concepts of "decorum" and conformity. This century— this millennium—is coming to an end in an atmosphere of fear, with society seeking unfair revenge on the poor, the sick, and the strange.

Rape and No Recourse

I regularly receive requests for referrals and assistance from prostitutes. In 1994 a woman contacted me to see if I could help with the following case. My friend and intern, Bharati Narumanchi, conducted this interview for me. The interview was submitted to the San Francisco Task Force on Prostitution and published in an appendix to the Task Force Final Report *in March 1996. The story focuses on police and prosecutorial response and illustrates the way the system fails prostitutes who are victims of violence.*

I got to the door and I knocked on it and he answered but I didn't see a face. Then 'Jim' kind of peeked around and opened the door wider. I just walked directly in. I picked up the phone and then I looked at him. I realized he was not incredibly unusual, but I was scared. I tried to pay no attention to the fact that he wasn't wearing pants. I just started talking to him like he was anyone else. I explained I was calling the agency. He told me he knew the way that it worked and he leaned into the staircase so I couldn't see him anymore.

I started dialing the agency's number, but before I finished dialing there was knife at my temple. He told me to drop everything and then he asked me if I had money, where I had my purse, if I had a driver with me. He kept repeating this. After I convinced him there was no weapon and there was no driver and I had no money. Then he raped me. From the very beginning he had the knife and he started picking the skin on my nose and describing what he was going to do to me.

Then for the rest of the time he sodomized me. I was there with him it was probably about 3 1/2 hours or 4 hours. I thought maybe he was going to kill me, and he was talking about all sorts of things. The reason he let me go is because I convinced him that I would come back the next morning dressed as I had dressed for him that night, very nicely, and he was going to introduce me to some friends. I convinced him that I was going to make him a lot of money, he was going to be my pimp, so we were going to work together. So he let me go.

I got in my car and I pulled away. I screamed and I drove like a maniac home. I was trying to get a police car to stop me because I was afraid that he was following me. And then I was running out of gas. I stopped once and I called the agency to tell them what had happened to me.

The agency is usually careful and just the week before we had a scare with my roommate who was also doing this. She didn't call the agency back and that is not typical. You were always supposed to call and then they would call back in an hour, but something went wrong. They called me about her, and told me they were calling the police and they did, but it was a false alarm.

The agency said, 'Don't do anything until you call us from home.' They asked me not to call anyone until I got home, meaning the police. I was so scared I was being followed and I went home. I called the police. Well no, I called the agency again and they told me to tell her, the woman who runs the agency. They asked me to tell her boyfriend what had happened to me and he told me that I should call the police then, which I did. I called 911 and the local police came first and then they stayed with me for a while but they couldn't take a statement until the Alameda police came because that's where it happened. In about an hour, three policemen came by and questioned me.

They started taking my statement here, then they had a detective come and took photographs of my wound and they checked all of my things and my purse and the clothes I was wearing. I had changed as soon as I got home except for my underwear and they took me down to the hospital and they took my statement there. They took my statement for a long time. It was a long story. I was trying to remember everything when it was happening. After I had given my statement they went to the apartment, his apartment building. I had given his address and phone number and everything that I knew about him that the agency had given me before I even went down there. Then they stopped taking statement and then they put off doing the exam and we went to the apartment to identify him. So I identified the apartment building first and then I tried to identify him. It was 4:30 or 5:00 in the morning.

When the first policemen came, I told them that I was—I totally wanted to be honest with them—and I said I was there because I was an escort and he said everyone was fine. All the policemen who were there, I had told that to, and I can't remember, like there was 50 of them. I remember there were like three people here at a time.

So I told them that I was an escort and they said it doesn't matter. You are a victim. You were raped. It has no bearing on it. I was so scared. So they all told me that it was okay. I had been raped and that was not a problem. It was good that I was telling them the truth and everything.

So, then I went to the apartment building. First they had me walk up the path and identify which apartment it was, then they asked me how I recognized it and I remembered that there was something weird at the front door, the way it was and the number of the apartment building and the door mat and everything. Then they took me back to the car and they sat me in the car and they told me they were going to bring him out in handcuffs and that I get to identify him so they brought him out.

That was really scary. I was terrified, and he came out. He was dressed differently than he had been and he had glasses which he wasn't wearing the entire time when I had seen him and so at first I was kind of shocked he looked the way he did, but then he turned to the side and I remembered the one thing about him. I identified him and then they took him in the car and he was looking back at me the whole time and they said he couldn't see me in the car but I thought he probably could.

They took me to the hospital. Actually, they made me wait for a while. He left first. They took him to the same hospital, the same hospital that I was in. So they made me wait right out in front of his apartment building in the car with the policemen and detectives for about 20 minutes before they took me back to the hospital because they wanted to be sure that he was out of the way and I didn't have to see him again. We went back then to the hospital and I finished giving my statement. Then I had the examination. The police were requesting that the nurses or doctors take photographs of my wound. They didn't take very good photographs. I wasn't in the position to tell them what to take pictures of because I hadn't even looked at my own body.

There was a woman there who was from the rape crisis center. That was her job there. She was there the entire time but I don't think she took the pictures. She stayed with me when everyone else was gone.

They took semen samples. And hair samples and nail samples. I know that they took a very long time, the doctor and the nurse practitioner. They were there setting up some camera and they were supposed to take pictures of me internally, the damage. They dyed me with this blue dye and they took forever because they had to call some guy in it took like an extra hour because they couldn't figure out how to use the camera. Then they ran out of film, and there were like three other people in there, two other people. They were laughing about how they couldn't figure out the camera and stuff. It was pretty horrible actually. I was kind of amazed that it was all happening like that but—so they finally got those pictures and said that they would be good evidence in this case, which was the reason they were going to such lengths to do this. There was a lot of semen. Then I left.

My relatives came to the hospital, but I didn't ask them to be present at the interview because I didn't want them to know everything about what had happened. I didn't have them call them until I thought we were almost done.

I found out that his arraignment was happening that Monday and this was on a Friday that it happened, so I had the weekend. Then, I think it was on Sunday, that the detective called me. I don't know which day it was but it was before they let him go. He said that they weren't going to charge him and I didn't understand why and then they told me that I should talk to the D.A. {District Attorney} but that it was because there wasn't enough evidence basically that I had been raped because I was an escort and it would be hard to prove that it wasn't consensual.

The detective told me I had to talk to the D.A. I called him, and it was a couple of days later that I talked to him, the detective also told me that I should go to the arraignment and that him seeing me there would make him angry and they can proceed with the investigation. So I went there but I couldn't stay, I just couldn't handle it. And I didn't understand why they wanted me there anyway because all the people were being held behind a wall, you couldn't even see them, but apparently they had him in there but the detective told me, he told me specifically, he told me, 'I'm not going to tell you not to go I think it would be helpful if he saw you for the rest of the investigation.' So then I came home and I ended up talking to the D.A.

I think that day on Monday and he said that the reason why they weren't charging the case was because it was, because I had a diaphragm in, I was an escort, it was going to be hard to prove that it wasn't consensual and he said that I should just do whatever it was that the detective wanted me to do to further the investigation and just work along with him and he was a very good detective and he had a plan.

Then I talked to the detective again and he asked me to come down to the police station. I went down to the police station I think the very next day after, and he wanted me to do a taped conversation with the guy who raped me. We tried to call him several times and nobody answered. He wanted me to say, 'You never did pay me and I had to pick up the bill and I had to pay the agency,' and try to get him to admit that he had done it, because his statement said that I was just angry because he didn't pay me enough, but he didn't pay me anything.

The same day that morning when I identified him, they showed me a knife and I knew it wasn't the knife that he used and then they showed me another knife that night. I thought that it might be the knife, but I wasn't sure. They said I had to come in and identify the knife and I couldn't be certain that it was but I thought it might be.

I went there and I wasn't staying at home at that point. I hadn't been home for a while. None of my roommates were here either so I went down the night that we had planned to meet to do the phone calls. The detective wasn't there and someone told me that the detective tried to reach me and told me that he had gotten a call from him saying that he was going out of town. 'Jim' called the detective to ask for his things back that they had taken from him. The detective said that he tried to talk to him and he was trying to get a phone number where he could reach him to do this call but 'Jim' said he would call him back when he got back into town and he never called him back. I guess he never got back into town that I know of.

He's pretty much a dead beat. I hired a private investigator and he found out a bunch of stuff that I didn't want to find out. The private investigator told me that 'Jim' hasn't paid rent and he told me about some charges for violating some laws.

I talked to the detective on the phone since then. He always told me that I needed to talk to the D.A. So I talked to the D.A. for an hour one evening and he told me some story about why my case isn't being charged. He told me that on paper my case was different and it would be hard to convince a judge and a jury that it was not consensual no matter how strong of a witness I am. And I told him, I mean, I could be a strong witness. As a character reference I know people who would stand up for me and help me. He didn't want that.

The other thing I thought was strange was that I had to tell the detective to look for certain things, they weren't even thinking about it. The day afterwards I asked them, actually when I was there with him, when I first met the detective, when I identified 'Jim' at his apartment, I said he took a piece of paper of mine that was in my car and had my name on it and he wrapped the knife in it before he got out of my car and you might want to look for that. Nobody ever looked for it outside or the piece of paper or anything. They knew that the agency had called 'Jim's' apartment while I was there and 'Jim' told them that I never showed up. I told them that in my statement. They tried to get the phone bill but they never subpoenaed it they just asked them for it.

I had talked to the detective and I told him that the D.A. told me I was supposed to harass him to help me. They didn't even know where 'Jim' was. They have no idea where he is. The detective told me he was counting on my private investigator to find him.

It's really frustrating because I know what they're going to tell me. The D.A. always tells me to talk to the detective and the detective always tells me to talk to the D.A. They're always rushing me off, they always tell me to talk to the other guy. I have a few lawyers in my family but none of them know I was an escort so I couldn't go to them for help.

After the last time I talked to the detective I told him that I wanted him to find 'Jim' and I felt that he hadn't done enough for me. I mean I'm angry at him, and then he never called me back.

Telling a Woman/Driving at Night

I tell a woman
what work I do for money
Don't you ever feel afraid?

She asks, staring into the headlights
through a curtain of long, brown hair
which obscures half her face
like Veronica Lake

Yes, I'm afraid
Sometimes I try not to feel afraid
Four months ago I was raped
I was afraid of being tortured or killed

I answer, driving my dark green Vega
wearing a turquoise angora sweater
dark red lipstick, new hairdo, good pants

I'm stronger, won't quit
and they're not going to stop me

She laughs and pushes the hair behind her ear
Bars of light drift upward, over our eyes

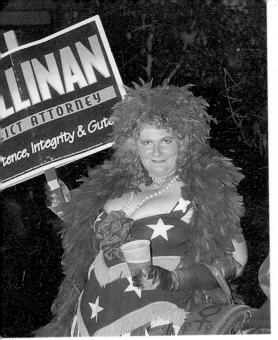

Photo: Marliese

Prostitutes Oppose Munipimp

[Reprinted from *San Francisco Bay Guardian*, December 8, 1993.]

As a proud San Francisco prostitute, I have been very angry at reports that San Francisco is moving toward forced brothelization of prostitutes. As the birthplace of the prostitutes' rights movement in the United States, this city is unlikely to go along with any reform that offends decent women and decent prostitutes . . . or even indecent women and indecent prostitutes. Not if we can help it. If the Board of Supervisors wants to own a brothel, it can buy one. I might even work there. It would take a pretty huge building to house all three or four thousand of us. We'd probably need all of City Hall or the Moscone Center, and I don't think the Supervisors want to give those up.

Of course, we want the right to work in brothels. Brothels are fine, if there are other options. Most of us are too independent to work in one. We need to be able to work legally in private apartments, as escorts at hotels, at bars, and in commercial neighborhoods without the danger of getting arrested.

Prostitutes don't want San Francisco to grant itself a monopoly and make the state into the pimp. Now, I don't categorically condemn "pimps." I don't like management in general, on principle, but people use the label "pimp" against anyone that they think shouldn't have our money. When power brokers want our money, they call themselves CEOs. People swear they're against pimps, and as soon as we turn around, they are ready to turn San Francisco into a Munipimp. Prostitute activists around the country are fuming. All ten of us.

This media campaign milking Supervisor Terence Hallinan's notion about re-creating Germany's Eros Centers in San Francisco is depressing. Now everyone thinks that San Francisco prostitutes will go along with a city-as-pimp system. I'm so humiliated. What about all those uptight feminists in

New York and the Midwest? They keep telling us that our liberal buddies will sell us out, that next we'll be doing hand jobs to fund Candlestick Park. They'll probably think we put out a press release: "Prostitutes So Happy about Being Locked Up in Tacky Brothels and Giving Half Their Income to the Board of Supervisors." I don't know what we're going to do to convince our sisters that we care about women's well-being and safety. Maybe we'll have to offer up the tricks to assuage them. We could agree to put the tricks in jail. Some people like that idea—but then some people like city-run brothels.

Hallinan told me that he never mentioned the word brothels except in passing. It was just the press. That's comforting. Hallinan has been an excellent ally for progressives and he's probably the only mensch on the board. Maybe that's the problem. Men always say they want prostitutes locked up and tested. That way clients don't have to worry about getting arrested, or robbed by the women. If men don't want to use condoms, they don't have to worry, because the women are "government inspected." Many people want to inspect prostitutes. The idea is tempting, but this city should resist mandatory testing in any form.

What about Nevada's system of brothels and registration? There they pulled a fast one by having the counties vote on whether to allow brothels, but the women who work in those brothels aren't allowed to vote in the county. Sure, they can pass legislation like that in rural Nevada counties, but not in San Francisco, a hotbed of prostitute activism. It couldn't happen here, could it?

'94 is the Year of the Whore, and San Francisco prostitutes are excited about the city's new prostitution task force. We worked hard for months to secure representation for prostitutes and advocates. We have been working all year to create a climate for mediation, doing street outreach in the Tenderloin. The task force will study prostitution laws and regulations in other cities nationally and internationally, and "explore all options for reform." That's a solid agenda.

By the way, I know that I have the right to have sex for any reason I want, including money. There's only one problem. If I say anything besides "I hate prostitution. I think it's disgusting," then that could be considered pandering. Maybe we need a moratorium on arrests so that we can exercise our free speech while we're participating in this study. That's a great idea. I'm holding my breath.

Economic Justice for Sex Workers: A First Hand Look at the San Francisco Task Force Report on Prostitution

[Reprinted from *Hastings Women's Law Journal*, Winter 1999.]

Introduction

There has been much debate about prostitution law reform over the last few decades. Although historically there have been reformist efforts and movements concerning prostitution, the prostitutes' rights movement, as we know it today, began organizing in the late 1960s and early 1970s. The difference between the contemporary prostitutes' movement and previous efforts is that prostitutes themselves have, in large part, defined the current movement. Prostitute activists have defined prostitutes' legal status in specific ways since the beginning of the prostitutes' rights movement. The current movement includes a recognition of the rights of prostitutes to autonomy and self-regulation.

One recent effort at reforming prostitution was the formation of the San Francisco Task Force on Prostitution (Task Force). As a "working prostitute," I represented San Francisco's Commission on The Status of Women on this Task Force and I coordinated the writing of its Final Report. I was fortunate to be part of the two-year process that led to a recommendation of decriminalization. This article is a brief look at how I have come to define the terms commonly used in the debate surrounding prostitution, a look at how the Task Force came into existence and excerpts from its final report.

Defining the Debate

There is no "official" definition of legalized or decriminalized prostitution. Often those who are not familiar with the "activist" discussion about prostitution law reform use the term "legalization" to mean any alternative to absolute criminalization, ranging from licensing of brothels to the complete absence of laws regulating prostitution. Most references to law reform in the media and in other contemporary contexts use the term legalization to refer to any system that allows some prostitution. These common definitions of legalization are extremely broad. Conflicting interpretations of this term often cause confusion in a discussion of reform.

Members of the San Francisco Task Force on Prostitution left to right: Art Conger, Rachel West, Dr. Judith Cohen, Margo St. James, Carol Leigh and Vic St. Blaise. Photo: Kat Sunlove, *Spectator Magazine*

Many (or most) societies that allow prostitution do so by giving the state control over the lives and businesses of those who work as prostitutes. For prostitutes, legalization often includes special taxes, requirements that they work in brothels or in certain zones, licenses, registration requirements and government records of individuals, and health checks which often means punitive quarantine. The term legalization does not necessarily refer to the above sorts of regulations. In fact, in one commonly accepted definition of legalization, "legal" can simply mean that prostitution is not against the law, which others refer to as decriminalization.

Legalization

From an activist perspective the term legalization as applied to prostitution usually refers to a system of criminal regulation and government control of prostitutes. In this system, certain individuals or specific prostitution practices (work venues, etc.) are explicitly recognized and "legitimized" by law, and practices or individuals outside those boundaries are illegal. These systems usually "legalize" a minority of individuals, and/or a narrow range of practices, so that many prostitutes and prostitution activities remain criminalized. Examples of such systems are seen in Switzerland, Nevada and a recently dismantled system in Taiwan.

Although the term legalization may be understood to imply a decriminalized, autonomous system of prostitution, activists use this term to describe

the reality of its use: police regulating prostitution through criminal codes. Laws regulate prostitutes' businesses and lives, prescribing health checks and registration of health status (enforced by police and, often corrupt, medical agencies), controlling where they may or may not reside and prescribing full time employment for their lovers (France) to give a few examples. Prostitute activists use the term legalization to refer to these systems of state control defining the term by the realities of the current situation rather than by the broad implications of the term itself.

Decriminalization

Prostitutes' rights advocates call for "decriminalization" of prostitution and usually use the term decriminalization to refer to an absence of specific laws criminalizing or legalizing prostitution. This would be accomplished by the repeal of laws against consensual adult sexual activity, in commercial and non-commercial contexts. The above definition also implies that decriminalization may be a process, and various legislative reforms may be viewed as decriminalizing.

Asserting the right to work as prostitutes, many claim their right to freedom of choice of management. They claim that laws against pimping ("living off the earnings" of prostitutes) often serve to prevent prostitutes from organizing their businesses and working together for mutual protection. Laws which criminalize "living off the earnings" of a prostitute, in effect in California (as well as throughout the U.S. and in most countries), may criminalize much of a prostitute's support system including a prostitutes' co-workers, landlords who rent to prostitutes, domestic partners, etc. Prostitutes report that even adult children and elderly parents may be charged as "pimps" under this type of legislation. Activists call for the repeal of current laws, which interfere with their rights of freedom of travel and freedom of association.

To address the exploitation and abuse that "anti-pimping" laws might have targeted, prostitutes' rights advocates call for the enforcement of laws against fraud, abuse, violence and coercion to protect prostitutes from abusive, exploitative partners and management.

Regulation

It is very difficult to invoke concepts of self-regulation or industrial rights in a context that views prostitution as a "social evil," or presumes police control over prostitutes. The "regulation of prostitution" usually refers to regulation through criminal codes, and the prostitutes' rights movement has been uniformly opposed to such regulation. Regulation may also refer to civil regulation and self-regulation. Prostitutes' rights activists call for industrial rights, health insurance and safety codes applied in workplaces, all of which may be guaranteed in a rubric of labor codes. In the case of solo and collective work arrangements, activists call for measures that afford prostitutes control of their own lives and businesses, such as enforcement of laws against discrimination in the rental of premises and in advertising.

Abolitionism

The modern abolitionist movement had its start at the end of the last century partially in response to the abusive prostitution regulatory systems spawned by national efforts to curb the spread of venereal disease. This movement had a great deal of influence throughout much of Europe, Canada and to some extent the U.S. Although many early abolitionists targeted the "regulation" of prostitution, the emphasis of the movement ultimately shifted, advocating the criminalization of most of the activities surrounding prostitution businesses, though not of prostitutes themselves. Current abolitionists define sex work as inherently exploitative, defining prostitution as violence per se, and emphasizing involvement in prostitution as a response to childhood sexual abuse. Historically, abolitionists have dedicated themselves to rescuing women from prostitution, and training women to find alternative careers or security in marriage. Abolitionist groups want to end the institution of prostitution, envisioning a world where no one sells sexual services for any reason. These organizations do not define themselves as prostitutes' rights organizations. They work to limit or abolish the sex business, advocating against pornography, strip clubs and the like.

The Creation of The Task Force

As a prostitute, an activist and an outreach worker on San Francisco streets, I have had a range of experiences with women and men who work in various types of prostitution and other sex work. I have also been involved in feminist debates around issues of sexuality and sexual representation as a feminist activist since the early 1970s. It is clear to me that there are many diverse perspectives among feminists and prostitutes. There are also many diverse experiences. The San Francisco Task Force on Prostitution recognized this diversity of experiences, concluding that "prostitution is not a monolithic institution. . . Because it is such a varied industry, the City's responses must vary as well."[25]

The report began with the premise that current responses were ineffective, as well as harmful: "They marginalize and victimize prostitutes, making it more difficult for those who want out to get out of the industry and more difficult for those who remain in prostitution to claim their civil and human rights."[26] As prostitution crimes are determined by state laws, the goal of the Task Force was to recommend that "City departments stop enforcing and prosecuting prostitution crimes and redirect funds from prosecution, public defense, court time, legal system overhead and incarceration towards services and alternatives for needy constituencies."[27]

The Task Force was originally formed in response to various media outcries and campaigns. One City supervisor decided to tackle the "prostitution problem" head on. The San Francisco Task Force on Prostitution was organized by an iconoclastic son of a "communist" lawyer, Terence Hallinan, and his aide, Jean Paul Samaha, a gay rights activist.[28]

Hallinan was one of the most progressive members of the Board of Supervisors and stood in opposition to Mayor Jordan's punitive "public order"

[25] *Final Report of The San Francisco Task Force on Prostitution 4* (submitted March, 1996 to the San Francisco Board of Supervisors)

[26] Ibid.

[27] Ibid. at 6.

[28] It was Samaha who had called me after hearing about my work. He had seen an ACLU newsletter discussing the censorship of my video, *Outlaw Poverty, Not Prostitutes.*

programs. However, he was reluctant to propose decriminalization, assuming that the City should certify and control prostitutes. He publicly announced his intention to study options for legalization. Hallinan had initially established the twenty-eight person group with the assumption that the interests of prostitutes and communities could best be served through some sort of legalization plan. Prostitutes' advocates and women's groups quickly protested this strategy in unison. Some of us worked with Hallinan's office and insisted that the agenda of this study group should examine law and social service reform rather than legalization.

From the start of discourse, the Nevada style was rejected from the merchant-gentrification perspective, because there was no guarantee that allowing legal indoor prostitution would decrease street prostitution anytime soon. Also, from a prostitutes' welfare perspective, it was assumed that establishing a legalized indoor system would further scapegoat and marginalize those who were on the streets and unable, for various reasons, to work indoors. It became clear to the group that opinions were generally divided between those who favored prostitution law enforcement as a way to address problems with prostitution, and those who favored decriminalization.

Hallinan's Task Force was comprised of Health Department representatives, legal advisors from the Public Defender and District Attorney's offices, and a representative from a State Senator's office as well as health outreach rights groups and neighborhood/merchant group representatives. The differing interests of those representing the latter factions became obvious during a debate. When it became clear to those who favored the law enforcement approach that the majority of those present favored decriminalization, the six representatives from neighborhood/merchant groups resigned.

Among those remaining a compromise was ultimately reached. The report recommended that, rather than arresting individuals for prostitution, the City should focus on infractions about which neighborhoods complain directly, such as noise and trespassing. This compromise was controversial, even within the progressive milieu of the Task Force as many members—including most notably Rachel West from US PROS—pointed out that "the current prostitution laws are enforced disproportionately against sectors discriminated against as a result of their race, sexual orientation, national origin, and/or economic background. Illegal arrests and harassment are common." [29]

Thereafter the Task Force added that,

[29] Rachel West, TASK FORCE REPORT, Appendix D (on file with the San Francisco Public Library).

Municipal Codes relating to public disturbances should not be used to target any population including homeless people or prostitutes. When fines are disproportionate or excessive, prostitutes may work additional hours to pay the fines. Such a structure can defeat the potential for efficient allocation of City resources away from expensive criminal prosecutions, thwart a policy of reducing street solicitation and can result in a breach of civil rights.[30]

Despite the diversity of opinion and the polarity of some views, the final report and agenda of the Task Force reflected the concerns and ideas of all constituencies that had been brought together on this important project. This is partly because the City supervisor had a progressive base of support ranging from the National Lawyers' Guild to the National Organization For Women- and because San Francisco is predominantly a liberal city. The Task Force recommendations support a humane, feminist agenda, which places the well being of women and marginalized individuals as the highest priority. These priorities were fine-tuned through long-term research and negotiation.

The complete report was comprised of an introductory summary of approximately fifty pages and five volumes of appendices of background material, including statistics on arrest and incarceration rates, texts of relevant laws, testimony of prostitutes and reports on research conducted over the nearly two-year period. These materials are available through the San Francisco Board of Supervisors and the San Francisco Public Library in the Government documents section.

Conclusion

The Task Force document has been an important tool in articulating the benefits of a system that does not penalize prostitutes. The document was published at the City's web site and has been read internationally.[28] The report has been translated into Hungarian by Salamon Alapitvany and Ildiko K. Memorial Civil Rights Institute and into Chinese by the Solidarity Front of Women Workers in Taiwan.

[30] *The San Francisco Task Force on Prostitution Final Report* is also available online at http://www.bayswan.org/SFTFP.html

Since the Task Force Final Report was submitted, and the Task Force dissolved, the Exotic Dancers' Union became part of the Service Employees International Union, Local 790 and the Commission on The Status of Women endorsed support for decriminalization. During the course of the Task Force, the Board of Supervisors adopted a resolution "urging the Mayor to urge the District Attorney and the police commission to no longer confiscate and/or alter or use the fact of condoms possession for investigative or court evidence in prostitution-related offenses." The US PROstitutes Collective, with the support of Supervisor Tom Ammiano launched a petition campaign to "implement the recommendations of the Task Force." Supervisor Hallinan launched a campaign and won his bid for District Attorney based on a platform which included support for decriminalization of prostitution. Margo St. James, a prostitutes' rights advocate representing COYOTE on the Task Force, came very close to winning a seat on the Board of Supervisors.

Decriminalization of prostitution is a long-term strategy, arising in San Francisco in the midst of a repressive political climate, which looks towards punitive strategies to address social problems such as arrest of homeless people, the "war on drugs," and exemplified by the increasing prison populations. Since the Task Force report was submitted to the Board of Supervisors, the police have moved in the opposite direction. Prostitution law enforcement efforts have stepped up and moved indoors. Currently police are targeting massage parlors and private homes for prostitution arrests.

This latest rash of arrests has spawned organizing efforts and coalitions among those who are targets including strippers, massage parlor owners and workers, fetish service providers and others.

The Task Force Final Report provides a basis for advocacy to improve conditions for sex workers and to challenge the discrimination that results in increased violence and harassment, health risks and economic and other coercion in sex work. Like prostitution, the "decriminalization of prostitution" has also been viewed as monolithic, prescribed as a cure-all, or criticized as "anarchy." Media reports and civic responses to prostitution become focused on a specific moral judgment and the details about the diverse conditions and aspects of commercial sex become obscured. The Task Force Final Report was part of a shift in the contemporary mainstream discourse towards a vision of sex workers as human beings with the same rights as other members of society. In this context, the report moves San Francisco's government towards a consideration of civil and industrial rights options for prostitution law reform.

Whoretopia

Every whore has their own idea of Whoretopia. For some, there would be endless well-paid sexual encounters. For others, the sex would be transcendental, a cure for all the ills of the world. For others there would be no sex, only money! This would only be whoring in the most abstract sense . . . too abstract to explain.

Would prostitution exist in a perfect world?

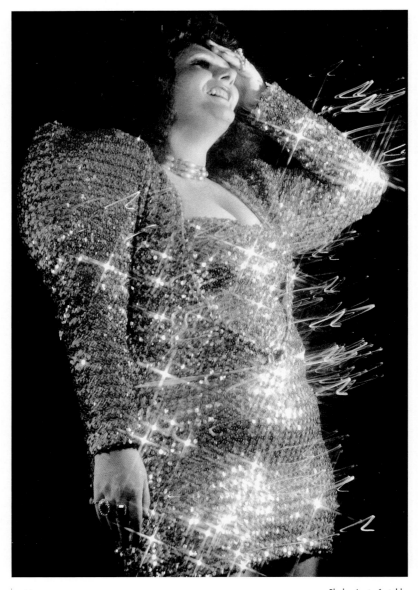

Photo: Annie Sprinkle

Socrates, Sarcasm and Survival Strategies

[Reprinted from *Sex Work*, Cleis Press, 1987; originally published in *Appeal To Reason*, 1982.]

Well, here I am again. The Whore. I admit it.

Oh, no. This can't be, you think. Not an actual, real-live prostitute spilling the beans? Isn't that dangerous? Won't she be arrested? What if her mother finds out?

And dangerous it is. Yet I forsake my well-being in an effort to satisfy your overwhelming curiosity about what prostitution looks like from the inside out.

Besides, I'm proud. Sex work is nurturing, healing work. It could be considered a high calling. Prostitutes are great women, veritable priestesses. Maybe that's an exaggeration.

"Prostitutes always glorify their work," says Margo. "They have to glorify it or they couldn't stand to do it."

Margo is an ex-prostitute. Ex-prostitutes are out of touch with the true glories of the trade. Plus, they were never very good at it. That's why they're ex-prostitutes. Ha ha. But I suppose everyone has their prejudices.

And so I strive to sift these complexities, to seek and present The Truth. Naturally, I've been barraged with letters from the curious masses. I've edited their substance to the quintessential. For instance:

Dear Scarlot,

Is it true that women made prostitution illegal? You said so once.

—Doubtful

Dear Doubtful,

No. I was over-reacting. I exaggerated. I guess I'm just angry at everyone. But some women helped.

Dear Harlot,

Is anything you say true?

—Just Wondering

Dear Wondering,

Yes.

Dear Whore,

Me and my friends never even think about prostitution. You shouldn't assume everyone is curious. By the way, what is truth?

—Socrates

I am the whore . . .

[Reprinted from *Autobiography of a Whore: The Demystification of the Sex-Work Industry*, Whorepower, 1983.]

The whores don't agree

One believes she is different
She has more choice
Another predicts doom
She is destined to become a victim

I get the message

The girls are right
The women are right
The whores are right
My friends are right

I am like them I am not like them

I am the good whore, the rare whore, the exception

No! I do not represent the whores!
The bad, angry, distrustful whores!

Hear the sweetness, confidence and trust in my voice
I am like them I am not like them
I have even begged at a N.O.W. meeting for support for decrim
In the name of the whores

Like them
I eat my fear of violence
I swallow the knowledge
that my sisters are jailed and beaten

I am like them I am not like them

I I I I I
I am the whore I am the good bad whore

Bad whores are vultures
feeding on the remains of the decayed
patriarchal system

They eat loneliness and shame
It passes through them
unchanged

I also work that way

I am like them no I am not like them

I am the strong, successful, independent-minded, creative
Whore !
I am the my mother loves me
Whore !
I am the fair to my clients
Whore !
I am the feminist
Whore !
I am the want power want money want glamour
Whore !
I am the whore who is proud of being a
Whore !

New definition: Whore means full body power sexuality power

Whore means get more!

When I have my way there will be no more of them

In the future whores
will be
Wise and
Holy and
Full of love

This poem is for the whores
This poem is about the whores
This poem is by the whores

whores whores whores whores whores

Shameless Pagan Whore

[Reprinted with permission from *Widdershins*, Beltane, 1996.]

Carol Leigh, AKA the Scarlot Harlot: sex worker, all-around good-time gal, sacred whore, pleasure activist deluxe, Goddess worshipper, witch and outrageous woman tells us what it's all about.

Sylvana SilverWitch: Describe yourself. Who and what is Carol Leigh, or the Scarlot Harlot?

Scarlot Harlot: I am a sex worker, life artist, bisexual, feminist, anarchist, pagan, humanist, poet, performance artist, video artist—and of course I don't like labels.

Sylvana: What is a whore, and what is a sacred whore? Is there any difference?

Scarlot: It's a continuum, I think, and then it also depends on whose perspective. Life is sacred, whoring is sacred, so all whores are sacred whores, from one perspective. Then there are those who define themselves as sacred whores. I was introduced to the Goddess through feminism about 20 years ago. I think my spirituality and belief systems are pretty idiosyncratic, and some might say essentialist.

As a hippie in the '60s, I was an earth mother, and since then I have embraced a vision of peace and compassion I associate with being female and nurturing. I know all sorts of feminists invoked all sorts of goddesses, and warrior goddesses were in vogue. Actually, Hecate, the goddess of the crossroads, was my special friend, because I was always on the edge . . . which is always a sort of crossroads. Now Squat (goddess of parking, finding one's place, etc.) is my favorite.

from *Sluts and Goddesses Video Workshop* by Annie Sprinkle and Maria Beatty. Photo: Tracy Mostovoy

Sylvana: How did you come to the Craft and service of the Goddess?

Scarlot: I was introduced by an anti-porn activist, Marcia Womongold, in around 1973. She embraced a variety of non-mainstream types of feminism. I met her in a women's writing group I founded in Boston.

Also part of the group was Hima, a stripper and poet as well. She was also a pagan and came to her service to the Goddess through [what some of us now call] sex work.

Sylvana: Have you always considered prostitution a sacred profession?

Scarlot: I embraced and invoked the Goddess before becoming a prostitute. When I started working, one of the first things I did was organize a circle among my whore friends, pledging our work to the Goddess.

Sylvana: Does sacred whoredom always involve charging money for sex?

Scarlot: Good question! There are sexual healers who don't receive monetary compensation, who identify as sacred whores in some way. I believe in accepting people's self-definitions, and anyway, if a person wants to call themselves a whore, I say, welcome, sister (and brother, for that matter).

Sylvana: Does the sex always ring true as a divine act, or does it sometimes fall flat?

Scarlot: I remember reading an old text (maybe ancient Greek?) in which a writer was complaining that the supposedly sacred temples were mostly really very secular and involved 'just plain ole whoring.' What is a divine act, anyway? Some say to the Goddess, all acts of pleasure are sacred.

Sylvana: What elements need to be present to have sex as a sacred act? What about sex for money?

Scarlot: As you see, I have a broad definition of sacred. For me, sex that contributes to healing and pleasure of the individuals, as well as peace in the world, is the most sacred.

Sylvana: Have you been happy in your profession? What has it done for you personally?

Scarlot: I love the whoring in many ways! I mostly like the issues and the politics, and the power of the imagery—whores, lacy underwear, leather whips. I like the secretive air around the trade. I love sex money, making money from sex. That has a positive magic to it we haven't explored much during these times. It's about the many kinds of power that sex has, as a mirror of our psyche, as a

way to get by when there is no other way, and more and more. This might be kind of 'essentialist,' as some say these days, but to me respect for sex means respect for women, because women are the source of some creative aspects of sexuality (childbirth). To reject sex, sexual power, through censorship, through stigmatization of sexual survival and spiritual sexual practices—according to my beliefs, that rejection will accompany rejection of women's power. Acknowledgment of sexual healing and power is part of my spirituality. At the center of my spirituality is a desire to increase the compassion on the planet, which means awakening the Goddess.

Sylvana: One of the things people use when they argue against prostitution is that women are forced into it or exploited; can you speak to that?

Scarlot: They usually are both, more or less. Force and choice are a continuum. I am forced to work basically at any job, and exploited, for that matter. I think whores are more forced and exploited than others. We need more respect, people advocating for our rights, etc.

The most problematic prostitution comes with industrialized poverty and imperialism. Will we ever see an end to the social conditions in which a very large percentage of the planet is exploited and oppressed for the benefit of a very small portion? As Americans, many of us are on the receiving end. Wouldn't it be great if we lived in a Utopia where every act was a matter of choice? I guess some people can create it for themselves, and perhaps that is a way their sexuality expresses itself.

The solutions to forced and exploitative prostitution have everything to do with economic equity. Some people use the suffering of those who are working and existing in these conditions as an indictment against the sex-for-money-trade. As Cheryl Overs from the Network of Sex Work Projects, said:

> "The persecution of sex workers is inexorably linked with the idea that sexual services should not be sold. Churches and other conservative institutions that have always held this view have been joined in recent years by feminists who argue that prostitution should be abolished because it is inherently exploitative. Sex workers are seen as victims who are 'forced' into prostitution either by violent coercion or economic circumstances.

To sustain these ideas involves dismissing the voices of prostitutes, or listening only to those whose experience and perceptions fit the idea that commercial sex is abusive." [31]

(The sex workers' movement emphasizes political participation of both current sex workers and former workers, not just those who will renounce the work, by the way.) My point is, there is a growing movement of sex workers who identify as pagans, witches, devotees of the Goddess, etc., who question the basic concepts that stigmatize the sex-for-money exchange, perhaps in that they are the baggage of a civilization that has been formulated to reduce women's power, to overthrow the Goddess.

Sylvana: How do you see yourself in relationship to the Craft or Goddess communities?

Scarlot: I am part of a circle of male and female sex workers in the Bay Area. I hope to expand this part of my life, and I hope one day to be part of a powerful circle of sex workers, a church of sorts, supported by sex work, and supporting sex workers, particularly many who I see all the time who are forced into this work. I admire the Sisters of Perpetual Indulgence, and the charity work they do, and I am interested in developing a spiritual group with an emphasis like that, art and charity.

Sylvana: Have you had any problems with discrimination from the Craft or Goddess communities?

Scarlot: I am not one to say, because I haven't put myself out there very much. Over the years many pagan-identified whores tell me they aren't out in the pagan community because people judge them, and they would be rejected. This may be changing to some extent, and it's good to acknowledge that, but from what I see, it would be hard to be a whore in many pagan communities. My advice to non-whores is never assume the person you are talking to isn't a sex worker. This way, you will be less likely to say something that would make us feel marginalized. We are still in the closet to a great extent. It's a touchy issue, and a person has to be pretty educated about sex workers' perspectives to know what can be insulting. Here is an example: "I support sex workers, but not sex work."

Sylvana: What would you say are the negative aspects of the 'oldest profession'?

[31] *Whores and Healers.* Dir. Carol Leigh. Video. Whorepower Productions, 1991.

Scarlot: The stigma and alienation. Really not wanting to but having to do it to support a drug habit because drugs are illegal. (Not all users who work feel this way, but some do.) The laws make it almost impossible to really protect ourselves from rape, and violence. Obviously, literally forced prostitution, is part of the most negative aspects. In terms of negative aspects of my day-to-day work . . . one needs to be strong and assertive, and I'm not always that strong or assertive. Generally, clients are either nice or neutral, but the exceptions are annoying—not to mention the sociopaths.

I wish whores were respected for the service we provide. Some of my clients act like I do this because I'm just horny, not acknowledging that I am a professional. They pressure me to tell them how much I like the sex with them. (And it's not like I don't respond. I do, a lot.) It's like they are confused about my motivations. If sex work was respected, I think the clients wouldn't bring all this guilt and confusion into the sessions. It could be better for both of us.

Sylvana: What would you say are the positive aspects of the sex industry?

Scarlot: Money. Inspiration for my art. Having a job that involves human interaction as opposed to factory work. I like working lying down in bed in pretty underwear. When I worked a lot, much of the work was on the phone, arranging dates. Now I see regulars, so most of my work is really in bed.

It's kind of a fun way to make money for me. But I did get bored with it after 20 years. I love it as a part-time way to have a bit of odd sex and make pocket money, but I remember before I found another way to make money, I was getting very tired of the work, and I was really worried that I wouldn't find another niche.

In terms of spiritual practices within prostitution, I am definitely not well versed in spiritual sexual practices, as are some of the whores in the book *Women of the Light*, such as Annie Sprinkle, Juliet Anderson or Jwala for example. I offer accepting, affectionate, loving energy, and it ties in with my dedication to increase these qualities in the world, but I'm not exactly a shamanitrix, like Debbie Moore, for example. My dedication to the Goddess has always had a political orientation, so as a holy whore, I see myself as a builder of the church rather than as a healer—although I have studied a variety of healing arts such as herbology, tarot and several massage disciplines.

Sylvana: Can modern women utilize this aspect of the Goddess to reclaim their sexuality and power?

Scarlot: Loving the Goddess means learning to love myself in a way I never could without Her.

Sylvana: How about the male's role in all of this?

Scarlot: Men as clients? This is a long story, but when I think about the best gender relationships, the first thing I toss out is the compulsory heterosexual nuclear family. Of course, it works for some people very well, and I think they are lucky that it does, given the prejudices in the world. But it seems like it's an impossible model for about 80 percent of the population.

That's why it drives me crazy—because it really works for so few. I associate this compulsory pairing with the patriarchal goal of patrilineal inheritance. But without this institution of compulsory pairing, in which other sexual options are stigmatized and criminalized, what kind of relationships would men and women have? What role would prostitution have? How would women be supported while and for raising children, and how would men contribute?

Sylvana: How can today's man learn to embrace the sacred whore, rather than fear and revile her? How about the sacred whore in him?

Scarlot: He can give me money! Just kidding. But not really.

Anyway, if he wants to love whores he can keep a little Goddess statue by his bedside. Or he can dress like a girl. Or he can even watch reruns of Bewitched. He can masturbate and think of the Beautiful Goddess and her Wondrous Vulva while he does.

Sylvana: Are there any other ways to use this energy other than becoming a sacred prostitute?

Scarlot: When one even uses the energy at all, she or he might be called a sacred prostitute.

I think we can take the role with our partners, any gender, any combination. Most people have sex in a very ordinary model, kind of like in the porn movies. Most people are afraid to really regard, look at or change their practices at all. It's nice, though, just to light candles first and invoke the Goddess. Or gods and goddesses. Dedicate your sexual encounter to a pur-

pose. More structure can be nice occasionally. Sensate focus is good, and massage. Find a good sex teacher (a.k.a. sacred prostitute).

Sylvana: What exactly do you think is the problem for most people with prostitution? Is it that people are having sex? Or that money is being made? What part of those things is bad? We don't think it's bad to spend money for anything else, or to have sex in other instances; why does it suddenly become bad when put together?

Scarlot: I don't know either, although I think about it. Perhaps the taboo around prostitution is one of the pivotal taboos that structure our civilization—perhaps, as I suggested earlier, because it's another way to make sure there is a mandatory system for patrilineage.

Prostitution is historically one of the main alternatives to marriage/coupling in terms of sexual relations between men and women. Without mandatory marriage (which results from all other options being criminalized and stigmatized—like lesbian partnership, 'free love', polygyny/polyandry, etc.,) we would have no patriarchy. The monopoly of property ownership by men that characterized early patriarchy was based on inheritance through male offspring. Without mandatory marriage, the identity of the father is not 'official'.

And why are some feminists so against it? Once we are fighting for the crumbs of self-determination in this patriarchy, then the non-whores are pitted against the whores. The beautiful women in magazines who show their pussies compete for the attention of men. Our skills and availability is a valuable resource. We are potentially powerful, but the laws and morality of our civilization curb that power by punishing those who wield it. Still whores potentially place other women at a disadvantage.

Sylvana: Do you think prostitution should be legalized? How would that look? What might it accomplish?

Scarlot: The image of police arresting prostitutes has always seemed like a symbol of the worst aspects of society. Now that they have criminalized it, some prostitutes feel like they don't want to change things for various reasons, sometimes because one develops one's skills to work in a certain system, so one has to start from square one if they start changing the rules.

Some say the prices would go down, but on the other hand, one could earn more because one wouldn't spend half the energy dodging the police in one way or another. It evens out.

The women sure make more in Nevada—on a weekly basis, though perhaps not per trick—than people can make in illegal contexts, mostly because it's just harder to get the business when it's illegal. The call girls here I know who worked in Nevada say it's harder to make money here. The Nevada brothels are a bad system of legalization, however, where the pros' rights are unconstitutionally limited. Decriminalization is preferable.

In terms of regulation, labor codes and OSHA work well, and standard business codes, as opposed to the intensive controls governments often put on prostitution when they 'legalize' it.

Sylvana: Do you have any suggestions on how the people out there reading this can begin to make changes for themselves and our world in the area of sexuality and power?

Scarlot: I hope people will organize circles for sex workers with the goal of making money and sharing it with others. Of course, at the same time people will have to work on making this legal.

I suggest working with attorneys on constitutional challenges to criminalization of sex work, including sex-for-donation rituals that we need to fund our temples. I think this would be a new direction, at least for contemporary society.

I think it's important to reclaim the prostitute's role as healer, and organizations dedicated to helping those in less fortunate situations seem like a good way to do it. C'mon, all you WHOGs (Whores with Hearts of Gold)! I know you're out there!

Sylvana: Any last comments or any wisdom you'd like to impart?

Scarlot: People might not know about my videos, new feminist porn and great for vulva worshippers. They can get the info at my Web site. Also, I would like people to visit my web site at http://www.bayswan.org and write me a note when they get there. They might even want to join my club, F.L.O.P., Friends and Lovers of Prostitutes. They get a signed photo of me with no shirt on if they do.

Thoroughly Modern Madam: How to Make a Million Dollars in "the Sauna Business"

[Originally published in *Gauntlet,*Volume 1, Issue #7, 1994.]

Experienced whores can be great madams, of course. They should be given teaching appointments at our whore universities. How else can we learn to be safe and sane in this business?

Scarlot: How did you wind up owning a million-dollar-plus prostitution business?

Rebecca: My motivation for being in prostitution was financial, overwhelmingly financial. When I started working, immediately it occurred to me that this business wasn't run right. After two years, when the original owners sold the business, I said to the new owners, 'How much money do you want to pick up a day?' And they said, 'A hundred bucks each,' and I said, 'Fine, you can pick up two hundred a day. Just leave me alone. Let me hire who I want. Let me run the ads. I'll do everything.'

I had a lot of good things happen with the employees and they had a certain respect for me, but also there were a lot of confrontations and that came about because other women do not necessarily have the same motivation for being in prostitution. Some of them see this as a way of playing on men. 'Bring out all your feminine wiles and get him to be stupid' kind of mentality.

My approach to prostitution is very businesslike. I'm in competition with all the other saunas, with all the other prostitutes, and I'm even in competition with all the other ways they might spend their disposable income. I want them to come to my sauna instead of the golf course. I would do things or institute policies that were designed to make more money, but were not always popular with the women.

Scarlot: Why were they fighting you? Give me an example.

Rebecca: Well, when I first opened the place the shifts were ten hours long. I noticed that customers would call in the afternoon and say, who is working and it would be the same people who were there when they called in the morning and they were not interested in coming in. You've got five or six people on a shift and that variety is important to the customers. I also noticed that women had a lot of trouble staying awake until four in the morning. Ten hours seemed too long. When they first came in they were sort of up. Those last few hours they are dragging. Guys come in and they aren't too enthused about seeing them.

A lot of my confrontation with employees just had to do with the fact that human beings are resistant to change. First I changed the hours to three shifts. They said they can't make enough money in seven hours. I said, 'You'll make just as much, if not more, in seven as you do in ten because it's plenty of time for a guy who wants to see you to get over here. And business will improve, so we'll all make more money.' I told them they could still work the same number of hours a week if they want.

Scarlot: It's hard to believe they would fight that.

Rebecca: Oh, they fight you on everything. Every time you run a special, or you dream up a promotional thing, they fight you on that, too. But part of it is just human nature to resist change. But sometimes it comes down to a real difference.

One of the arguments we used to have is about not seeing customers. The WHISPER people say any woman should be able to turn down any customer she wants. I go, well, that's very nice in theory, and if you want to work alone, as a sole practitioner, I guess you could do that. I say, if it's for a cause, I will side with the employee, if he looks dangerous or drunk . . . the biggest thing I had is that they want to turn down black guys. Now, for the most part, they all have black boyfriends. Now, this is a town with only a small minority population. To a large degree all the black guys know each other. So, what the men say to the women is, you can't see black men because he could turn out to be my friend or something. And I'd say, 'Well, excuse me,' but if a guy comes to the door and he's got the money and he's behaving himself and he gets introduced to five women and they all go, 'Well, I'm sorry, I can't see you,' it's not okay with me.

Scarlot: Well, I don't like that. No manager has ever done that with me. In those days the other working girls told me not to let in black clientele.

Rebecca: Well, the manager makes the decision about who to let in and that has more to do with their age, the time of day, whether they are alone or with somebody, more things than just their race. Now if somebody says to me, 'Oh, I don't want to see him. I used to know him in high school or something. I'll say, 'Oh, fine, you're busy,' but what you can get is a situation where there's a certain customer and he would come in and he would choose to see someone and she would be happy that he chose her and she would go off, but before he had finished the shower, when they are all sitting in the lobby, the other four would start in about what a jerk he was. It's not that he's really a jerk. This was their way of getting back that he didn't choose them. You're constantly dealing with ego problems.

Sometimes I'd say, 'If you don't have something good to say about a customer, don't say anything. Just shut up.'

'Oh, he's so boring and he does this.' You gotta try to reduce that. If you let it go, pretty soon you have people turning down every other guy who came to the door, there'd be something wrong with. Probably, it would get real out of hand.

Scarlot: The only time I ever worked in a group was in a massage parlor in the Tenderloin. I worked with women from all over the world. We were all very supportive and our relationships were good. On the other hand, I heard that the women who worked at night used to fight. Our management was completely hands off. Yoko was the owner, a skinny junkie with a heart of gold. There were almost no rules or pressures. It was the sleaziest parlor in town. Maybe we made less money than the other parlors.

Another thing was, when I first started working there, we took turns. It reduces the conflicts.

Rebecca: But it's not good business. What if, the one who goes to the door, he has no interest whatsoever in seeing. If a guy comes to a place three times and he keeps getting somebody he doesn't want, it's very likely he's too embarrassed to say anything. He's usually too much of a gentleman. He hands over the money and does it and he's in the position of paying for sex with someone he doesn't even want to have sex with.

Necessarily, in a capitalist, free market system, you're going to have to compete and to prioritize business success over all of the feelings that women have. The problem is that your feelings don't have any place in a business. My theory is, just push it aside. We're here to make money.

Scarlot: Capitalism is the problem there. I don't like money to be that important that I would have to work in a competitive, stressful situation. It's more of an advantage to the owner. If we had a guaranteed fixed income or a socialist system, you wouldn't be pushed into that.

Rebecca: You wouldn't have prostitution, not in a society where everybody makes the same amount of money.

Scarlot: Yes, you would.

Rebecca: The person who is paying the money has the right. This is like going in a restaurant and they bring out whatever they feel like feeding you and set it down.

Scarlot: That's why the WHISPER people hate this. They don't like to prioritize financial need over women's feelings when there are other options.

Rebecca: I mean, I agree with that. We should have a choice about how to work. But there are different kinds of prostitution, so if you have a big problem with this kind of work environment, then you should work somewhere else or on your own.

Scarlot: But if a lot of the employees don't like it, then it's up to management to reexamine policies.

Rebecca: And that's what happened. Another thing they didn't like was most of the other places had only three women on a shift, but I had five rooms, so I figured I would have five to a shift. The girls at my place made as much and usually more money. They just didn't like the competition.

Scarlot: Didn't you have workers that were allies?

Rebecca: Yes. But other people would bitch and I would say, 'Everybody makes what they're worth.' Part of it was, they wanted to feel that they were each enti-

tled to make the same income, which is nonsense. Some are prettier. Some are friendlier.

Scarlot: It's not really what you are worth that is the point. It's what men will pay you. People don't like to think of their value on the sex market as equal to their worth.

Rebecca: In the long run you make what you're worth. I said, 'It's not hard. I can make a list of all the things the guys pay for. It's not a matter of you turning yourself into what you don't want to. Do what you want. Blondes make more money than brunettes. Big tits make more money than small tits. Thin girls make more money than fat girls. Young girls make more money than old girls. Girls who make noise make more money than girls who say no.' This isn't a hard thing to figure out.

Scarlot: My dream about prostitution is that, at the same time we need to make money and offer them what they want, at the same time it's important to influence them, change their priorities, develop their taste for older fatter women, because they'll ultimately be more satisfied, and we can keep our incomes going.

Rebecca: You can do that. But you gotta start out with what they like. It wasn't that hard for me because I went to work when I was twenty-four. That's not old, but it's old to start, because most of the other women are younger. I wasn't that pretty. I never had big tits. I made tons of money because I know something about men, which is that, whatever it is they think they want, they don't really know. What they want, truly, is someone who'll listen, be enthusiastic, act like they're enjoying it and make them enjoy it and forget about what time it is. And if you can give that to them, it doesn't particularly matter whether you have big tits or not, but it will when they come through the door, making their first selection, and it will matter to a certain number of guys who are fetishists. The average guy who calls up on the phone will say, 'I want somebody about twenty to twenty four, slender, tall with big tits and blonde hair.' They all say the same thing. That's because they don't know how to say, 'I want somebody who's really enthusiastic and can just relax and have a good time, is imaginative.'

The first thing we had a big conflict about was that I got tired of people sitting around bitching that they weren't making money, and they would not do their hair, not put any make up on, and not even look up at somebody and smile when they came in.

I mean, when I was a prostitute every guy who came in I asked, 'Why did you come here instead of the ten other places you could have gone?' And I would listen. This is before I ever bought the place. The first thing I learned was that cleanliness was a big seller. Most of these places were dumps because nobody cleans them. So we put up a cleaning list. There are six or seven people and everybody on each shift has to do one job, which takes you about ten minutes. And all the other places, the girls come in and they sit. Nobody does anything, so nobody else does anything and they all sit on their ass. The place gets filthier and filthier, to the point where guys are afraid to come in.

I fired a girl once because she went in the room to see a guy with rollers in her hair. She was stunningly gorgeous. She was terrific. She had customers lined up to see her. She didn't realize that just because you have a lot of customers doesn't mean you can take them for granted, treat them like shit and do anything you want and they will still keep coming in. She used to make them wait really long. They all do that. To me it was like, when the guy is in the room and they shut the door, within one minute I want you in there. I don't want you sitting around sucking cigarettes, waiting till the soap opera ends. Get in there. Give him the time he paid for.

We fought about that all the time. And customers that I have known for years and years say it's endemic. They go to a sauna and it's extremely uncomfortable to be laying on a bed or a table with a towel wrapped around you, and they'll let you wait a half an hour.

Scarlot: I never owned a business, but it seems like, if they have problems, they should be able to negotiate with you through a worker's organization.

Rebecca: The thing is, most of these places aren't run. The few big ones, the reason they are organized is that somebody's cracking the whip. Most of them have no management. The women come to work and they make a pot of coffee and they sit and watch TV and they do things however well they please. They let somebody in or they don't let him in and they charge what they want and they treat them how they want. They just do exactly as they please and they do a really poor job.

Scarlot: It seems like we should have schools to educate women about how to run collectives, so that they can create and work in the best environments.

Rebecca: They don't think about the concept of building a business. Whenever I saw a customer, all I thought about was what I could do to get him to come in next week. Other women don't think like that. What they are thinking is how can

they get out of the room as quick as possible and get away from him and go back to the TV show.

Scarlot: Well, we need an academy for prostitutes.

Rebecca: But that's illegal.

Scarlot: I'm not so sure that it is as illegal as people assume. There's always free speech. We are deconstructing legality. Priscilla Alexander says she is going to set up the Institute for Prostitution Studies. We could visit massage parlors and give workshops.

Rebecca: You have to put yourself in the position of the customers to run any business successfully. At the same time you have to think about the community and you have to think about the workers. That's true of every business, that you have to try to look at all three positions and come out of it. I started a policy of, somebody answers the door, brings the client in, introduces him to everyone who is there, puts him in a room, and the manager comes in and asks who he would like to see. You can't imagine the shit I got from the women. I mean, they just went crazy.

Scarlot: It is harder because then you have to feel competition with the other women.

Rebecca: But you're better off if he sees the woman sitting next to you, because the next guy who comes in, she won't be out there and then they'll just be two of you. The more we keep everybody busy, the better off we are.

Scarlot: Well, for us, it's true that the guys didn't necessarily always want to go with the woman he wound up with, but our customers were mostly tourists anyway, and we didn't want to put too much pressure on ourselves to get repeat business. I mean, with the cops we were under enough pressure as it

was. Another thing is, some women would prefer not have repeat customers because they require more work.

Rebecca: You're right. But Minneapolis is not a tourist town. We totally depend on the men who live here. One client told me that he was in a place in New York and they put you in a room right away and then the women come in individually and say hi. You might be intimidated from being overly friendly with the guy when the other women are sitting there because they'll criticize you. You can be much more natural and be yourself if you can walk into a room and just say something by yourself. So I changed it. And I got a lot of shit about that.

Scarlot: From my perspective, I'm one of those women who never was into big money. I wanted to spend my time in a relaxing way, make as much as I could, get some inspiration for my work and some stories. And it was most important to me to have a relaxing, non-pressured atmosphere.

Rebecca: After being in it for a number of years, I started seeing that my problem was that everybody did not have the same motivations for being there that I had and that I had to learn to accommodate myself to people's different ways of feeling about the business. And at the same time, they had to accommodate themselves to the fact that they were part of a business organization, that this was not their living room.

Scarlot: What about in a collective?

Rebecca: You're really into this collective stuff. I'll tell you, that was a dream of mine, too, but in all the years I worked, I met hundreds of women, but there's a mere handful of women who could work independently in a collective. It requires something that almost no one has, that is, the ability to manage money. The people in the collective need to have a common philosophy of business.

Scarlot: What I'm concerned about is, while we're trying to present models about how to work together in San Francisco, decriminalization, what kind of systems we want, we really do have to draw up a plan, here.

Rebecca: We need options. If you want to work at an intense, competitive, money making place, then do that. If you want to work in a hippie pad, then do that.

Scarlot: It's about class. There are going to be class divisions in prostitution as long as there are in society. It's unfair that people always point the finger at us and our classism.

Rebecca: Prostitution is really just like any other business.

Scarlot: I always hear that it's really important to treat prostitution like any other business. On the other hand, there is a reality that the women really are more vulnerable. It is true and is hard to fit it into the free market.

Rebecca: Why is it different?

Scarlot: It's different because there's so much stigma. So many trips in our heads.

Rebecca: I had this one woman who was really gorgeous and really terrific and she made tons of money. No one wanted to work with her because she did every customer, unless she was busy. And then somebody else might get a chance, but she was really top notch. But the problem was that she was so fragile, that if she was sitting there and a guy came in, ever, if she had had five customers and no one else had had one yet, if the sixth guy comes in and he asks for one of the other women, she would cry. Literally, go in a room and cry. And one time, I had a customer who liked her a lot and one day he came in and she was busy and so he saw someone else. And after he was done, she went up to him and she said, 'Don't let those girls pressure you into seeing them because you could always wait for me.' She eventually quit and went to outcall, because on outcalls, you don't have that competition. You don't know when they see somebody else. That girl needed help.

Scarlot: We were thinking of forming a trade guild that offers services, like maybe health insurance and counseling.

Rebecca: You could provide psychological evaluations that tell women whether they are suited to this occupation. The problem is you can't keep people out of it. Sometimes I try to talk people out of it. I will talk anyone out of it who tries to tell me they can do it behind their husband or boyfriend's back. Eventually, he's going to find out and there's going to be a big blowup. If you're trying to get out of your marriage, and you don't care, then well and fine.

Scarlot: Last, about your future. You don't have a career now.

Rebecca: I don't know what direction to take. There are tugs and pulls in a couple of different directions.

Scarlot: Are you going to keep dealing with prostitution as an activist?

Rebecca: It's not something I could walk away from. I don't know about an organization. There's starting to be in the gay and lesbian community, the begin-

nings, in an embryonic state, of a reaction against the overwhelming sex phobia of the local movement, which is very, very MacKinnonite. We have a mainstream gay newspaper, and then we have the radical paper. So there are different communities, an arts community of people who are of like mind. What I would love more than anything is a prostitutes' organization. I don't know how to do that. People could hardly show up for work, let alone show up for meetings. I tried to organize a union and they really made fun of me. WHISPER. Yeah, an organization for prostitutes run by management. I didn't want to run it. I wanted them to run it, but they weren't going to. But, see, the worst part of their working conditions is not the boss. The worst part is the police department.

Scarlot: We could try to organize in Nevada.

Rebecca: What's wrong with Nevada is not necessarily the management—it's the laws that the women have to live there with. They can't live in town and have an apartment and go to work every day. They totally keep them separate from interacting with the community or any sense that they live there. Don't you think that it's probably unconstitutional to lock them up like that?

Scarlot: Definitely. And nobody is challenging it. That's where I think our law reform has to take place, in the courts, not predominantly in the legislatures. Most of the laws that might be passed should be knocked down in the court, and we won't have the resources. It might be best to work on public opinion, which can influence judicial decisions and litigational challenges to current laws.

Rebecca: They haven't been very receptive so far.

Scarlot: Anyway, I have to wind this down. Why don't you join the National Task Force on Prostitution?

Rebecca: Well, I'll think about it.

Scarlot: I guess that's enough. Thanks so much, Rebecca.

Roaches and Ruminations

[Reprinted from *Sex Work*, Cleis Press, 1987; originally published in *Appeal To Reason*, 1983.]

. . . I live in a posh, modern apartment with rustic wood paneling, a push-button fireplace and a panoramic view stretching from San Francisco to San Mateo. The gall to defy taboo, a series of risks and an inclination towards sexual experimentation have provided me with this aesthetic environment where I entertain clients, poke at my typewriter and recline on my queen-size bed, pondering.

The comfort and luxury of my solitary brothel is in sharp contrast to the fear that haunts me. Often I dwell upon my worst fears. Uncontrollable paranoia grips me as I gaze into the starry night. Men who hate prostitutes will rape and kill me. The Moral Majority will conspire with the Mafia against me. I will be arrested for everything. No man will ever really love and accept me. My whole family will find out and confront me with their disapproval. Prostitution is not okay. I am deluding myself and I will go crazy avoiding that revelation.

Food! I need food. I will become obese. I need to eat. I lift my head from velvet pillows, rolling off the queen size blue satin and head for my kitchen. Tomorrow I will go on a diet. I flick on the fluorescents.

There they are. A tiny tribe of enemies, scampering across my private moment. The truth, the truth and an irritating lack of perfection. And I pay so much rent. But I will never be safe.

I confess, I am to blame. I don't use Raid. I don't squash them. There are no vacancies in my Roach Motels—in fact, they've become symbols. There is no solution.

This whole issue reminds me of something. Birth control. Did you know that there is no good form of birth control? Foams and jellies are poison. I.U.D.s puncture the womb. Birth control pills are a crime against women. All that's left is rhythm and prophylactics. The rubbers bust and my cycles are obtuse.

Never mind, I'm just making excuses. I should go out and buy some boric acid. That works fine. I confess, I just practice avoidance, telling myself the roaches don't really multiply that fast. They'll die of old age, so I'll never have to fight. But I know the truth. I'll make a list. I'll go to the store. I'll use rubbers and rhythm and Roachproof . . .

I guess paralysis is a common affliction. I guess most people wrestle with apathy, pessimism, and confusion, not just prostitutes. So why should I be ashamed?

I'm not ashamed. I'm proud. I'm proud that . . . I'm not ashamed.

I have only one thing left to say. I'm a prostitute and if you don't like it, you're stupid . . .

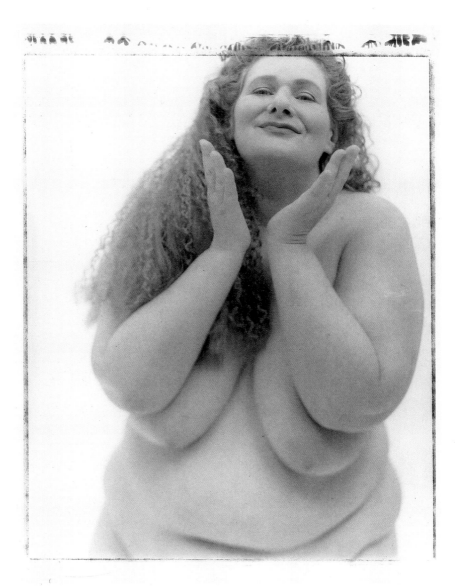

Photo: Michele Clement

Afterword: The Harlot's Progress, August 2003

> "Liberty presumes an autonomy of self that includes freedom of thought, belief, expression, and certain intimate conduct . . . liberty gives substantial protection to adult persons in deciding how to conduct their private lives in matters pertaining to sex . . . this Court's obligation is to define the liberty of all, not to mandate its own moral code . . . Times can blind us to certain truths and later generations can see that laws once thought necessary and proper in fact serve only to oppress."
>
> — Justice Kennedy, *Lawrence et al.* v. *Texas,* June 26, 2003

In June the Supreme Court overturned a Texas antisodomy statute in the name of sexual liberty. Hallelujah! Even Justice Scalia, in his *dissenting* opinion, recognized this decision as a "massive disruption of the current social order," claiming that state laws against prostitution are sustainable only with "validation of laws based on moral choices." We've been saying that for years . . .

There is progress, despite the continuing arrests and victim campaigns by the anti-pro moralists. There is progress, even in my city, which has always been on the frontline in the prostitution wars. The recommendations of the San Francisco Task Force on Prostitution are now invoked as guidelines by progressives at City Hall. Although policy change has not been substantive, we have new efforts and new hopes. Our friend, District Attorney Terence Hallinan, is up for re-election again amidst controversy about a doggie bag of fajitas and his indictment of a number of police officers for misconduct. During his tenure he reduced prosecution of marijuana users and prostitutes, much to the chagrin of the police, who continued making arrests.

One great gain has been the opening of the St. James Infirmary, the first occupational health and safety clinic for sex workers in the U.S. This clinic, founded by COYOTE and Exotic Dancer's Alliance, drew its inspiration from OSHA guidelines drafted for the World Health Organization by Priscilla Alexander. The recently unionized Exotic Dancers Union of the Lusty Lady Theater organized a co-operative corporation that purchased the Lusty Lady, launching the first such sex worker owned co-op in the country. San Francisco's Sex Worker Film and Video Festival, in its third season, is one of a number of sex worker cultural festivals around the world.

The term *sex work* establishes prostitution as work, as opposed to the definitions of prostitution as exploitation, rape or sluttiness. The concept of sex worker rights is now a viable issue in labor relations, even in the U.S.

Influenced by new "sex radical" subcultures, local call girls are prouder than those I met when I was first working in the late '70s. Whore pride was always a part of the consciousness—the older generation was proud to see through the hypocrisy of the stigma. Now some are actually proud of being whore-rebels, healers and teachers. In some circles I hear that being a sex worker is considered cool—but when people tell me that it's usually a complaint about class or fashion.

Of course, the diversity of prostitutes, strippers, doms—sex workers—defies my generalizations. There are millions of sex workers in the world by anyone's count. In some countries, such as Sweden, the prostitution policies become more punitive. Even where prostitutes' rights improve to include social security and labor rights, as in the Netherlands, migrant prostitutes are subject to increased criminalization and marginalization.

So, what is the state of the movement? I seek a global perspective because the sex industries, more than many others, are greatly influenced by global trends, economic changes, migrations and wars.

Subject: Asian prostitutes rights movement urgently needs support

A few weeks ago I received an email from my friend. Josephine Ho, a professor at National Central University, Taiwan, writes on behalf of Ziteng, a sex worker organization in Hong Kong:

"Dear Friends,

I am writing to beseech your help and support in fighting off the immense pressure that is increasingly hampering our efforts to empower and organize sex workers. These pressures come mainly from those first-world feminists and women's NGOs who have now joined the UN workers and other international organizations in characterizing Asian sex work as nothing but the trafficking of women and thus is to be outlawed and banned completely.

Now the immense power of western aid, coupled with the third-world states' desire for modernization (that is, putting up fronts of democracy and equality so as to gain aid funds without moving toward social justice), is making it increasingly difficult for sex workers to win legalization or decriminalization. New laws and rulings are instituted to outlaw sex work; condoms are held as evidence of sex work; police harassment and even extortion of sex workers are

common. The seemingly righteous discourse of anti-trafficking is becoming ever so strong in this area, interpreting all forms of women's migration toward economic betterment and sex work as mere trafficking. For those working toward decriminalization, the urgent need for a counter discourse is obvious."

The Good, the Bad and the Feminists

"Will you make a comment Ms. Harlot?" the reporter asks. "The Society for the Rescue, Reform and Revirginization of Prostitutes says that decriminalization is bad for prostitutes. They say we have to keep the business criminal to discourage prostitution, which is the best way to protect prostitutes."

"Using criminal laws to control prostitution is like using a chain saw to fix a hangnail," replies the Unrepentant Whore.

"Ms. Harlot, the Society says that only white, middle-class whores want to be legal."

"Luckily the United States is not really the center of the universe," quips the Harlot. "The U.S. is exporting anti-prostitution philosophy. It's whorebaiting!"

Durbar Mahila Samanwaya Committee Sex Workers' Manifesto, 1997

For comfort and validation, I turn to DMSC. According to an email they sent inviting me to the 2001 conference, Durbar Mahila Samanwaya Committee has a membership of 50,000 sex workers in India. A few years back they sent me their manifesto, a 4,000 word document that analyzes the movement in the context of morality, sexual expression, heterosexism, poverty and more.

> "The term 'prostitute' is rarely used to refer to an occupational group who earn their livelihood through providing sexual services, rather it is deployed as a descriptive term denoting a homogenised category, usually of women, which poses threats to public health, sexual morality, social stability and civic order. Within this discursive boundary we systematically find ourselves to be targets of moralising impulses of dominant social groups, through missions of cleansing and sanitising."[32]

[32] Durbar Mahila Samanwaya Committee, *"Sex Worker Manifesto,"* Calcutta, November 1997. Available at http://www.nswp.org.

Stop The Wars on The Whores

In California, the women's prison population has increased 850% since 1980.[33] As the *correctional industrial complex* grows, fundamentalists are funded to reform the poor and the prostitutes. Arrest is seen as a form of rescue. The fundamentalist feminists had the monopoly, but now churches are eligible. Prostitute rehabilitation groups and "Twelve Step" programs are the darlings of the prostitute reform industry, but most prostitutes don't fit into their programs. They are left to the streets and the police.

My friend, Duran Ruiz, embraces the whore persona. Duran is a legend on the streets, in the prisons and in the homes of Americans who saw her on ABC's *20/20* a couple of years ago.

> "I have accumulated 14 years total in prison and I'm only 38. I don't do bad things. I've never stolen. I'm a prostitute because it's honest and I'm honest. I mean I don't find a lot of crime going on as far as women are concerned. I can't think, off-hand, of four women that actually belong in prison and I know thousands."[34]

My friend, Victoria Schneider, is a very expensive street worker—she cost the city nearly a million dollars, awarded as settlement in 1999. Each time she was incarcerated she was strip-searched and humiliated. The officers said they were trying to determine her gender, but they knew her and her gender. Now she travels around the world as Victoria W.H.O.R.E (World Health Out Reach Educator). She sent me this poem:

> What I Learned as a Sex Worker
> People hate me for what I choose to do for work and want to hurt me.
> I go to jail a lot for the work I do. People think I am disease.
> Some people want to get rid of me or kill me.
> I am survivor not victim.

Trafficking 101

Movements against "'trafficking," immigrant prostitution and sexual slavery have been central to the legal status of prostitution in the U.S. This issue is

[33] Justice Policy Institute, *"The Disparate Imprisonment of Women Under California's Drug Laws,"* 2001. See http://www.cjcj.org/cpp/ccf_growth.php.

[34] *Blind Eye To Justice,* Dir. Carol Leigh, Cynthia Chandler, Narr. Angela Davis, Video, 1998.

complicated, crucial and mired in competing definitions.

In the nineteenth century, concern about enslavement and abuse of women in Chinese brothels lead to a federal law which restricted entry of women who had been prostitutes and excluding any who were "supported by the proceeds of prostitution.[35] Lurid tales of "white slavery" portrayed all prostitutes as innocent victims. This fueled prostitution prohibition, which spread across the United States. Brothels were closed down and prostitutes were forced to the streets, vulnerable to organized crime, pimps and police corruption. The "good women" led these campaigns. As contemporary activists reflect on escalation of criminalization and the harm done to prostitutes under the guise of stopping forced prostitution, we see history repeat itself.

The realities of migration are nuanced. The abuses and hopes are varied and complex, so I decided to call Spain. My friend, Laura Agustín is a rebellious academic, a perpetual migrant. Laura has, on occasion, gotten more for sex than pleasure. I tried my simplified version on her: "A person in a third world country who wishes to migrate usually cannot obtain a visa or work permit, so they depend on criminal networks for travel. Sex workers also must use criminal networks. The conditions of labor and price for such a journey varies, and therein lies the degree of exploitation."

"No, no, no!" Laura exclaimed, "You need a much more nuanced treatment of trafficking. You've fallen into the usual trap in wanting to acknowledge the bad stuff. The word criminal doesn't belong here. 'Illegal' and 'gray economy' are not the same as criminal. People use informal travel agents to get documents, tickets and contacts. In all situations, according to luck, you may run into someone who's a bastard or not. But most informal networks are people's own family and friends, or networks have multiple members and only one has to be bad."

"Oh, that's right."

"There is no single truth. The obsession with 'trafficking' works to erase the human agency necessary to undertake migrations as well as the experiences of migrants who do not engage in sex work," she explained.[36]

Anyway, politicians are even less sensitive to nuance. They don't tend to worry too much about how "foreigners" feel, or what's best for them. But they

[35] Vern and Bonnie Bullough, *Women and Prostitution: A Social History* (N.Y.: Prometheus, 1987), pp. 278-79.

[36] Laura Agustín, February 2003. See "Sex, Gender and Migrations: Facing Up to Ambiguous Realities." *Soundings*, 23, Spring 2003 and Connexions for Migrants,

will become involved when they want to keep foreigners out, or if their U.S. aid is threatened, or if they can win political points by enforcing a moral agenda. Enter the current discourse on trafficking.

Sexual politics isn't rocket science, but to simplify this discussion, I will subsequently refer to the opposing sides as the *"good" anti-traffickers* and the *"bad" anti-traffickers*.

The *good anti-traffickers* want to assist victims of forced labor in all industries. They recognize that sex workers have rights. They are wary of police corruption and the governmental tendency to scapegoat immigrants. For this reason they emphasize assistance to victims rather than escalation of police powers.

The *bad anti-traffickers* are comprised of anti-prostitution and anti-porn activists. They also want assistance for victims, but their priority is not about protecting migrant workers; it's about rallying governments against the sex industries. They equate prostitution and other commercial sex with rape. They welcome increased police intervention, especially in the area of prostitution.

The two sides were engaged in fierce debate, first at the UN Crimes Commission in Vienna, creating the "UN Protocol" and later, lobbying in conjunction with the U.S. Trafficking Victims Protection Act in Washington.

There is actually good news about the UN Protocol. For the first time sex worker rights representatives participated in the discussions. Ultimately, human rights and labor advocates managed to keep the UN Protocol from condemning all prostitution. Instead, the UN Protocol targets slavery and forced labor. Sadly, the UN Protocol does leave a loophole for countries to use it against the sex industries if they want. The bad news is, the United States *wants!*

Protecting the Innocent or "Whore War" Mongering?

Next, all the *bad anti-traffickers* rushed home to make sure that the US anti-trafficking bill was punitive and stigmatizing toward the sex industry.

The year before, the *good anti-traffickers* were working on an anti-trafficking law with the late Senator Wellstone to protect victims of forced labor and slavery. The *bad anti-traffickers* developed an alliance with the Christian

[37] Mindy Belz, "Coming Together for all the Right Reasons: Political enemies work side by side to end the international sex trade," *The World On The Web*, March 25, 2000. http://www.worldmag.com/world/issue/03-25-00/cover_3.asp.

Right.[37]

Laura Lederer, 70s feminist anti-porn activist,[38] praised this alliance in World magazine: "Women's groups don't understand that the partnership on this issue has strengthened them, because they would not be getting attention internationally otherwise. But it makes some in the women's groups uncomfortable, mostly because it is an election year."[39]

U.S. Out of My Underwear

So what have those *bad anti-traffickers* done lately to further criminalize, marginalize and stigmatize us all over the world? They lobbied various government officials to include nasty little caveats like the paragraph in the USAID strategy statement issued January 15, 2003. (USAID controls the moral agenda of the world, allocating billions of dollars to non-profit organizations).

> F. Partnerships against Trafficking
> An effective anti-trafficking strategy depends upon partnerships. Organizations advocating prostitution as an employment choice or which advocate or support the legalization of prostitution are not appropriate partners for USAID anti-trafficking grants or contracts.

I called Dr. Ditmore, who wrote a thesis "Trafficking and Sex Work: A Problematic Conflation" which sounds dry but is actually a juicy description of the feminist battles at the United Nations Crimes Commission meetings in Vienna.[40]

"Dr. Ditmore," I beseeched. "It's really not so bad, this USAID statement. The peer advocates, the folks at Ziteng or the sex workers at DMSC in India, they don't advocate legalization. They advocate decriminalization. And they don't speak about choice too much, do they? It's more about their rights, right? They don't really get that much money from USAID, do they?"

"This is very serious," she said. "It is akin to the U.S. government's approach to abortion. Funding is withheld to those who support abortion

[38] Laura Lederer edited the anthology, *Take Back The Night, Women on Pornography* (New York:Morrow, 1980).

[39] Mindy Belz, "No Sale," *The World On The Web*, March 25, 2000. http://www.worldmag.com/ world/issue/03-25-00/cover_1.asp.

[40] Melissa Ditmore, "Trafficking and Sex Work: A Problematic Conflation" (Ph.D. diss., Graduate Center of the City University of New York, 2002).

although abortion is actually legal in both countries."

"I don't get it. These middle-class American women are supposed to be progressives! How do they justify trying to destroy organizations of sex workers in Thailand or India who are working to stop abuses in prostitution, trafficking, whatever you call it?"

Dr. Ditmore sighed.

"I suppose I'm getting a bit rabid, accusing my fellow feminists of first world imperialism, classism and racism. All they want to do is stop forced prostitution."

"No, they want to stop all prostitution, not just forced prostitution. That's where trafficking and prostitution get conflated. Read my book."

The alliance between the *bad anti-traffickers* and the Christian right was formidable. Soon the entire mainstream feminist leadership wrote a letter, petitioning Senator Wellstone to make sure that the new trafficking law would be against all prostitution, not just forced prostitution and forced labor. The letter basically implores Wellstone to protect women "lured by traffickers...mercilessly exploited" AND to protect those who consent to prostitution from themselves by *discounting consent* in the sex industry and fighting "sexual exploitation," which, to them (and Jesse Helms) means prostitution, porn, etc. I suspect that some who signed it didn't really understand the implications of what they were signing, but that is no excuse.

The good news is that the Trafficking Victims Protection Act (TVPA) calls all businesses involving commercial sex acts "evil," which would include porn, phone sex and strip clubs. This is good news because now this law can be challenged on the basis of being overly stupid.

Thanks But No Thanks

And so, to the crux of my tirade—thanks but no thanks for making prostitution just a little more illegal and making sex workers lives a little more dangerous all over the world. Of course, I reserve blame for the handful of academics and other zealots who lead this campaign against us, but I expect more from the "mothers of our movement." Thanks but no thanks to the short list of signers of that petition, feminists who we once admired, among them: Gloria Feldt, President of Planned Parenthood–she should be called to the carpet by the membership for taking sides in this feminist controversy; Patricia Ireland of the N.O.W.—NOW should at least *vote* before signing on to this anti-prostitution agenda; Laura Lederer, the 70s anti-porn activist—

the Bush administration promoted her to *Special Assistant to the Under Secretary of State for Global Affairs*; Robin Morgan—her enmity is sad for me because I was inspired by her poetry; the Feminist Majority may feign neutrality, but President Eleanor Smeal signed on for her organization and last, Gloria Steinem of *Ms.* Magazine.

"No, not Gloria Steinem! I can't bear it!"

"When she was editor, every issue of *Ms.* had something stigmatizing to say about porn or women in the sex industry," sociologist Andrea Miller told me. "It's different now. Sex work is coming out of the closet. The new editors, young feminists, *get it* about sex worker rights. They read about it in their Women's Studies classes. Who knows, they may have tried it themselves?"

Only Rights Can Stop the Wrongs

As we learned in Sex Workers' Rights 101, criminalizing *the business of prostitution* makes life more dangerous for the prostitutes. But the *bad anti-traffickers* say we must criminalize the commercial sex business—supposedly to protect the prostitutes.

"You can't be free because THE EXPLOITERS are too powerful and they'll take advantage of you. And if you don't agree with us, you're probably one of THEM."

My respectable friends gather round to comfort, commiserate and explain why those women are so mean.

"According to this logic," writes Jyoti Sanghera, "bettering the health of the sex workers with (HIV/AIDS prevention) measures creates a more enabling environment for women in the sex industry to perform better. And, therefore, programmes for HIV/AIDS prevention are actually reinforcing violence against women."[41]

"This is the 'fate worse than death' mentality: the Victorian ladies' view that sexual 'violation' is so devastating, death is actually preferable," explains Hilary Kinnell.[42]

[41] Jyoti Sanghera, *"Only Rights can Stop The Wrongs,"* Centre for Feminist Legal Research, Global Alliance Against Traffic in Women (GAATW), March 16, 2001. Actually, Jyoti's comments were not about anti-traffickers at all, but about feminists from India who tried to close down a huge sex workers conference a few days before it was scheduled to start.

[42] Hilary Kinnell, *"Why feminists should rethink on sex workers' rights,"* UK Network of Sex Work Projects, paper presented to the Economic and Social Research Council Seminar Series 'Beyond Contract? Borders, Bodies, Bonds', University of Oxford, December 16, 2002.

Durbar Mahila Samanwaya Committee Sex Workers' Rights March, Calcutta, 1997.

"When the sex workers complain, they just say: 'You are wrong, misled or evil and we know best,'" Scarlot adds.

"To denigrate women's choices as self-delusional or based on 'false consciousness' is not feminism but fascism. I find this dismissal of women's choices especially offensive when those doing the dismissing are privileged, university-based westerners and the women whose choices they dismiss are from poor communities bearing the brunt of global economic and social inequalities."

"For someone whose book is called Unrepentant Whore, you certainly give a lot of attention to *their* critiques of the movement," says my friend and confidante, Penny Saunders, formerly of SIN (Sex Industry Network) in Australia, now a Ph.D. professor at NYU.

"Oh yeah," says Scarlot.

"Durbar" Means Unstoppable

"The sex workers movement is going on—it has to go on. We believe the questions about sexuality that we are raising are relevant not only to us sex workers but to every man and woman who question subordination of all kinds—within the society at large and also within themselves . . . Sexual inequality and control of sexuality engender and perpetuate many other inequalities and exploitation too. We are faced with a situation to shake the roots of all such injustice through our movement. We have to win this battle and the war too—for a gender just, socially equitable, emotionally fulfilling, intellectually stimulating and exhilarating future for men, women and children . . . Sexuality, like class and gender after all, makes us what we are."

— DMSC Sex Worker Manifesto, Calcutta 1997

Scarlot Harlot's To-Do List for Sex Worker Rights Activism

• Review the history of prostitution research and expose the twisted stats and historically shoddy, deceptive academic work on prostitution. Facilitate responsible research and study of sex work issues.

• Repeal the laws that criminalize the poor, including prostitution and drug laws.

Ana Lopes and Camilla Power, London's

• Do research on the effects of incarceration on prostitutes and how mandatory recovery and rehabilitation programs affect us, in the short term and long term. Support those who are currently incarcerated by writing letters and advocacy.

• Demand that social services be available to sex workers when they are victims of violence and other abuse. (You may have community resources for victims of domestic violence, but where are the resources for those who are not privileged enough to have a home, or those who suffer violence outside of the conventional family?)

• Think and write about the connection between poverty and violence. Feminist rhetoric obscures this connection, emphasizing that "any woman can be a victim of violence."

• Value, document, celebrate and enrich your own sex worker community, your friends, women, men and everyone including transgender sex workers in your community.

• Develop solidarity across gender, race, class, nationality and other divides in sex worker groups. Support sexual freedom for all including the disabled, queer, transgender, polyamorous, etc.

• Empower sex workers with computer training, cameras, art supplies and other tools for self-expression and community documentation.

• Create local commissions of sex workers to plan decriminalization campaigns and to address immediate local issues. Get funding for stipends, food, childcare, etc.

• Keep your government accountable for police crimes against prostitutes. Do research and get involved in police liaison and review projects. Sue the police.

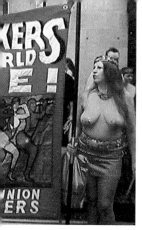

rade, 2001. Photo: Fredericco Amicci

- Organize supporters: attorneys, health and social workers, politicians and others. Make your positions known to the media through publications, press releases and press conferences, demonstrations and street theater.

- Take a cue from the U.S. Supreme Court and organize support for litigational challenges to the prostitution laws. Find attorneys, workers and clients to challenge arrests and convictions. Liaison with law schools and students.

- Start drop-in centers, occupational and health clinics, housing resources, bad trick lists, workshops, schools, etc. for sex workers in your community.

- Organize sex worker performances, performance ensembles, festivals, conferences, publishing companies and TV and radio shows. Include sex workers from all walks and genders.

- Do research on the economics of your local sex industries. How many are employed, income, tax revenue, etc.?

- Unionize the legal sex industries, phone sex, porn, etc. Unionize brothel workers in Nevada. Organize sex work businesses and cooperatives. Buy brothels in Nevada and create multi-gender sex work businesses everywhere.

- Help your local or national sex worker organizations by donating money, volunteering and writing funding proposals.

- Network with other sex worker organizations. Sex work is global. Join the International Union of Sex Workers at iusw.org. Stay informed about international issues. Review international and national legislation and policies.

- Sex worker rights advocates should be included as presenters in sex education curricula so that young people can understand the diversity of experiences in the sex industry, the real lives of sex workers, the real pitfalls and successes.

- Help organize young people with *diverse* experiences in the sex industry to make recommendations regarding policies and laws that affect youth.

- What about religious freedom? Sex worker goddess worshippers should have our own churches, tax deductions, temple prostitutes. I know an attorney . . .

- If you want to completely stop injustice and the cycle of violence, you need: no discrimination, guaranteed income, global living wage, open borders and world peace, just to name a few.

Videography

Politics/Sociology

↑ ***TWITS Visit the Democratic Convention***—Vintage Harlot with TWIT (Tucson Western International Television), Dave Bukunus at the Atlanta convention. Scarlot joins Dolores French (*Working: My Life as a Prostitute*) during Dolores' appearance on CNN. Tucson's OASIS AWARD winner. (28 minutes, 1988)

Die Yuppie Scum—"Leigh's unique guerrilla-style coverage of events has met its match in this impressionistic mélange of events and happenings during the 1988 Anarchist Conference in San Francisco." --SF Bay Guardian. Definitions of anarchy plus the aftermath of the Berkeley riots. Musical interludes by the Yeastie Girlz, Blue Vulva Underground, Dead Silence and Mourning Sickness. Winner Athens International Film Festival 'Best Documentary'; finalist at Hometown U.S.A.; screened at the Film Arts Festival (San Francisco) and the 2nd International Film and Video Festival in Kupio, Finland. (28 minutes, 1989)

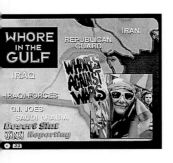

←***Whore in the Gulf***—In response to the networks' censorship and the nationalistic zeal, Leigh produced weekly coverage of the Bay Area anti-war movement during the first Gulf War. San Francisco protesters discuss world peace, the growth of fascism in America, and activism in the nineties. "Peace-positive propaganda, CNN . . . revised and improved." Includes "Sunreich, Sunsetup," a music video featuring Scarlot Harlot and Barbara Bush. Screened at the American Film Institutes' National Video Festival, Film Arts Festival (San Francisco), W.O.W. Cafe (New York) (28 minutes, 4 episodes, 1991) →

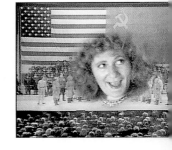

P.C. High School—Shot by student videomakers, a cafeteria performance by Scarlot as guest instructor for an interdisciplinary arts class as part of a high school arts program. (28 minutes, 1991)

Scarlot Visits the Democratic Platform Committee—Boring, except for the part where Leigh advises the Democrats to include prostitutes among other disenfranchised populations when targeting social services. (28 minutes, 1992)

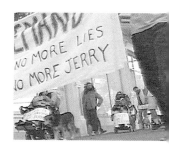

Jerry's Orphans—Ex-poster child from Jerry Lewis' Muscular Dystrophy Telethon and Berkeley Independent Living activists protest negative stereotypes promoted by Lewis in his fund raising. (28 minutes, 1993) →

←***No Place Left To Go***—San Franciscan homeless people and activists join to protest Mayor Jordan's notorious "Matrix" program. (28 minutes, 1993)

Fuck the Verdict—Street demo in the Fillmore neighborhood, documents African American community members' and activists' responses to the second Rodney King Verdict. Watchable, and a very good document. (30 minutes, 1993)

Guerrilla Theater: Making A Scene in the Bay Area 1988-1995—by Carol Leigh and Carol Burbank. A collection of short clips from political street theater addressing a broad range of issues including queer rights, AIDS activism, sex workers' rights, Gulf War protests and more. Features Gilbert Baker as Pink Jesus, leading the San Francisco Pride Parade with his protest of the censorship of Jesse Helms. (28 minutes, 1996) ↓

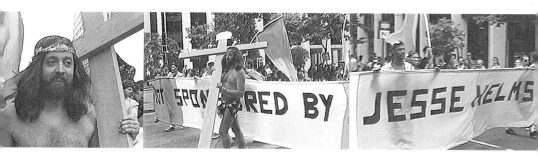

Blind Eye To Justice: HIV+ Women Incarcerated In California—by Cynthia Chandler and Carol Leigh; drawings by Isis Rodriguez; featuring Duran Ruiz, Twillah Wallace, Yvonne Knuckles, Miriam Jones, Lisa O'Conner, Gwen Patton, Mary Lucey, Judy Greenspan, Loren Jones, H. Gutierrez, Bobby Castillo and Cynthia Chandler. Narrated by Angela Davis, this compelling and experimental documentary portrays the injustices of the California prison system as seen through the eyes of incarcerated HIV+ women. Personal accounts, found footage and statistics tell a story of violation and empowerment. Best Documentary at the Black International Cinema (Berlin). Screenings include Women in The Director's Chair, MIX Lesbian and Gay Experimental Festival (NY), Sex Workers Video Festival (Portland, OR), Critical Resistance Film Festival (Berkeley), Michigan Women's Music Festival, Pacific Northwest Festival of Fiction and Anthropological Cinema and the World AIDS Day Festival, Walker Art Center (OH). Funded by a grant from Agape Foundation Fund for Nonviolent Social Change. (34 minutes, 1998) ↓

↓ *The Needle Exchange & The Women's Site*—Commissioned by the AIDS Foundation and the HIV Prevention Project as a tool to train volunteers, these two unique videos portray the exchangers and staff at the needle exchange in San Francisco through a series of interviews. Victoria Schneider teaches how to clean needles at the women's site of the needle exchange. (20 minutes, 1998)

Carol Leigh/Scarlot Harlot

The Adventures of Scarlot Harlot—Document of Leigh's one woman performance piece about prostitution and stigma performed at the National Festival of Women's Theater, University of California at Santa Cruz. (45 minutes, 1983)

War and Pizza in The Global Village—Scarlot's first show with T.W.I.T, a musical pizza comedy nostalgia. (35 minutes, 1984)

Weird Women of The West— Dave Bukunus produced and directed the original TWIT shows from which this material was assembled. Leigh plays five characters including Janis from A.S.S., the Alaskan Solicitation Society. (28 minutes, 1986)

Safe Sex Slut—Music videos include *Pope, Don't Preach, I'm Terminating My Pregnancy*. Talk show clips: Scarlot on *The Late Show with Arsenio Hall, Nightline, Geraldo* & more. Screened at the 5th International AIDS Conference at PARADISIO in Amsterdam, Deep Dish Satellite TV, the New Museum of Contemporary Art (NY) and as part of Video Against AIDS by Video Data Bank. (28 minutes, 1987) →

Sex and Sports—In Part 1, Scarlot gives safe sex advice and counseling to Tucson callers. In Part 2, Scarlot Harlot appears with Fred Willard on the Comedy Channel's national cable show, *Access America*. (28 minutes, 2 episodes, 1991)

↓ *Mother's Mink*—Multi-format comedy about Leigh's efforts to obtain respectability as an artist, and to secure funding for a video about her mother's mink. In a parallel tale, Leigh's mom (and co-star) Augusta reminisces about how she "saved and suffered" to buy a mink stole to impress her mother. Featured at American Film Institute's National Video Festival, the Jewish Video Festival (winning

Honorable Mention), Video In's Jewish Film Festival in Vancouver, the Mill Valley Film Festival and Syracuse University's Matrilineage Festival. Director's Citation Award at Black Maria Film Festival, and second place for non-fiction at the American Film Institute's SONY Visions of U.S. Video Contest. (15 minutes, 1994)

Sex Worker's Issues

Just Say No To Mandatory Testing—1987 campaign against testing of prostitutes organized by Leigh with The AIDS Action Pledge (precursor to ACT UP). Mandatory Testing Demonstration at the Hall of Justice- Prostitutes and ACT UP members protest mandatory HIV testing of prostitutes in San Francisco. (28 minutes, 1989)

Daisy Anarchy at Klub Kommotion—Sex worker/poet performs poems about the Green River Murders and other issues. (28 minutes, 1989) →

Sex Workers Take Back The Night—Scarlot Harlot attends San Francisco's Take Back the Night (December 1990). Clashes and controversy emerge between sex workers and anti-porn feminists about sex, violence and men—with an emphasis on the perspectives of strippers and sexual rights activists. An excellent feminist discussion piece. W.O.W. Cafe (NY), Video Witnesses Festival of New Journalism (Hallwalls, Buffalo, NY), Los Angeles Gay and Lesbian Film Festival. (28 minutes, 1991)

Whores and Healers—Compilation addressing the role of prostitutes as teachers. Includes: Gloria Locket (left) in CAL-PEP, a model HIV prevention/education program designed and implemented by prostitutes and ex-prostitutes for prostitutes; Cheryl Overs (right), from the Network of Sex Work Projects speaking ↓

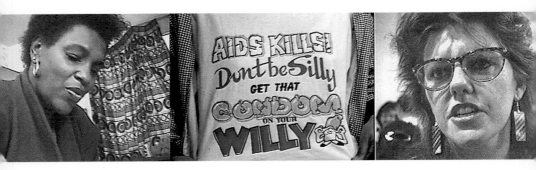

on use and abuse of prostitutes as outreach workers; POCAAN (People of Color Against Aids Network); and the Yeastie Girlz' safe sex rap, "Put a Lid on It." (28 minutes, 1991)

We Are Not A Force To Be Taken Lightly—Street journalism in two parts. "That's Right, I'm Fat"—Interviews about sex, body image, fatness and compassion from a fat dyke's street party featuring photographer Jane Cleland among others (15 minutes); "Scarlot Harlot's Interstate Solicitation Tour"—Scarlot and P.O.N.Y. (Prostitutes of New York) engage in civil disobedience on Wall Street. (15 minutes) Spew Zine Conference; LA Contemporary Exhibitions; Video Witnesses Festival of New Journalism (Hallwalls, Buffalo, NY) 1992, Lookout Festival at DC-TV (Downtown Community Television, NY) Los Angeles Freewaves Festival and Tour. (Total 30 minutes,1991) ↓

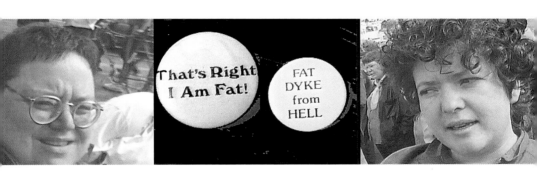

Outlaw Poverty, Not Prostitutes—Documentary of the 1988 World Whores' Summit in San Francisco. Prostitutes and activists from around the globe discuss human rights as they affect prostitutes. American Film Institute's SONY Visions of US award winner. Screened at Film Arts Festival (San Francisco), International Women's Day Video Festival, on Deep Dish Satellite TV, at DC-TV's WHAM Festival (Downtown Community Center, NY), & the San Francisco & Chicago International Gay and Lesbian Film Festivals. (23 minutes, 1992)

Free Whores—The World Charter for Prostitutes' Rights scrolls down as Tracy Thomas and Mourning Sickness perform "Sex Trade Worker." (6 minutes, 1993)

Feminists Come Out for San Francisco Strippers—A fairly rough piece featuring WAC (Women's Action Coalition) women and other feminists discussing alliance with strippers at a protest against the labor-exploiting Mitchell Brothers. An encouraging document of feminist support for sex workers. Basically raw footage. (23 minutes, 1994)

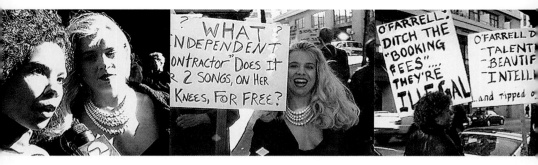

↑ **Strippers Protest the Mitchell Brothers**—Raw footage of strippers protesting labor violations and mistreatment by Mitchell Brothers. (28 minutes, 1994)

SWAM: Sex Workers Addressing MacKinnon—Sex workers protest outside Herbst Theater before Catharine MacKinnon's appearance. Should have been called Sex Workers Against MacKinnon, but we were being nice. (20 minutes, 1994)

Whore on Whore—Directed by Victoria Schneider; Produced by Carol Leigh; starring Victoria Schneider. Schneider directed this autobiographical snapshot of her own philosophical musings and stories about working on the streets. Says the director "Usually movies about ladies who happen to be prostitutes are just about them being prostitutes. That's the problem. What's different about our movie is that it's about the whole person." (7 minutes, 1995) →

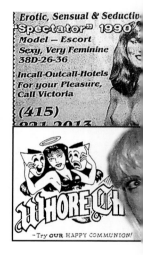

Whore Church—Clips from the San Francisco performance series/community benefit produced by artist and provocateur Tallulah Bankheist. (20 minutes, 1998-99) →

Stripper Sinema Montage—Vintage stripper performance clips from the '30s through the '70s. (25 minutes, 2000)

↓ **A Gram O' Pussy**—by Carol Leigh and Duran Ruiz. This short video is featured as part of Alex Juhaz's *Released*, a 28-minute documentary which artfully merges five short videos to create a powerful and empowering forum to

consider the personal and political meanings of the contemporary prison indus-
trial crisis. In this segment Duran Ruiz (featured on a ABC *20/20* segment
exploring prostitution) deconstructs how the mainstream media represented her,
prison, drugs, and prostitution. This work re-presents her as an artist and
activist. (3 minutes, 2000)

Sex work and health in a changing Europe—
Documenting the 2002 EUROPAP conference,
Sex Work and Health in a changing Europe
(Milton Keynes, UK). A resource for health
service providers addressing issues of migra-
tion, trafficking and sex workers' health, (top)
Jo Doezema, (left) Helen Ward, (right) Laura
Agustín. Leigh filmed, directed and created
this unique compilation as a CD, DVD and
video. (120 minutes, 2003)→

Additional Women's Issues

Mills College Women at Anti-apartheid Demonstration—Young activists vs. old
guard feminist dean. (28 minutes, 1989)

International Women's Day March 1991—Organized by Women Against
Imperialism, a lively document of early '90s feminism, in-depth interviews. (28
minutes, 1991)

Yes Means Yes. No Means No.—Powerful, interracial date rape drama starring, and co-
directed by performance artist, Dee Dee Russell. A groundbreaking portrayal of
sexual assault and a sharp satire on interracial sexual perceptions. "Best of the (Mill
Valley) festival," said the *Sentinel* and the *San Francisco Weekly*. First place for fiction
American Film Institute's SONY Visions of U.S. Video Contest; Best Narrative
from Brooklyn Arts Council, Juror's Merit from Louisville Film and Video Festival.
Screened at San Francisco International Film Festival, Denver International Film
Festival, Simone De Beauvoir Festival (Paris) and more. (8 minutes, Video: 1990;
Film: 1992) ↓

Bad Gurlz in a Bad Mood—Dee Dee Russell, Chelsea Bonacello & Scarlot Harlot perform wild and angry street theater at City Hall. (28 minutes, 1992)→

Choice?—As seen nationally on the '90s Cable Network. A San Francisco pro-choice rally provides the backdrop for a series of thought-provoking interviews about control over our bodies and self-determination including drugs, surrogate motherhood, sex work, and

Filmmaker Chelsea Bonacello and Scarlot at City
Photo: Jane

racism within the women's movement. Includes a rare interview with Ladies Against Women. (28 minutes, 1992)↓

WAC Attack Video Series—Women's Action Coalition Video Series includes "Let Them Eat Crumbs: Queen Isabella Commemorative Riot", "Pink Slips for The Bush Administration" at Bimbos; Tailhook demonstration and others. (28 minutes, 8 episodes, 1992 & 1993)

Dead Men Don't Rape—featured nationally on the '90s network. Interesting comments and debates by activists and male and female students about an incident of date rape at the University of California, Berkeley campus. (28 minutes, 1993)↓

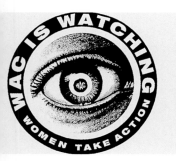

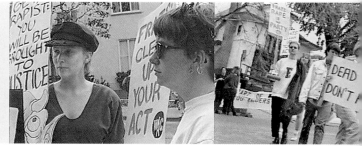

Street Survival Project #1 and 2—A short collection of interviews from this youth employment program. Suitable for health outreach workers, service providers, etc. This video features Nellie Velasco right, a great outreach worker, loved by all who knew her, who died of an overdose. (16 minutes, 1994) →

Gay/Bi/Lesbian Issues

Videovaudeville & Queen of Flags—Vignettes from The Sisters of Perpetual Indulgence, Unincorporated & Scarlot Harlot, written & directed by Gilbert Baker (AKA Sister Chanel 2001). (60 minutes, 1989) → →

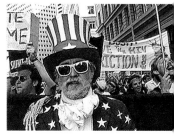

Spiritual Warfare: THE G.H.O.S.T. CAMPAIGN—Grand Homosexual Outrage at Sickening Televangelists in a Halloween confrontation with televangelist Larry Lea and his "prayer warriors" invading San Francisco to exorcise the demons from the Bay Area. Includes TV news, in your face interviews, and street theater by the Pink Jesus (Gilbert Baker), Sadie, Sadie, The Rabbi Lady, author Sara Diamond, Cleve Jones in drag and Ms. Harlot, dancing nude with a live snake. Wild and shaky! Screened at Film Arts Festival (San Francisco) & Cinematheque (San Francisco), Video Witnesses Festival of New Journalism (Buffalo, NY) (28 minutes, 1990)

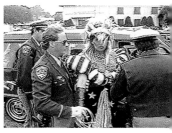

Aunti-Sam vs. the Fascist Zealots—Anti-censorship activists Bobby Lily and Micki Demerest meet Christians at a support rally for gay rights legislation, in Sacramento, California. (28 minutes, 1991)

Beat the Bigots—Sadie Sadie, The Rabbi Lady leads the troops in a fight against Lou Mayshore (Coalition for Traditional Values) at a Concord City Council Meeting. (28 minutes, 1991) ↓

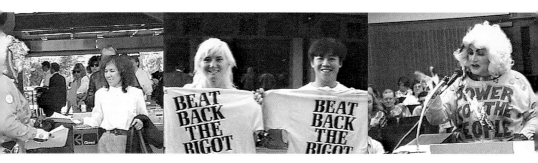

Queer Nation and ACT UP Visit the Bill of Rights—Righteous queers invade the Phillip Morris multimedia tour. Screened at Video Witnesses Festival of New Journalism (Hallwalls, Buffalo, NY). (28 minutes, 1991)

Public Access Hits

Elaine's—Six episode situation comedy based on political issues (drugs, homelessness, domestic violence) produced by Leigh with T.W.I.T., Tucson Western International Television, on public access in Tucson. (28 minutes, 6 episodes, 1985)

Bored in the U.S.A.—San Francisco performance poets Peter Pussydog, Deirdre Evans, Chris Trian, Vampire Mike and more. (28 minutes, 10 episodes, 1988)

Xmas Anti-special—Scrooge would love it . . . featuring Mom, Mark Beckwith. Music by Rotoclef Unit Orchestra. (28 minutes, 1990)

Topfree—Debbie Moore & The X-Plicit Players go Topfree at a picnic and on the streets of Berkeley. First place East Bay Media's Video Festival. (28 minutes, 1993)

Actual Sex

Fire on the Mountain—Sex teacher Joe Kramer's visionary penis massage movie with Taoist Erotic Massage, co-directed by Carol Leigh (45 minutes, 1992)

Masturbation Memoirs Volume (4 volumes)— by Scarlot Harlot and Dorrie Lane. A groundbreaking exploration of sexual imagery from a "feminine" perspective, *Masturbation Memoirs* is uniquely lyric, comic and political, marking a new wave in women's pornography. "For me, the discussion of feminist porn is secondary to actually creating the imagery," says whore activist cum porn star Scarlot Harlot. Scarlot Harlot (300 pounds of porn star) masturbates amid images of Americana. (30 minutes/volume, 1995-98) ↓

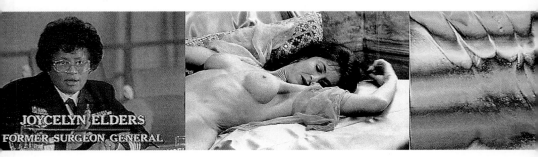

JOYCELYN ELDERS
FORMER SURGEON GENERAL

Sluts and Goddesses Video Workshop or How To Be A Sex Goddess in 101 Easy Steps—by Annie Sprinkle and Maria Beatty. A humorous, absurd, heartfelt and worshipful look at SEX. Guided through this unique adventure by sexpurt extraordinaire Annie Sprinkle and the "transformation facilitators," explore the ancient and forbidden secrets of female sexuality. Starring Scarlot Harlot, Diviana Ingravallo, Kelly Web, Trash, Chris 'Teen,' Jade, Amy Harlib, Jocelyn Taylor and Barbara Carrellas. (50 minutes, 1992)

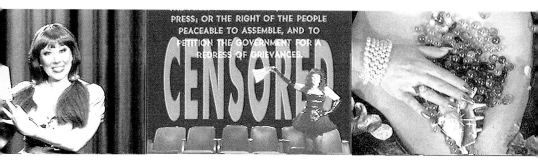

↑ *Annie Sprinkle's Herstory of Porn*—directed by Annie Sprinkle and Scarlot Harlot. Sprinkle's 25-year evolution through the sexual revolution begins with rare vintage hippie porn. You'll see clips from dozens of movies which include over 75 porn stars. Screened at Santa Barbara Film Festival, L'Etrange Film Festival (Paris), San Francisco Lesbian and Gay Film Festival (69 minutes, 1999)

Art of The Loop—by Annie Sprinkle, Dr. Jeff Fletcher and Scarlot Harlot. Two sexology students at the Institute for Advanced Study of Human Sexuality discovered thousands of old 8-mm sex films in the school basement. These "loops," belonging to the Exodus Trust Archives of Erotology are likely the largest collection of its kind in the world. Screened at the San Francisco Sex Worker Film and Video Festival. (17 minutes, 2001) →

Best of Vulva Massage—Dr. Joseph Kramer's interactive DVD compilation featuring work by Betty Dodson, Juliet Anderson, Jwala and Annie Sprinkle; Art direction and editing by Scarlot Harlot. (90 minutes, 2003)

Sources

Autobiography of A Whore: The Demystification of The Sex Industry, Oakland: Whorepower, 1983.

"Carol Leigh AKA Scarlot Harlot," *Felix: A Journal of Media Arts and Communication*, New York, Volume 1, Number 2, Spring 1992.

"Carol Leigh: Senate Judiciary Committee," *City Lights Review*, Volume 2, San Francisco, 1988.

Confessions of a Jewish Nun, Gil Block, San Francisco: Fog City Press, 1999.

"Economic Justice for Sex Workers: A First Hand Look at the San Francisco Task Force Report on Prostitution," *Hastings Women's Law Journal*, San Francisco, Volume 10, Number 1, 1.

"Further Violation of Our Rights," *AIDS: Cultural Analysis/Cultural Activism*, edited by Douglas Crimp, Cambridge: MIT Press, 1988.

In Defense of Prostitution, edited by Carol Leigh, *Gauntlet, Exploring The Limits of Free Expression*, Springfield, Pennsylvania, Volume 1, Issue # 7, 1994.

"Inventing Sex Work," *Whores and Other Feminists*, edited by Jill Nagle, New York: Routledge, 1997.

"P.I.M.P. (Prostitutes in Municipal Politics)," *Policing Public Sex, Queer Politics and the Future of AIDS Activism*, edited by Dangerous Bedfellows Collective, Boston: South End Press, 1996.

PENet, Prostitutes' Education Network Website, Bay Area Sex Worker Advocacy Network (http://www.bayswan.org), San Francisco, 1995.

San Francisco Task Force on Prostitution Final Report, San Francisco: Board of Supervisors, 1996.

"Prostitutes Oppose Munipimp," *San Francisco Bay Guardian*, December 8, 1993.

"Good Luck and I Hope you Make A Lotta Money," *Northwest Passage*, Seattle, November 1994.

"Shameless Pagan Whore," by Sylvana Silverwitch, *Widdershins*, Seattle, Volume 2, Issue 1, Beltane, 1996.

"Thanks, Ma.," *Uncontrollable Bodies: Testimonies of Identity and Culture*, edited by Rodney Sappington and Tyler Stallings, Seattle: Bay Press, 1994.

"The Continuing Saga of Scarlot Harlot," *Sex Work: Writings by Women In The Sex Industry*, edited by Frederique Delacoste and Priscilla Alexander, San Francisco: Cleis Press, 1987, 1997.

"The Continuing Saga of Scarlot Harlot," (monthly column), *Appeal To Reason/Open City,* San Francisco, Volumes 1& 2, 1982-4.